The Bellagio Gallery of Fine Art

Impressionist and Modern Masters

THE BELLAGIO GALLERY OF FINE ART

Impressionist and Modern Masters

Foreword by Stephen A. Wynn

Edited by Libby Lumpkin

This catalogue is published in conjunction with the opening of
The Bellagio Gallery of Fine Art, Bellagio, Las Vegas, Nevada, October 15, 1998.

© 1998 by The Bellagio Gallery of Fine Art,
Mirage Resorts, Incorporated, Las Vegas, Nevada

First published in 1998 by The Bellagio Gallery of Fine Art,
Mirage Resorts, Incorporated, Las Vegas, Nevada

Distributed by The Bellagio Gallery of Fine Art, Bellagio,
3600 Las Vegas Boulevard, Las Vegas, Nevada 89109

Library of Congress Catalog Number: 98-67355
ISBN 0-9666625-0-4

Edited by Libby O. Lumpkin, Curator

Produced by The Bellagio Gallery of Fine Art, Mirage Resorts, Inc.
Production supervision: Libby O. Lumpkin, Curator, and John Schadler,
 Vice President of Advertising, Mirage Resorts, Inc.
Production assistance: Robert Gordon–Private Editions, New York

Designed by Abraham C. Brewster, New York
Photographs of the Bellagio Gallery artworks by Mark Naegle,
 Supervisor of Physical Operations, the Bellagio Gallery of Fine Art, and
 Russell MacMasters Photography, San Francisco
Photograph research by Jennifer Bright, New York,
 and Robert Gordon–Private Editions, New York
Printed and bound by Arti Grafiche Amilcare Pizzi S.p.a., Milan, Italy

Front cover: Vincent van Gogh, *Peasant Woman against a
 Background of Wheat,* June 1890
Back cover: Willem de Kooning, *Police Gazette,* 1955 © 1998 Willem de Kooning
 Revocable Trust/Artists Rights Society (ARS), New York.

Contents

Foreword

The popular question that seems to have overshadowed the lively speculation about the Bellagio Gallery itself seems to be "Why?" Why, of all things to feature in a new resort hotel in Las Vegas (of all places!) would one select an enormously costly and potentially limited-appeal attraction such as a serious fine art presentation of paintings and sculptures? The choice would seem to be unorthodox at best and a bit risky at worst.

Well, I think the question itself is fair enough. I have always had a great deal of appreciation for Impressionist art since my days as an undergraduate at the University of Pennsylvania. That interest accounts for how the whole notion of fine art came to mind in the first place.

I'll start at the beginning. For the past five years all of us in the Mirage Resorts' design and development group have been deeply immersed in the complexities of creating Bellagio, our new and hopefully standard-setting resort in Las Vegas. From the start the task, as we understood it, was to create a hotel that was simply an experience of absolute quality, with the emphasis on a mood of romance and elegance—romance in the literary sense, a place of ideal beauty and comfort, the world as it might be if everything were just right. A dreamy notion, to say the least, but a notion that is quite imperative under the circumstances of today's very competitive world leisure market. Folks just plain expect more these days. All the old ideas of resort attractions have become, well, just old. It is time, we thought, to revisit our assumptions. Bellagio had to become a synonym for beauty and elegance, which meant we would need to address our guests' higher sensibilities. The hotel would somehow have to be more than just the best place to stay in Las Vegas. (We had, perhaps, already achieved that goal with the Mirage.) Bellagio had to be perceived as being "distinguished" by people who would not easily be fooled by advertising or hype. That perception of a place of special elegance, quality, and distinction is very hard to create in a cynical world. There are few areas of universal agreement about what is truly lovely, graceful, or admirable. One of the subjects on which there is some general agreement, in spite of cultural, economic, or social differences, is that of fine art. Somehow great painters and sculptors and their works are held in high esteem by everyone. Attendance at museums in the past few years has exceeded atten-

9

dance at professional sporting events throughout the U.S.A. This surprising statistic seems to represent a popular and fundamental yearning in our diverse cultural souls for a glimpse of beauty, a desire to be near examples of singular creative energy.

For me the acknowledgment of art's deep attraction is not surprising at all. I believe that great art—whether in painting, sculpture, architecture, music, or dance—has always had the power to deeply stimulate human consciousness. So, therefore, why not focus on that simple idea? Bellagio shall become a place of fine art even more noteworthy because of its location. (In Las Vegas, of all places!)

So, that's how I came to the provocative notion of creating a gallery that would very well grace the resort with a certain degree of distinction or at least with a certain degree of curiosity. What really matters is that by offering our guests (and my fellow residents) the Bellagio Gallery of Fine Art, I am acknowledging their highest capacities for the appreciation of beauty and elegance. When someone does that for me, I am pleased and grateful. I feel a kinship with people who demonstrate that level of sensitivity, and I believe it is a worthy aspiration in business and life in general.

To sum it all up simply as I can, the idea of art in the hotel doesn't seem risky to me at all. I love to look at a landscape by Claude Monet. I feel romantic and transported by a scene in Montmartre painted by Auguste Renoir, I am provoked by a portrait by Pablo Picasso or Vincent van Gogh and delighted by the dancing colors of Henri Matisse. I am warmed when I am near the blazing creative heat of Jackson Pollock or Willem de Kooning. There is, for me, a palpable energy that radiates from their works. All of these artists, regardless of chronology, share the most remarkable power to move us. I feel them and somehow am stimulated to think and feel more about the world around me than I did before. It's habit-forming in a way, and I'm betting that lots of intelligent, discriminating people who are prone to this lovely habit will join me to delight in the experience of the gallery, which just happens to be located in the Conservatory of the Bellagio. (In Las Vegas, of all places!)

—Stephen A. Wynn

Editor's Note

This book of essays was assembled with a single thought in mind: to enrich the public's experience of visiting the Bellagio Gallery of Fine Art. The principle guiding the selection of writers was simply to invite those with special insight or knowledge, and let them bring to the works what they would. Thus the essays are as various in character as the works themselves, ranging from impassioned appreciations to rigorous scholarly contextualizations, from anecdotal narratives to theoretical analyses. To the writers I owe a debt of gratitude. All delivered their best.

To Stephen Wynn, Chairman of the Board and Chief Executive Officer of Mirage Resorts, Incorporated, I owe the greatest debt. He has my admiration for assembling the Bellagio's remarkable collection and my gratitude for providing me the opportunity to produce this book. At every point he has demonstrated his commitment to providing the Bellagio Gallery's works of art with the scholarship and stewardship works of this importance demand, and has freely taken time from his busy schedule to bring his expertise, enthusiasm, creativity and generosity to bear on all phases of production.

The staff of the Bellagio Gallery of Fine Art is simply the best in the world. Mark Naegle, Supervisor of Physical Operations, whose beautiful photographs bring the art works to life on many of these pages, and Catherine Brundage, Registrarial Assistant, who has pulled our team through the busiest days imaginable, have been a part of this project from the beginning, providing constant, resourceful, and efficient support. Thanks also to Kathleen Clewell, Registrar, who walked in one day and became an invaluable proofreader the next; and Charlotte Carrier, Manager, for cheerfully and graciously keeping operations on track amid the swirl of activity.

A special word of thanks must go to John Schadler, Vice President of Advertising for Mirage Resorts, whose expertise in production saved the day more than once; Ted Pillsbury, Consultative Director of the Bellagio Gallery of Fine Art, for taking time to read the essays and providing welcome editorial advice; Joyce Luman and Cindy Mitchum, Executives, Mirage Resorts, for showing me the corporate ropes and helping in every other way; Charles Moffett, Sotheby's, New York, who

in addition to contributing three outstanding essays, generously shared of his expert production advice; Robert Gordon, Private Editions, New York, who assisted with production and the collection, organization, and reproduction of images, and has sought throughout to make this book shine; Sandro Diani and Mary Prevosti, American Pizzi, New York, for bending over backward to accommodate our delays; and Abraham Brewster, New York, whose role has been greater than that of designer and who, more than anyone, has made this a beautiful book.

Claes Oldenburg and Coosje van Bruggen generously shared information and photographs for my essay on Claes's *Clothespin—45-Foot Version (Model).* Many thanks for the loan of photographs go also to Jasper Johns and Sarah Taggart; Stephen Mazoh; Agnes Gund; Sebastiano Piras; Robert Sharpazian, Gagosian, Los Angeles; and the New York offices of Leo Castelli Gallery; Barbara Divver Fine Art; Christie's and Sotheby's.

Thanks also to Russell MacMasters Photography; Jerry Miller, Senior Designer, Graphic Arts, Mirage Resorts (our "last-minute man"); Jennifer Bright, New York, who helped order the corollary images; Timothy Erwin, University of Nevada Las Vegas, who helped edit the essays; Fronia Simpson, Bennington, Vermont—proofreader extraordinaire; and Dante Stirpe, Albuquerque, for technical advice.

Finally, heartfelt thanks to Roger Thomas, Vice President of Design, Mirage Resorts; Gary Kornblau, *Art issues,* Los Angeles; and Dave Hickey, Las Vegas for encouragement and support.

—Libby Lumpkin

An Archive of Eden

Most of the great American art collections were assembled swiftly by determined individuals in sunny days of passion and opportunity. Henry Clay Frick's furies of acquisition in the early years of this century made his bequest to New York City, the Frick Collection, inch for inch the best art museum in the world. Such swashbuckling audacity may shock snobbish connoisseurs, but it gives them, ever after, something to be connoisseurs about. Whether staying intact like Frick's treasures or, like those of an Andrew Mellon, providing jewels to the crowns of our leading art institutions, the American way of collecting has helped to distinguish this nation as, in a phrase of the philosopher George Steiner, the Archives of Eden.

Now another remarkable American collection comes together suddenly in a place that seems ever less unlikely the more one thinks about it. Las Vegas is an international crossroads of dynamic prosperity—an Oz-like emerald city, a reminder of Renaissance Venice—whose reason for being happens to be the pursuit of pleasure. All pleasures are pleasurable, but not all are equal. Some, such as art's joy, stand in relation to others like mountains to foothills. With the public christening of the Bellagio Gallery of Fine Art, the sprawling fun of Las Vegas begins to generate standing monuments of supreme delight.

Stephen Wynn here attempts a type of collection—spanning a hundred years of modern art from Impressionism to Pop—that art-world common sense will gladly tell you is inconceivable today. Most modern masterpieces have long since migrated from private hands into museums, and highly competitive markets for the rare exceptions that become available afford no bargains. Only wealth and will on the scale of Las Vegas itself could dare to undertake such a project from scratch now. One might wonder at the wisdom of so expensive and difficult a goal. What's the point? When craving an experience of great art, why not just visit one of the old American cities that have it already?

Reasons include the urgent desire of the American Southwest for cultural assets to mark the region's growing prestige in the world. Local pride, a historical force that is often underestimated, must be

served. Then there is the truth that place matters in our perception of art. An Edgar Degas in one metropolis is not the same as a Degas in another. The French high priest of the aesthetic speaks differently to geographically different audiences. It matters where his radiant ballet star takes her bow.

Walk up to Claude Monet's *Water-Lily Pond with Bridge* and try not to be enthused by the painting's new status as a citizen of Nevada. You can't. The canvas constitutes an oasis, slaking thirsts of which, a moment before starting to look, you were probably unaware. For one thing, it delivers beauty of a kind exactly antithetical to the beauty of a desert city: liquid splendor of nature in Monet's Giverny, where air that is saturated with scintillating dampness meets water that amasses reflections of riotous vegetation and cloud-fretted summer sky. The picture is a moisturizer of the soul.

Monet's painting also observes a high holy day of the human hand. This is a sacred quality that is not to be had via photographic reproductions and that is radically scarce elsewhere in Las Vegas—whose world-famous feats of aesthetic innovation rest on a contrary principle. Las Vegas architecture and design entail deliberately impersonal surfaces, presenting forms that seem magically to have arrived directly from dreams without manual intervention. The factual little traces of Monet's brush—each as alive as a heartbeat and as particular as a fingerprint—complement and balance the disembodied phantasmagoria of the fabulous city that has become their home.

If the Bellagio Gallery steers by a consistent theme of taste, it is the Monet-like marriage of color and texture, sight and touch, eye and hand. Nowhere else on planet Earth, I think, could the rapt solemnity of that doubleness register more sharply. Think of this when viewing Picasso's portrait of Dora Maar, a work whose depth charge of brooding gravity is unique in the Spaniard's career and in art history. The picture is a frankly melancholy image of despair. And yet, by the alchemy of art that makes spiritual gold of even or especially the most leaden emotion, it occasions thrilled awe at the human capacity to exalt any and all truth.

What truth is at issue in Joan Miró's enchanting *Dialogue of*

Insects or Willem de Kooning's delirious *Police Gazette?* The answer is special in the first case and elusive in the second. It calls on our abilities to feel and imagine, not to think. Many people deprive themselves of modern art's rewards by defensively assuming that it requires grueling intellectual preparation. In a real way, it requires the opposite: a suspension of intellect in sheerly beholding. If we manage to silence our chatty brains in the art's presence, the art will explain itself with wordless eloquence straight to our hearts.

The Miró is as good a work as this pictorial poet ever made and one of the best made by anybody in the middle 1920s, when stylistic impulses of Surrealism and abstraction were in peak bloom. Miró merges the impulses, producing an overall decorative harmony that harbors funny, alarming little apparitions. Nagging at the mind like sandy grit caught in your eye, the apparitions clamor to be identified, but none is anything you have seen before. Gradually, as you look, you sink into the condition of those winsome critters, sharing a perspective by which, say, a grain stalk towers like a redwood tree. In the universe, aren't we all odd, dwarfed critters, too? For protection we have the childlike wonder that Miró lyricizes for us.

De Kooning's *Police Gazette* is a pivotal work in the career of Holland's gift to American art. Some authorities believe (and I agree) that the painting probably began as one of the last of de Kooning's classic, wild series of "Women." It's fun to seek remnants of a savage goddess in the crashing surf of paint, but a turn away from figuration to pure painterly sensation is the work's primary meaning. Looking, we seek eyeholds like sailors grasping for survival in a storm at sea. De Kooning, who among other things was one of the century's finest draftsmen, everywhere provides the amazing security of gestures as firm as they are free.

Come to close quarters with all of the works here assembled. Think of the hands that made them—because those hands are thinking of you! Whether suavely caressing like Pierre-Auguste Renoir or cheerfully pummeling like Jasper Johns in his aggressive *Highway*—art history as a rushing vehicle whose headlights transfix you like a deer—the arousing touch of one immortal master after another will reach and hold

you if you let it. Why not let it? You have nothing to lose except your fear, and a life-affirming rapture stands to be gained. No onerous effort is required, but only openness.

Vincent van Gogh makes it easy. The cobbled strokes of *Peasant Woman against a Background of Wheat* almost suggest that we could discern its image with our fingertips in the dark. Van Gogh's brushwork is often popularly misconstrued as turbulently emotional and even frenzied. In fact, it is patient and precise. Mighty design, ardent color, and—hard to explain but impossible to miss—the artist's reverent passion for his subject's livingness fulminate the painting's heat. The technique of no other painter who ever lived is at once so obvious and so mysterious.

To let viewers in on the physical process of painting is a point of honor for most modern art after Post-Impressionism, which first established it. It is there in Paul Gauguin's electrifying tableau of Marquesan bathers, producing passages of drawing that seem to take on painted flesh before our eyes. Paul Cézanne became the painter's painter of the twentieth century for the searching, almost desperate sincerity he vested in every touch of brush to canvas. And, of course, Picasso was never reluctant to show us how he did a thing, as if inviting us to try it ourselves. (Good luck.)

"My kid could do that," more than one cursorily glancing skeptic has remarked of an Abstract Expressionist touchstone like Jackson Pollock's *Frieze* or Franz Kline's *August Day*. If it were so, the skeptic would be beaming from magazine covers as the parent of a world-famous child. In fact, these paintings' disconcertingly abrupt methods—dripped paint in one case, use of housepainters' brushes in the other—cut through our normally idling responsiveness like a child's cry in the night. To confront the pictures is to be plunged into violent events, where we must rely utterly on the painter's guiding skill and saving courage. Doubt is reasonable at first. But look for a while.

Andy Warhol's *Orange Marilyn* occurs in the collection like a rock on a heretofore smooth road. An icon of the nineteen sixties, when the mainstream of modern art became definitively Americanized, this painting startlingly downplays evidence of the artist's hand. Like Mini-

malist sculpture, Pop painting announced a new aesthetic that embraced the real-world dominance of mass culture and industrial design—two powerful trends that come to utmost, fantastic fruition in the desert aurora that is Las Vegas. The Warhol perfectly mirrors the town with a robust, apparent vulgarity that is actually an effect of cunningly subtle sophistication.

Classic Pop art makes almost too much sense in Las Vegas, perhaps. At any rate, Mr. Wynn's first priority so far has been to supply something locally lacking: a vibrant connection with history that predates the city's rise. A spiritual heliport to the past, the Bellagio Gallery of Fine Art quietly changes everything in the cultural atmosphere of a place that henceforth will no longer be only spectacular and only new. Amid the collection's intimate trophies, we feel ourselves affirmed as inhabitants of a civilization that was not born yesterday and that will persist tomorrow and beyond.

—Peter Schjeldahl

The Bellagio Gallery Collection

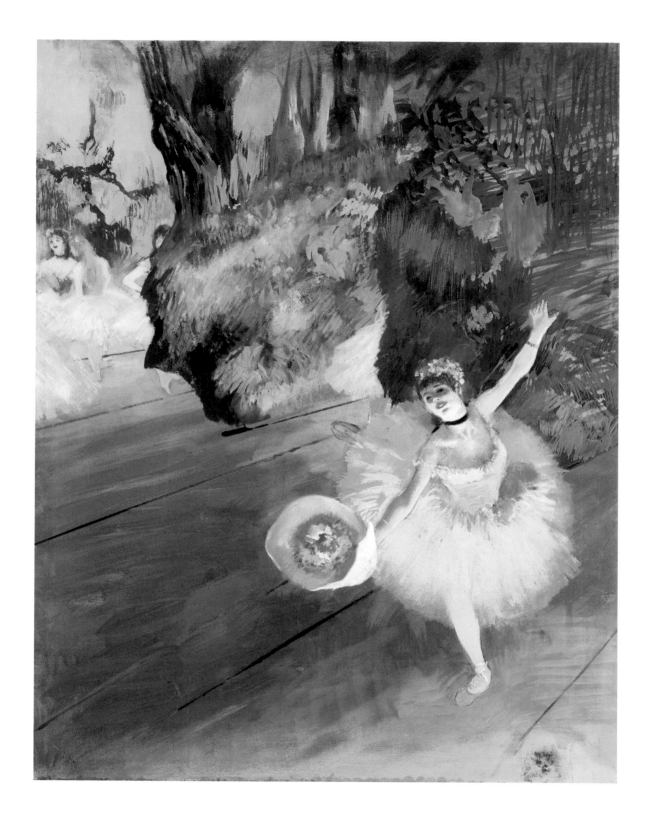

Edgar Degas

Dancer Taking a Bow (The Prima Ballerina)

Circa 1877. Pastel and gouache
on paper, 33 1/2 x 27 inches.

It was in the mid-1870s that one of the most celebrated subjects of Degas's art made its first appearance: that of a solitary dancer who detaches herself from the *corps de ballet* and advances into the footlights, either to receive the floral tributes of her audience or to launch herself into a spectacular arabesque. So popular with his admirers and so rich in pictorial drama was this invention that the artist returned to it on many occasions, making more than a dozen variants of the theme in monotype, etching, pastel, and gouache on a variety of scales.[1] In 1877, Degas included two examples from the series among his contributions to the third Impressionist exhibition, where the works were listed as *Danseuse, un bouquet à la main,* and simply *Ballet* (now believed to be the Musée d'Orsay's monotype-and-pastel *Étoile*). Both pictures were enthusiastically welcomed by the contemporary press. Critic Georges Rivière claimed the former belonged to a category of works by Degas "that could not be praised enough"; another writer, Paul Sebillot, described the two pictures as "among the strongest and most interesting in the exhibition"; and a third, anonymous, commentator proclaimed *Danseuse, un bouquet à la main* to be one of several "little masterpieces of truthful and spiritual satire." Yet another writer, known only as "Jacques," was so startled by the pose of one of the ballerinas that he announced, "If I had been on the conductor's rostrum, I would have tried to support her."[2]

Of the dozen or so versions of this composition made by Degas, the Bellagio Gallery's *Dancer Taking a Bow (The Prima Ballerina)* is the largest and most finely detailed. Paradoxically, it is also the least well known. It was acquired at an unspecified date in the artist's lifetime by Pierre Goujon and remained with his family until 1919, when it was sold at auction as part of the collection of Etienne Goujon. Little is known of the Goujons, except that Madame Pierre Goujon owned two other pastels by Degas, both from his later career, and that *Dancer Taking a Bow (The Prima Ballerina)* was considered to be the most important item in their holdings of Impressionist and later pictures.[3] Subsequent to the 1919 sale, the work was bought by a private collector and then passed to successive members of his family until its acquisition in 1997 by Mr. Stephen Wynn, for the Bellagio Gallery of Fine Art. Dur-

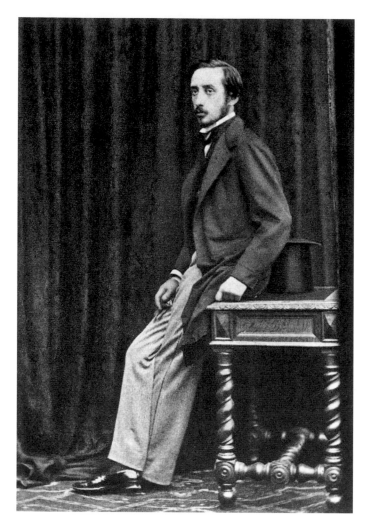

Portrait of Edgar Degas (1834-1917), circa 1869–1874.

ing this period, the picture appears to have been exhibited only twice, in 1924 and 1948, and to have been reproduced in color only once. Thus it has remained largely unknown both to specialists and the world at large for the past half century.

In contrast to this later obscurity, *Dancer Taking a Bow (The Prima Ballerina)* made its first appearance when Degas's imagery of the dance was more conspicuous than at any previous point in his career. By 1877, when the picture was probably executed, he had been depicting the ballet for more than a decade, acquiring a reputation (which he claimed to dislike) as "the painter of dancers" and attracting increasingly high prices for his scenes of preparation, rehearsal, and performance. The subject suited Degas's temperament perfectly, allowing him to exercise his prodigious skills as a draftsman and as a designer of figure compositions, while simultaneously tackling one of the most audacious themes of his age. Though the Romantic ballet was long past its best, productions at the Paris Opéra were crowded with the socially aspirant and the frankly rapacious. Black-suited male subscribers, or *abonnés,* would loiter in the wings for dancers who caught their eye (one is just visible at the left in the Orsay's *Étoile*). It was precisely this atmosphere of glamorous confrontation that lured Degas to the scene, complemented by a fascination with the athletic disciplines and backstage intrigues of ballerinas at work and play.

An examination of the Bellagio picture alongside other works from the same "family" of images reveals its affinities with the group as well as its subtly distinct character. Common to all the variants is the steeply raked stage in green grays and warm browns that implicitly locates the viewer both close to and above the action, the distant indications of scenery and the shadowy recesses of the wings, and the bright foreground illumination that suffuses the ballerina's tutu with

pale pinks, golds, and greens and almost flattens her features with its harsh brilliance. In comparison with the smaller *Étoile*, the Bellagio's *Dancer Taking a Bow (The Prima Ballerina)* has more spatial complexity, and a less ominous narrative. Extending the composition at top and left, Degas allows our gaze to wander across the stage and up into the painted foliage and branches, then beyond to the bright off-stage area

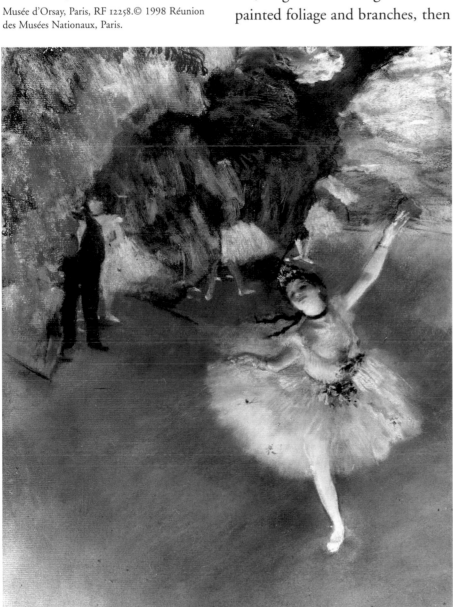

Edgar Degas, *L'Étoile,* circa 1878. Pastel and monotype, 22 7/8 x 16 1/2 inches.

Musée d'Orsay, Paris, RF 12258.© 1998 Réunion des Musées Nationaux, Paris.

that seems like an oasis of calm beside the public spectacle. Here, instead of the sinister *abonné* and the faceless dancers in *L'Étoile,* we find a casual gathering of girls from the chorus, evidently relaxing as they wait for the curtain call or—like the figure half-hidden by the tree trunk—flexing their tired feet. More than is the case with *L'Étoile,* or most other pictures in this series, we are encouraged to contrast proximity with depth, formality with extravagant ease, and artifice with limpid, shadowy intervals that unfold throughout the composition.

A curious, if understated, element of the picture is its wit, a quality known to have been characteristic of Degas as a man, and one frequently found in his works of art in this decade. Even the exquisite *prima ballerina* in the foreground is touched by it; the easily overlooked sole of her pink-shod left foot—like an unopened bud or a crustacean claw—peeps out from her tutu at the very center of

23

the composition. Beside the gravity of her pose, however, the idle chatter and crude features of her colleagues seem near-caricatural, while the blur of a tutu at the picture's left edge, the glimpse of another pink foot beneath the adjacent scenery, and a further, half-obscured dancer just behind the ballerina suggest a sophisticated game of hide-and-seek. As so often with Degas, such playfulness extends to the more private languages of paint, gesture, and the depiction of human behavior. What could be more fanciful than a young woman pirouetting against cardboard greenery? Yet how plausibly the artist depicts her limbs, torso, and head. How ironic that "real" flowers wrapped in tissue have been offered to the dancer, whose head is crowned with artificial blooms

Edgar Degas, *Étude de Danseuse.*
Black crayon, 18 x 11 3/4 inches.
Private Collection. Courtesy of Barbara Divver Fine Art.

painted on real paper; and how slyly Degas reminds us that the scribbles of color on the scenery are the illusion of an illusion, another trick in the necromancy of art.

Despite its scale, the Bellagio picture was executed on a single sheet of paper and shows remarkably few signs of revision during its making. Where several other related compositions were begun as monotypes or extended by the addition of broad strips of paper to their edges, Degas appears to have determined the forms and spaces of *Dancer Taking a Bow (The Prima Ballerina)* from the beginning, refining only details and nuances of hue as he progressed. For this reason, we might deduce that the work followed rather than preceded the smaller, more experimental *Étoile* and other such monotype-based variants as the Philadelphia Museum's *Star* and the Art Institute of Chicago's *On the Stage,* if only by a few weeks or months.

The Bellagio's work in gouache and pastel has no monotype foundation. It was initially drafted with strokes from a fine brush, some of which are still discernible around the legs of the distant dancers. The dancer figures themselves derived from preliminary

Edgar Degas, *Two Dancers in Pink Standing in the Wings,* circa 1879. Pastel on three sheets laid down, 19 7/8 x 15 7/8 inches.

Cincinnati Art Museum, Bequest of Mary Hanna, 1956.113. Photograph: Forth 1997.

drawings and other studies made from the model. As was his practice at this time, Degas seems to have posed a fully attired dancer in his studio in the appropriate attitude, then made at least three rapid drawings, one delineating the *prima ballerina*'s posture, another the position of her head and arms, and the shape of her slipper, and a third her facial expression.[4] The minor background figures were evidently based on similar drafts, or perhaps on the larger but near-identical characters that occur in the pastel *Two Dancers in Pink Standing in the Wings,* which is now in the collection of the Cincinnati Art Museum.

Having mapped out his principal components, Degas then brushed in the dominant tones of floor, scenery, and such features as the ballerina's tutu with gouache, varying his strokes to suggest the dusty breadth of the stage and the finer textures of foliage and bark. Taking up his pastels, he proceeded to build up the lighter forms of the dancers' limbs and costumes, introducing hints of crème-de-menthe into the fabric, lavender and apricot into shadows, and a surprising mid-green into the modeling of the *prima ballerina*'s lower neck. Always sensitive to the qualities of his support, the artist encouraged the inherent warmth of the peach-tinted paper to glow through these thinly applied colors, enhancing the hothouse atmosphere of the performance and the radiance of its illumination. In places the different

media became indistinguishable, for example, where colored washes merged with tinted chalk in the dancer's bodice and her forward-thrusting right leg. At some juncture, the artist seems to have splashed a spot of dark blue paint onto the picture, creating a fine vertical streak just to the left of center which he later partly erased, before covering some of it with adjacent forms such as the bouquet and the lines of the floorboards. A few final touches—the smear of scarlet on the lips of the star, the dense black of her choker, and a fine detail on an ear or a shoe—along with the bold addition of orthogonal lines to indicate the stage surface, brought the work to its sparkling conclusion.

Since its inception more than a century ago, the major areas of *Dancer Taking a Bow (The Prima Ballerina)* have survived with exceptional freshness and—like the bulk of Degas's works on paper—with its colors untainted by the passage of time. It has now been established that the artist habitually used fixative in such circumstances, here preserving the crispness of pastel accents and the subtleties of his tonal modulation. At some point in the intervening years, however, probably in the postwar period, a plan to conserve the picture coincided with, or conceivably caused, some tearing in the paper at the corners of the composition. This may have occurred while the sheet was being transferred from its original card backboard (which still survives) to a thin fabric lining, which in turn was attached to a wooden stretcherlike support. (The original coarse card backboard is now screwed to the rear of the picture frame, where a number of labels in varying states of preservation and legibility confirm details of its auction and exhibition history.)[5] Alarmingly, moisture was evidently introduced to the upper and lower edges of the picture surface, perhaps to "restretch" the paper on its new support, with the subsequent loss of some detail in these areas. A black-and-white photograph in the 1919 sale catalogue shows, for example, that a more precise pattern of twigs and leaves once graced the tops of the scenery and that the dark lines across the stage formerly extended to the lower edge.

The most surprising losses, however, occurred at the bottom right-hand corner, where a blur of dull blues, russets, and whites marks the position of a second bouquet of flowers at the dancer's feet (a device of-

ten used by Degas during this period), which both the 1919 photograph and P. A. Lemoisne's 1946 *catalogue raisonné* reproduction of the work show clearly. The same sources reveal that a passage of raw paper slightly above and to the right of the bouquet was formerly the site of a flourishing example of Degas's signature, also washed or wiped away in uncertain circumstances. If a number of paintings mysteriously acquire the signatures of suitable and unsuitable artists in the course of their histories, it is distinctly unusual to find a work that has lost one. We can only be thankful that the photographic records of previous generations have preserved this link between the artist and one of his major works from the Impressionist years.

—Richard Kendall

1. Apart from examples in which the dancer curtseys or simply acknowledges the applause, works with variations on the distinctive arabesque, with or without bouquet, include: P. A. Lemoisne, *Degas et son oeuvre* 4 vols. (Paris, 1946-48), nos. 418, 491, 492, 572, 574, 591, 601, 627, 735 and 736; S. W. Reed and B. Shapiro, *Edgar Degas: The Painter as Printmaker* (Boston, 1984), no. 57.

2. While it has widely been assumed that *Danseuse, un bouquet à la main* was Lemoisne no. 418, the *Fin d'arabesque* currently in the Louvre, none of the contemporary references or historical circumstances preclude the possibility that it was the Bellagio Gallery's picture that was shown in 1877. The critical responses can be found in R. Berson, *The New Painting: Impressionism 1874-1886*, 2 vols. (San Francisco, 1996), vol. 1, pp. 157, 176, 181, and 190.

3. The works in question were an unidentified drawing related to Lemoisne 815 and Lemoisne 1146. The claim for the importance of the present picture was made in the 1919 catalogue.

4. The drawings in question can be found in *Catalogue des tableaux, pastels et dessins par Edgar Degas* (Paris, July 1919) Vente IV, nos. 281(a), 283(b), and 269.

5. Both front and back of the picture were fully examined out of its frame by the author in April 1998.

Édouard Manet

Portrait of Mademoiselle Suzette Lemaire, in Profile

1880. Pastel on paper,
21 3/8 x 17 3/4 inches.

Édouard Manet's ravishing pastel of Suzanne Lemaire, at first sight a work not about much more than the pretty profile of a young and fresh Parisienne, opens a window onto a fascinating web of personal connections in the art world of Paris in the Third Republic. The model, whose nickname was Suzette, was the daughter of a minor artist named Madeleine Jeanne Lemaire, née Colle. The mother, born in 1845, was only thirty-five or thirty-six when her daughter's portrait was made in 1880, and the daughter, whose birth date has not yet been found, thus was probably no older than twenty and possibly as young as fifteen. According to the painter Jacques-Emile Blanche, she was brought to Manet's studio by Charles Ephrussi, a sometime art dealer, collector, and critic who became the owner of the influential art journal *Gazette des Beaux-Arts,* in 1885.

There are several accounts of the sitting. Tabarant recorded that Ephrussi appeared at Manet's door and said, "Je veux que Manet fasse un pastel de Suzette" (I want Manet to do a pastel of Suzette).[1] Jacques-Emile Blanche, then a young painter who was friendly with Manet, Edgar Degas, and others in their circle, published a brief, diaristic note in 1912: "Séance de Mlle Suzette Lemaire; pastels; Manet peine, se courbe, se retourne vers le petit miroir qu'il tient à sa gauche et où reflète, inverti, le joli visage de la jeune fille. Manet veut prouver à Mme Madeline Lemaire qu'il peut faire concurrence à Chaplin, le maître portraitiste de ces dames" (A sitting: Mlle. Suzette Lemaire is posing for a pastel; Manet is laboring, bending forward, turning toward the little mirror he keeps to his left where the image of the young girl is reflected. Manet wants to prove to Mme. Lemaire that he can rival Chaplin, the master portrait painter of these ladies).[2] However in 1921, Blanche repeated the above words and elaborated further: "He believes himself to be prettifying, flattering, he selects the choicest pinks, blends the pastel colours. He rubs out, begins again. The modeling is becoming more and more uneven, black predominates, ringing the contours. 'It's a crow,' says Aurelian Scholl. 'You're hard on women.'"[3]

Today it is difficult to agree with the remark ascribed to Scholl, and its absence in Blanche's earlier record of the event arouses suspicion. There is little evidence of extensive changes in the profile portrait,

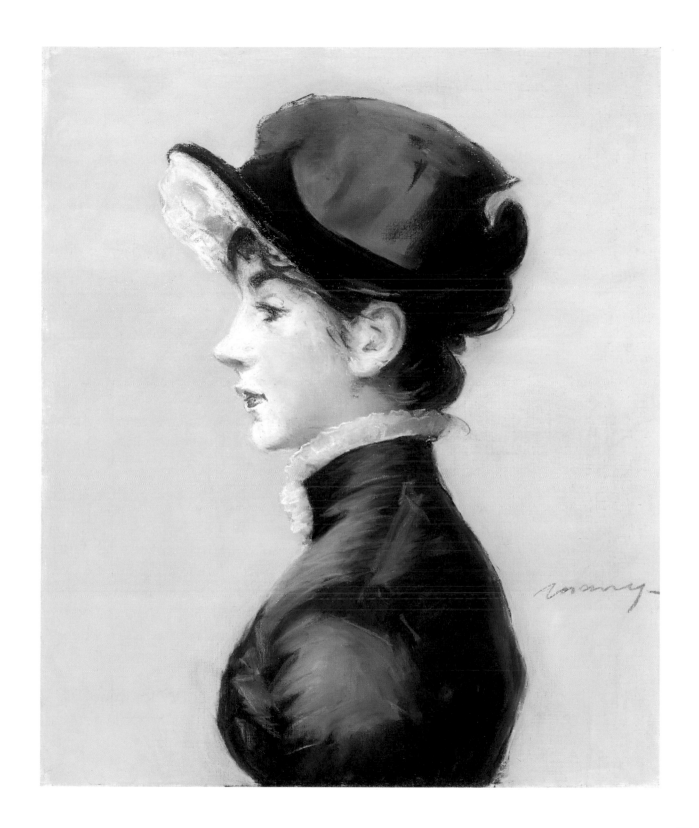

Portrait of Édouard Manet (1832-1883), circa 1878.

© Collection Roger-Viollet, Paris.

apart from the usual reworking of the contours. But he was correct to invoke Charles Chaplin, for Chaplin was both a teacher of Madame Lemaire and the author of a grand half-length portrait of Suzette two years later.

Ephrussi paid Manet 1,000 francs for the portrait. According to Tabarant, Manet made a full-face portrait pastel as a gift to Ephrussi in thanks for the referral.[4] Madame Lemaire, who had apparently commissioned the pastel, was delighted with the result. According to Tabarant, she had accompanied her daughter to Manet's studio. Later, she wrote the artist to say, "Je comptais aller vous voir pour vous dire tout le succés de votre ravissant portrait…. C'est charmant, très ressemblent, et je pense que vous entendez l'echo de tous les compliments que j'en recois" (I have been intending to come to see you to tell you of the great success of your ravishing portrait…It's charming, a good likeness, and I think that you must be hearing echoes of all the compliments that I am receiving on its account).[5]

Madame Lemaire was first received at the Salon of 1864, ironically during the period when Manet had such difficulty gaining admission. She continued to exhibit her ingratiating genre scenes and flower pieces for the rest of her career. By the time Manet portrayed her daughter, he was routinely accepted (though still notorious). Blanche, perhaps cruel, wrote that then "Manet ne travaillait que pour le 'Salon.' Les tableaux qui restent de lui sont 'des Salons.' Il fit relativement peu d'études, presque pas de dessins ou de croquis. Ce gentil causer d'atelier et de café, qui veut plaire, aime la vie en commun, le boulevard, Tortoni, le café de Bade….le Paris de Manet a une saveur qui parfume ses oeuvres les plus frêles" (Manet was working only for the Salon. His remaining paintings are, as they say, Salon paintings. He made relatively few studies, almost no drawings or sketches. This gentle habitué of studios and cafés, who wants to please,

Charles Chaplin. *Portrait de Melle. L.*, 1882. Oil on canvas.

Cliché Bibliothèque Nationale de France, Paris.

Edouard Manet, *Portrait of Mademoiselle Suzette Lemaire*, 1880. Pastel on canvas, 20 7/8 x 13 inches.

Location unknown.

loves urban life, the boulevard, [the restaurant] Tortoni, the Café de Bade...Manet's Paris has an aroma that pervades his most delicate of works").[6]

Blanche also recalled seeing Ephrussi in Manet's atelier at 27, rue de Saint-Petersbourg, behind the Gare Saint-Lazare. He was included in a list of visitors, including boulevardiers and "jolies demi-mondaines" (pretty women of questionable repute). Was Suzette Lemaire included in the latter group? Ephrussi himself belonged to several worlds and the Goncourt brothers disliked him for it. "These Russian Jews, this Ephrussi family, are terrible, with their craven hunt for women with grand dowries and for positions with large salaries.... Charles attends six or seven soirées every night in his bid for the Ministry of Fine Arts."[7] He never was made minister, but along the way he acquired some very important pictures, including Monet's *Grenouillère,* Degas's pastel *At the Milliner's,* and works by other artists such as Puvis de Chavannes and Gustave Moreau. While one can imagine why Ephrussi wished to curry favor with Manet by bringing the Lemaire mother and daughter to the artist's studio, one wonders why Manet returned the favor by giving another portrait of Suzette to Ephrussi. Was Ephrussi courting Suzette? Or was, perhaps, Madame Lemaire attempting to place her daughter under the protection of a well-connected society figure, influential in the arts?[8] It hardly seems necessary for Ephrussi to have made the introduction to Manet, since Madeleine Lemaire had participated with Manet in an amusing exhibition at the offices of the review *L'Art Moderne,* for which artists had been invited to decorate ostrich eggs.[9] But Madame Lemaire was clearly bent on ad-

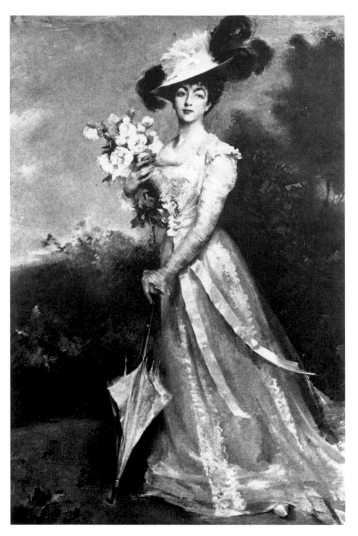

Madeleine Lemaire, *Portrait of Melle.
S.L.,* n.d. Oil on canvas.

Cliché Bibliothèque Nationale de France, Paris.

vertising her daughter's beauty, since she arranged for portraits by Manet in 1880, the Chaplin in 1882, and she exhibited her own portrait of her daughter in the manner of Thomas Gainsborough. In 1889 she was photographed wearing a costume entitled "Palais de l'Electricité," inspired, presumably, by the pavilion at the World's Fair in Paris that year. It cannot be determined today whether Suzette ever married, but she did follow in her mother's footsteps and became an artist. In 1908 she was listed as a painter of flower pictures and decorative objects.[10]

Madeleine Lemaire kept the profile pastel of her daughter until 1908, when she sold it to the Durand-Ruel Gallery, which sold it the same day for 12,000 francs (about $2,400 in 1908) to the New York collectors Louisine and H.O. Havemeyer. Young Louisine had been the first American to purchase works by Degas, Monet, and Pissarro when, on a trip to Europe in the late 1870s, she was encouraged to do so by a new acquaintance, Mary Cassatt. After she married a millionaire industrialist, Harry Havemeyer, they formed one of the most important collections of French avant-garde painting anywhere in the world. In her memoirs, written around 1915, she recalled, "our third and last woman's portrait [by Manet] is that of a young girl with a retroussé nose and with a pretty tipped bonnet, that carries out the line of the dainty nose, on her head. She is perky and jaunty in her pretty clothes. You feel she took pleasure in posing for her portrait and was quite satisfied as the youthful face developed under Manet's brilliant pastels. I admire it very much for it is full of fire and life and youthful insouciance."[11]

Upon Mrs. Havemeyer's death in 1929, many important works from their collection were bequeathed to the Metropolitan Museum of Art in New York, and her three children augmented her bequest with many more objects. Nevertheless, she wanted her children to have works

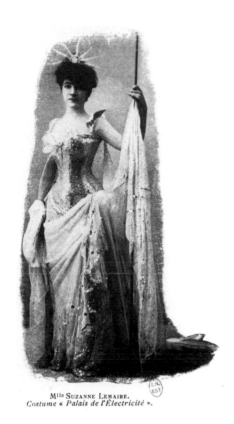

MLLE SUZANNE LEMAIRE.
Costume « Palais de l'Électricité ».

Mlle Suzanne Lemaire. Costume "Palais de l'Electricité," 1889.

Cliché Bibliothèque Nationale de France, Paris. Cabinet des Estampes et de la Photographie.

from her collection, and Horace Havemeyer, Adaline Frelinghuysen, and Electra Havemeyer Webb each received an impressive group of works. Electra Webb became an important collector in her own right, and ultimately established the museum at Shelburne, Vermont, to house her collection of Americana. She kept the French pictures that she inherited from her mother in her Park Avenue apartment. Upon her death, her children donated those works to the Shelburne Museum as a memorial. In 1996 the Trustees of the Shelburne Museum sold six works of art to establish a fund to preserve the other works of art in the Museum. It was at that auction that Mr. Stephen Wynn acquired for the Bellagio Gallery Manet's charming portrait of Suzette Lemaire.

—Gary Tinterow

1. A. Tabarant, *Manet et ses oeuvres* (Paris, 1947), p. 429.

2. J.-E. Blanche, *Essais et Portraits* (Paris, 1912), p. 155.

3. J.-E. Blanche, *Propose de peintre – Some notes on Manet for George Morre,* 1921, quoted in the sale catalogue *Five Impressionist Works of Art: Property of the Shelburne Museum,* Sotheby's, New York, November 12, 1996, lot 8.

4. Tabarant 1947, p. 429.

5. Quoted in Tabarant 1947, p. 429. (It is possible that Blanche recalled the making of the full-face portrait, which shows more signs of hesitation.)

6. Blanche, *Essais,* pp. 153-154.

7. Cited by Colin Bailey in *Masterpieces of Impressionism and Post-Impressionism: The Annenberg Collection* (Philadelphia, 1989), p. 20, from Edmond and Jules Goncourt, *Journal: Mémoires de la vie littéraire,* ed. Robert Ricatte. (Paris, 1956), vol. 3, p. 116.

8. A further connection is that Ephrussi's secretary, Marcel Proust, admired Madeleine Lemaire's paintings and mentioned them in his work.

9. Presumably held in the spring of 1889; see Tabarant 1947, p. 375.

10. Archives, Musée d'Orsay, Paris.

11. Louisine W. Havemeyer, *Sixteen to Sixty: Memoirs of a Collector* (New York, 1992), p. 233.

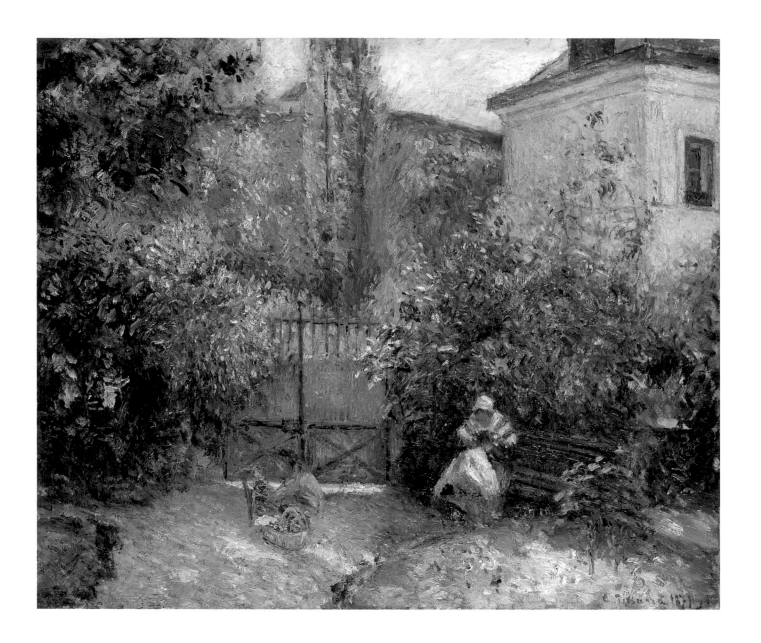

34

Camille Pissarro

Hermitage Garden, Maison Rouge

1877. Oil on canvas,
21 1/2 x 25 3/4 inches.

Camille Pissarro once wrote that his art was not destined for the beholder in a hurry. He insisted that it required time in order to be appreciated and understood. No work illustrates this point better than Pissarro's own *Hermitage Garden, Maison Rouge,* of 1877. One is compelled to give this image both time and generous attention. Failing that, the complex subtleties and even oddities intrinsic to the work might be missed. The apparent immediacy of the scene—a child playing under the eyes of an older woman, perhaps the child's grandmother, whose gaze is occupied elsewhere while she is sewing—belies the intricacy and ambiguity of the composition. Indeed, though Pissarro here resorts to the traditions of both landscape and genre painting, the work gently subverts these two categories, being properly classified as neither of them.

What should we call it, then? In escaping and subverting both categories, landscape and genre, the painting bears comparison with a work that slightly earlier had performed the same feat. This painting had received considerable notice and had had a strong impact on the Impressionists, all the while baffling its viewers, just as it does today. I am referring to Édouard Manet's *Railway,* exhibited at the Paris Salon of 1876 and now in the National Gallery of Art, Washington.

Pissarro's *Hermitage Garden, Maison Rouge* and Manet's *Railway* seem at first to have little in common. One might even say they are of two different types of art: *The Railway* was consciously designed by Manet to be seen by the public, whereas Pissarro intended *Hermitage Garden, Maison Rouge* to be seen only intimately, by the artist's close friends and family. In contrast, the same year it was made, Pissarro exhibited two of his most "public" works, *Les Toits Rouges* (Musée d'Orsay, Paris) and the *Côte des Bœufs* (National Gallery, London), at the third Impressionist exhibition. In addition, Manet's and Pissarro's paintings look vastly different from the formal point of view. Nevertheless, in *Hermitage Garden, Maison Rouge* Pissarro addresses the same kind of problems and employs the same devices as Manet had a year earlier. He represents a child and an adult interacting with one another, an uncommon theme for Pissarro, and in both artworks the child ignores the older person. In both cases, the child and the adult seem to

be related, or at least linked in some way, though the exact nature of the link remains unclear to the viewer. (Given the date of the painting, the child in Pissarro's work is likely to be the artist's second son, Georges, born in 1871.) In both works, each of the characters is absorbed by or engaged in a personal activity, such as playing or sewing, and they are staged against an uninviting iron structure, the railing in Manet's work, the street gate in the present work. The space in each work is what I would call an "in-between" sort of space, one that invites the viewer to look beyond the iron gate or railing. Finally, one notices that the adult and the child in each painting wear the same colors, blue and white. Whether or not these parallels with Manet's painting were consciously considered by Pissarro, the fact re-

Portrait of Camille Pissarro (1830-1903) circa 1875-1878.

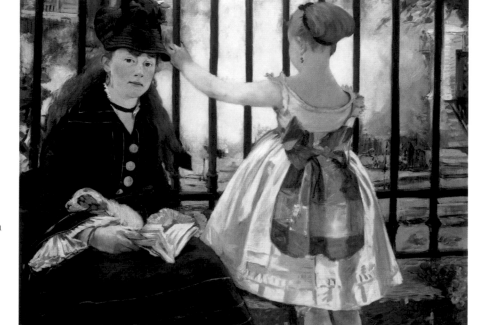

Edouard Manet, *The Railway,* also known as *Gare Saint-Lazare,* 1872-73. Oil on canvas, 36 3/4 x 45 1/8 inches.

Camille Pissarro, *Les Toits Rouges, Coin de Village, Effet d'Hiver (The Red Roofs, Edge of a Village, Winter Effect)*, 1877. Oil on canvas, 21 1/4 x 25 5/8 inches.

Musée du Louvre, Bequest of Gustave Caillebotte. Musée d'Orsay, RF 2735. © 1998 Réunion des Musées Nationaux, Paris.

mains that in *Hermitage Garden, Maison Rouge* he exploits many of the same devices as does Manet to arrest the beholder's gaze.

Pissarro subtly forces our eyes to wander across the surface, finally to arrive at the gate, an eccentric center for a composition. We ask ourselves: At what am I looking? As in the case of the larger, more ambitious painting by Manet, Pissarro's picture defies categorization; it possesses a subject matter that is not really a subject, at least not in the traditional academic sense. While two autonomous activities take place—playing and sewing—a third activity binds these two together while remaining equally autonomous: the painter's activity itself.

For even as we encounter the gate, we also notice, that this very gate throws us back to what it is made of: a rich, crusty surface saturated with hues of green, blue, and yellow paint. The surface is densely packed with flecks of color. All over this painted surface, it reveals innumerable individual brush marks, of all shapes, that appear to have fused from all directions, brush marks that were laid onto the canvas with varying degrees of force and energy. In fact, as we look around we see that these individual marks of paint have become almost autonomous. The cluster of green and yellow paint strokes that are clinging to the wall of the house, not far below the edge of the roof, for instance, appear to be without reference to the scene; although we read them as "leaves," they appear detached from any twig or branch that might support them. Floating against a plane of slate blue chalky wall, these green and yellow marks tend to swing between their status of "leaves" set off against a wall and their sheer materiality as mere traces of paint

Camille Pissarro, *The Côte des Bœufs, at L'Hermitage,* 1877. Oil on canvas, 45 1/4 x 34 1/2 inches.

on another plane of color. And the more we engage the work in all its fascination, the more we are reminded of how baffling the art produced by this artist, and other Impressionists, must have appeared to most contemporaries. The paint surface, at almost any point of contact, resists even the most enduring glance; it stems from a strange and inexplicable alternation between vigorous or nervous marks (applied as though the artist were fencing with his brush against the canvas) and blocks of paint slowly applied in long vertical gestures, as in the garden gate, the right-hand part of the tall poplar tree, the walls of the house, the bench, and even in the marks of pale color upon the child's coat.

The complex balance of varying types of paint marks is made all the more complex by the rich spectrum of colors. The explosions of vivid colors interspersed throughout the surface may be likened to a chaotic flurry of flowers blossoming randomly in a field. Their apparent randomness must be juxtaposed to the clearly deliberate and highly controlled set of harmonies that pervade the canvas. And, in fact, the harmonious combination of pale light blue, dark green, and bright yellow imposes a chromatic coherence as well as a solid unity. It is these dominant colors that, beneath the flurry of vibrant individual marks fused throughout the canvas, impose upon the work a tight chromatic grip, structuring the work and holding it together. The compact and dense pictorial space contributes to the same effect: the oblique, plain wall of the house on the right together with the counterbalanced foliage on the left frames the composition. These architectonic features also direct the gaze to the center of the composition by opening a perspectival axis. This highly traditional perspectival triangle is in fact reinforced by the triangular orientation of the lower part of the composition—the path on the left and the bench on the right leading the eye to the center of the composition.

The trouble is, this conspicuous perspectival construction is denied by everything else in the spatial arrangement of this composition. The gaze is denied access to the distant horizon by the gate that keeps us within the pictorial space, and the space beyond and above the gate counteracts the perspectival axes created there. The tall poplar shooting skyward and the steep vertical hillside fight against the vector dictated by the perspectival construction like two triangles pointing against each other, triangles just like those in the lower panels of the gate.

Autonomy, then, is the key word for understanding Pissarro's *Hermitage Garden, Maison Rouge*—whether it be the autonomy of each touch of paint as applied to the canvas, the autonomy of each activity depicted in the scene (the child lovingly dressing his doll, the older woman sewing), or the autonomy of the artist's own activity of creating his picture. Thus, the present work owes little to tradition. One senses, nevertheless, that Pissarro sees himself in the child—or perhaps the older woman—that he discretely depicts. Likewise, the artist never can, nor wishes to, ignore that his own being (just like his art) is made out of all sorts of relationships. He, like everyone else, and no less than the child and the older woman, is ultimately dependent on others.

—Joachim Pissarro

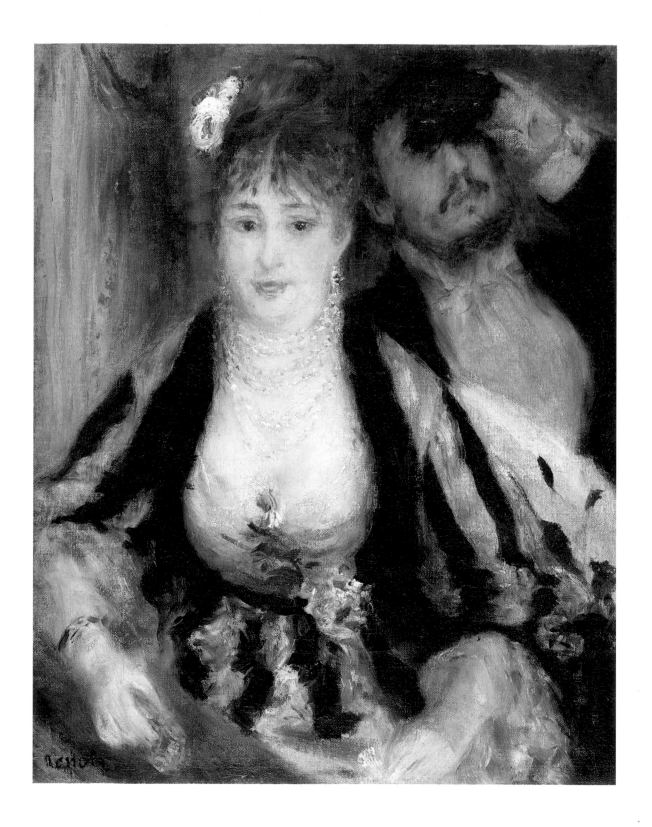

Pierre-Auguste Renoir

The Loge

1874. Oil on canvas,
10 3/4 x 8 5/8 inches.

In 1874 Pierre-Auguste Renoir painted two versions of *The Loge,* the example in the Bellagio Gallery of Fine Art and another in the collection of the Courtauld Institute Galleries, London. The image has become one of the best known and most popular of the Impressionist movement. The artist's brother posed for the figure in the background who looks through opera glasses. The handsome woman in the foreground was a model known as Nini, but whose unlikely nickname was Fish Face (Gueule-de-Raie).[1]

The composition is a quintessential example of the Impressionists' emphasis on subjects from modern life. Indeed, *The Loge* might well have served as illustration for certain passages in the critic Edmond Duranty's landmark essay *The New Painting* (1876), which describes the principal characteristics of Impressionist painting:

> The very first idea was to eliminate the partition separating the artist's studio from everyday life…. It was necessary to make the painter come out of his sky-lighted cell, his cloister, where his sole communication was with the sky—and to bring him back among men. Out into the real world…. In actuality, a person never appears against neutral or vague backgrounds. Instead, surrounding him and behind him are furniture, fireplaces, curtains, and walls that indicate his financial position, class, and profession…if in turn one considers a figure, either in a room or on the street, it is not always in a straight line with two parallel objects or at an equal distance from them. It is confined on one side more than on the other by space. In a work, it is not shown whole, but often appears cut off at the knee or mid-torso, or cropped lengthwise.[2]

By the late 1860s Renoir and the other key figures of the Impressionist movement had begun to depict people in everyday situations, whether in cafés, on the street, working, conducting business, or participating in a variety of leisure activities as diverse as sailing or attending a theatrical performance. The revolution in French painting that took place during the second half of the nineteenth century was as rooted in changing attitudes toward subject matter as in new ideas about color,

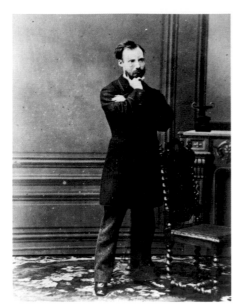

Portrait of Pierre-Auguste Renoir
(1841-1919), circa 1875.

style, and composition. Edgar Degas and Honoré Daumier had depicted theatrical scenes before Renoir's, and Mary Cassatt was inspired to make a contribution to the genre slightly later, but Renoir's *The Loge* remains remarkable for its extraordinary sense of immediacy. Nini makes eye contact with the viewer in a way that seems perfectly natural and unrehearsed. Although the figures did in fact pose in the artist's studio, we seem to encounter them spontaneously as we make our way to our own seats in the theater. Renoir has taken us into the world of

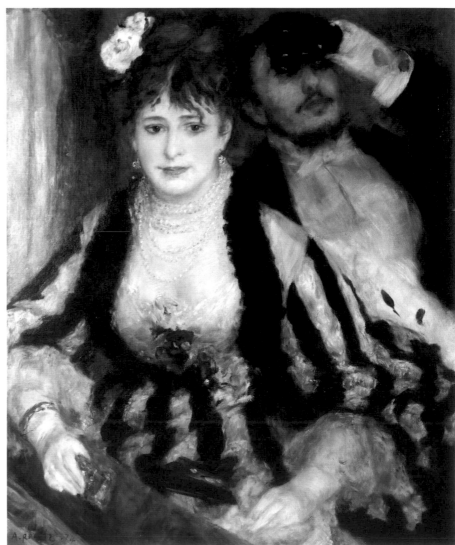

Pierre-Auguste Renoir, *La Loge,* 1874.
Oil on canvas, 31 1/2 x 25 inches.

The Courtauld Gallery, London

42

upper-class theater patrons, and it is by no means a coincidence that within a few years he would be painting the portraits of many of the most affluent Parisians as well as their wives and children.

The version of *The Loge* in the collection of the Courtauld Institute Galleries was exceedingly well received by the critics. As the scholar John House observed at the time of the Renoir retrospective in 1985:

Mary Cassatt, *In the Loge,* 1879. Oil on canvas, 32 x 26 inches.

The critics who reviewed the 1874 exhibition dwelt on this painting at length and stressed its novelty. Prouvaire saw the woman as a typical *cocotte,* 'one of those women with pearly white cheeks and the light of some banal passion in their eyes…attractive, worthless, delicious and stupid.' Montifaud, however, thought she was 'a figure from the world of elegance.' Their views are not necessarily contradictory, of course. The obvious pleasure that the painting gave them did not make them overlook its purely pictorial qualities; on the contrary, [the critics] Burty, Chesneau and especially Montifaud all praised them. It is noteworthy that none of the critics who reviewed the exhibition unfavorably attacked *The Loge* directly.[3]

Edgar Degas, *At the Theater*, 1880. Pastel,
21 5/8 x 18 7/8 inches.

Private Collection. Document Archives Durand-
Ruel, Paris.

The first owner of the Bellagio Gallery's version of *The Loge* was the
collector Jean Dollfus (1823-1911).[4] Dollfus bought the painting in an
auction of works organized by the Impressionist artists themselves in
1875. During the course of his collection career, Dollfus acquired five
paintings by Renoir, among which is the well-known *Portrait of Claude
Monet* in the Musée d'Orsay, Paris. Whether the present version of *The
Loge* is preliminary to the example in the Courtauld Institute Galleries
or is an autograph replica, as indicated by Professor House,[5] is difficult
to determine. The smaller size, looser manner of execution, and differ-

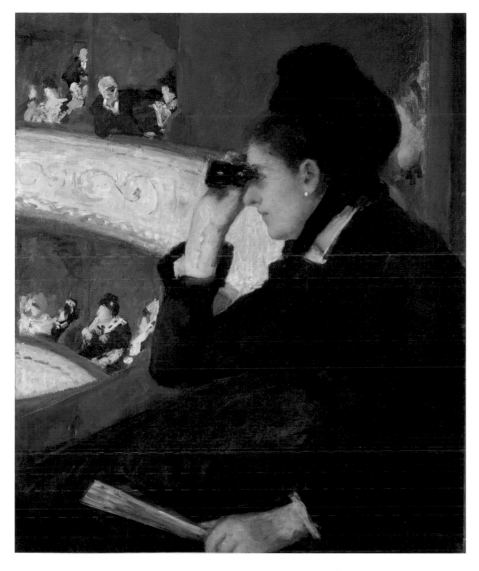

ences in areas such as the treatment of Nini's face suggest that the present version was in fact painted first. Renoir seems to have fully resolved his treatment of the composition in this smaller but beautifully realized version before executing the example in the Courtauld.

—Charles Moffett

Mary Cassatt, *The Loge,* 1882. Oil on canvas, 31 1/2 x 25 1/8 inches.

National Gallery of Art, Washington, D.C., Chester Dale Collection, 1963.10.96. Photograph © Board of Trustees, National Gallery of Art, Washington, D.C.

1. See John House in *Renoir,* ex. cat. (London: The Arts Council of Great Britain, 1985), p. 203, no. 26 (full catalogue entry for the version in the Courtauld Institute Galleries, London); François Daulte, *Auguste Renoir, Catalogue Raisonné de l'oeuvre peint,* Vol. I: *Figures 1860-1890* (Lausanne, 1971), no. 115.

2. Edmond Duranty, "The New Painting" (1876) in Charles S. Moffett et al., *The New Painting: Impressionism 1874-1886,* ex. cat. (San Francisco; The Fine Arts Museums of San Francisco, 1986), pp. 44-45.

3. House 1985, p. 203.

4. Anne Distel, "Renoir's Collectors: The *Patissier,* the Priest and the Prince," in House 1985.

5. House 1985, p. 203.

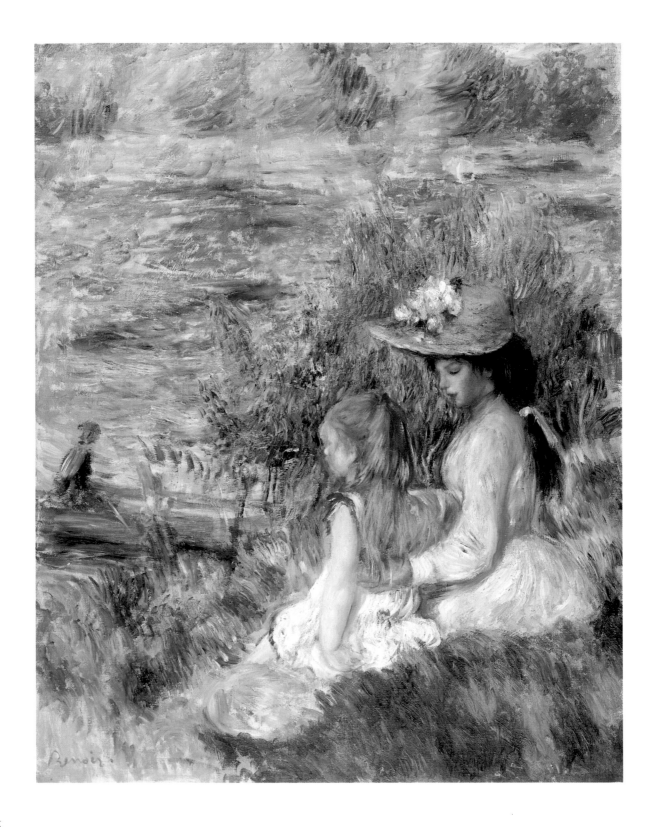

Pierre-Auguste Renoir

Young Women at the Water's Edge

1885. Oil on canvas,
32 x 25 3/4 inches.

Beginning with the series of paintings that Pierre-Auguste Renoir and Claude Monet painted at La Grenouillère in 1869, Renoir executed numerous works that depict people enjoying the pleasures offered by the Seine. Late nineteenth-century Parisians of a wide variety of ages and classes enjoyed spending their leisure time along the riverbank, a practice facilitated by the introduction of train service to villages on the outskirts of the city. Sailing, rowing, swimming, walking, eating in restaurants, or simply 'watching it all go by' were among the favorite pastimes.[1] Renoir's own *Luncheon of the Boating Party* (1881), which now hangs in the Phillips Collection in Washington, D.C., is perhaps the most famous painting to capture the gaiety of these nascent years of the *belle époque.*

In the decades of the 1870s and 1880s, Renoir created quite a number of compositions that include a pair of figures, most often parent and child, or sisters, who enjoy light-drenched afternoons along the river. The two best known of these are *By the Water,* which was painted around 1879, and *Two Sisters* of 1881 (in the collection of the Art Institute of Chicago). Other works such as the Metropolitan Museum of Art's *In the Meadow,* of about 1890, also feature pairs of figures in bucolic settings that are related in mood and theme to those depicting scenes along the river. In each instance, the viewer is afforded a glimpse of two young women who apparently share a special bond. They have taken an outing together to enjoy a beautiful day and share the delights and beauty of the river or the countryside. Indirectly related to these works are the well-known paintings of young women at a piano painted in the 1890s.

In *Young Women at the Water's Edge,*[2] two well-dressed figures—a young woman and a girl—sit on a high bank of the Seine and watch as a rower passes on the river below. The young woman has her arm around the girl's back and seems to hold her both tenderly and protectively. The exact nature of the relationship between the two is not known, but clearly it is a close one. Possibly they are Parisians who have come by train to one of the villages along the river. In fact, Renoir and his family spent the summer in a rented house in La Roche-Guyon, a town on the Seine not far from Giverny. Very likely *Young Women at*

Portrait of Pierre-Auguste Renoir (1841-1919), circa 1885-1890.

© Collection Roger-Viollet, Paris.

Pierre-Auguste Renoir, *In the Meadow*, circa 1890. Oil on canvas, 32 x 25 3/4 inches.

The Metropolitan Museum of Art, Bequest of Sam A. Lewisohn, 1951. 51.112.4.

the Water's Edge was painted there, perhaps between June 15 and July 11 of 1885, when Cézanne, and Cézanne's wife and son, were guests of the Renoir family. Alternatively, it may have been painted in Wargemont, a town on the coast of the English Channel, where Renoir stayed with his friend and patron Paul Berard during the second half of July.

Interestingly, *Young Women at the Water's Edge* combines characteristics of both the artist's "high" or "classic" Impressionist style of the 1870s and the more linear, so-called dry manner of the early 1880s. The

Pierre-Auguste Renoir, *Bathers,* 1892. Oil on canvas, 18 1/8 x 15 inches.

Private Collection. Courtesy Sotheby's, New York.

palette and the loose, variegated brushwork seen in the foliage, river, and sky have their origins in Renoir's work of the early and mid 1870s, but the carefully defined figures, especially the treatment of the faces, suggest the more conservative approach that appeared in Renoir's portraits of the late 1870s, and in such figure compositions as *The Luncheon of the Boating Party* in the early 1880s. In addition, the artist's elevated viewpoint is a hallmark of earlier Impressionist paintings. It creates the illusion of compressed space and results in an emphasis on

49

the surface of the painting. Instead of a clear view into well-defined, perspectively correct space, the viewer's eye is encouraged to dwell on the painterly surface and the rich brushwork.

Lastly, *Young Women at the Water's Edge* anticipates two paintings of 1892, both titled *Baigneuses,* also known as *Baigneuses à Guernsey.*[3] In each, two young women, probably girls in their teens, contemplate the sea and figures playing in the shallow water along the beach. In short,

Pierre-Auguste Renoir, *Two Sisters (On the Terrace),* 1881. Oil on canvas, 39 1/2 x 31 7/8 inches.

Pierre-Auguste Renoir, *Girls Picking Flowers in a Meadow,* circa 1890. Oil on canvas, 25 5/8 x 31 7/8 inches.

the themes of companionship, leisure, and contemplation that we see in *Young Women at the Water's Edge* and earlier works continued to be of importance to Renoir in the years ahead. The values and interests that propelled him into the leading ranks of the Impressionist movement in the 1860s and 1870s continued to drive his achievements in the 1880s and 1890s.

—Charles Moffett

1. Eliza Rathbone, Katherine Rothkopf, Richard R. Brettell, and Charles S. Moffett, *Impressionists on the Seine: A Celebration of Renoir's "Luncheon of the Boating Party,"* exhibition catalogue (Washington, D.C.: Counterpoint in association with The Phillips Collection, 1996).

2. François Daulte, *Auguste Renoir, Catalogue Raisonné de l'oeuvre peint,* Vol. I: *Figures 1860-1890* (Lausanne, 1971), no. 487.

3. Daulte, nos. 452-53. See also Sotheby's, *Impressionist and Modern Art, Part I,* auction catalogue (New York, May 13, 1998), pp. 24-28, no. 6.

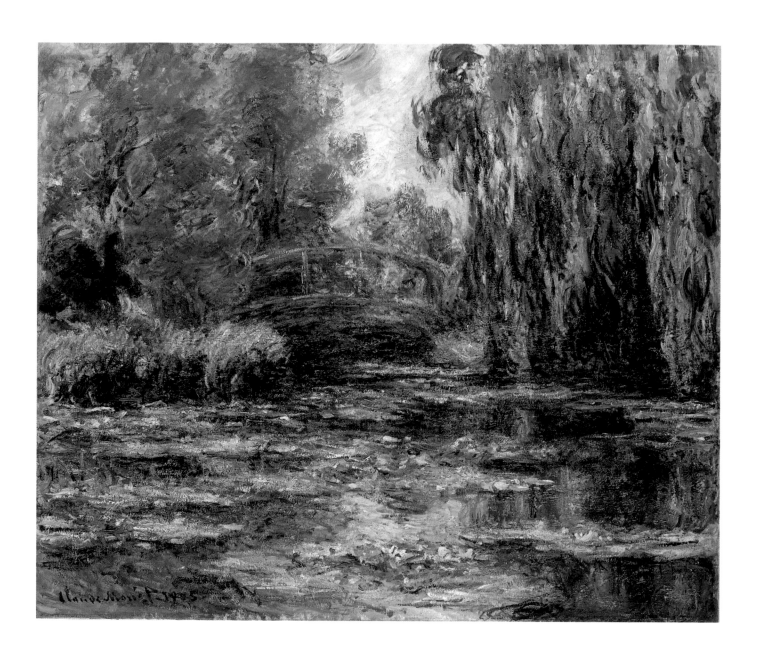

Claude Monet

Water-Lily Pond with Bridge

1905. Oil on canvas,
33 7/8 x 39 1/2 inches.

In 1883, at the age of forty-three, Claude Monet moved to the village of Giverny, a small, peaceful town along the Seine river, west of Paris. When he moved, Monet was just beginning to be recognized as an important artist. He was looking for an ideal and more private location where he could be close to Paris and be able to devote more time to his family, gardening, and painting. As his reputation grew, his presence in Giverny attracted a large colony of primarily foreign artists who, in turn, attracted artists' models and tourists; cafés and hotels emerged to cater to the bustling activity. Monet, however, stayed away from the frenzy. Each morning he woke at dawn, enjoyed a hearty breakfast, and set out to his chosen painting site, stopping at noon for lunch and returning to his painting until evening. The painting site he chose most often for the last quarter century he lived in Giverny, until his death in 1926, was the water-lily garden across the road from his house. Monet had designed it himself and had supervised its installation. He had placed the small pond in a grove of willows, added a Japanese-style bridge that spanned its surface, and planted the water lilies, which he tended himself with the aid of a gardener. He recorded the ever-changing light effects of his personally created paradise in many of his finest paintings, including the Bellagio Gallery's *Water-Lily Pond with Bridge* of 1905.

Among the water-lily paintings that depict the pond there are two fundamental types developed before 1905. The earliest works, produced between 1899 and 1900, are elegant, naturalistic renditions that show the rich fabric of multicolored water lilies and the plants and trees growing on the banks of the pond. The paint is thick and rich, a flourishing mix of color, lavish and textured. Consistently, the dominant element in these works is the Japanese bridge, designed by Monet and constructed by a local carpenter.

The Bellagio Gallery's *Water-Lily Pond with Bridge* shares the quiet elegance of the works of this earlier period. It is, in fact, Monet's last realistic depiction of the pond in which the bridge plays a major role. In comparing the 1899-1900 series of water-lily paintings with the Bellagio picture, however, one finds substantial differences in the shape and size of the pond. *Water-Lily Pond with Bridge* shows that Monet is

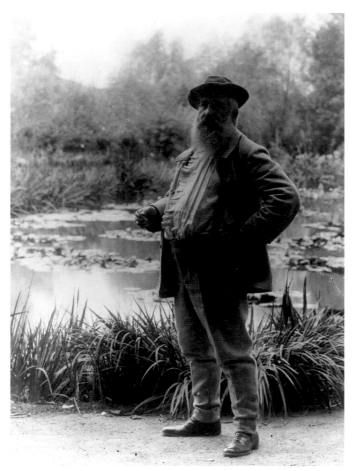

Portrait of Claude Monet (1840-1926) standing by his water-lily pond, 1904.

Photograph: Bulloz, Paris.

now working from a distance of at least forty feet farther away from the bridge.

By 1903 Monet had completed a series of excavations to create a larger pond whose surface area was approximately four times greater than the original body of water. He also sought a greater lushness; he had trelliss constructed atop the Japanese bridge, which eventually became engulfed in the luxuriance of white and mauve wisteria that trailed along the arched framework. In the course of the next ten years, Monet developed a new way of recording the seemingly natural forms on the water's surface, together with the changing effects of light reflected in the water. In this type of water-lily painting the horizon disappears. With no sky and no ground, the beholder floats in a near-abstract world of color and light.

The enlargement of the pond required enormous expense and effort, which indicates the crucial importance to Monet of increasing the size of his dreamlike world. He often found himself in battle, not only with the forces of nature but with local authorities. The excavations aroused numerous debates among the local farmers who feared that the newly introduced plants might poison their livestock and with village officials who were reluctant to authorize the considerable changes that Monet requested. Further, to accomplish the pond's enlargement, the path of the Ru, the stream that fed fresh water into the pond (and continues to feed the pond today), had to be rerouted, a task that required considerable expense and a great deal of politicking with regional authorities. It also was necessary for Monet to exchange parcels of property with the local railway company, which entailed extensive negotiations, and to buy land from local proprietors.

By 1903, Monet had established the substructure of the water-lily pond that he desired, but he continued to make subtle changes for the rest of his life. It is as if he were changing the costume on a model or

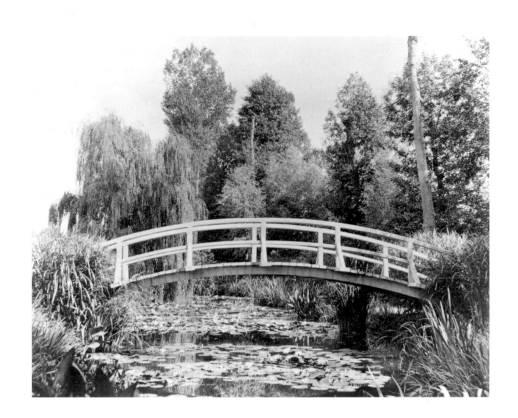

Photograph of the water-lily pond, September 1900.

Document Archives Durand-Ruel, Paris.

rearranging the fruit in a still life. When it came to his water garden, he was a perfectionist. Neither the arrangement of the water lilies nor the choice of colors was left to chance. Monet's lily pads were trimmed into circular patterns. The plants themselves had only recently been developed by Latour-Marliac, a horticulturist who at the turn of the century had achieved advances in the breeding of hybrid, colorful water lilies hardy enough to survive in the colder climate of northern France. He quarreled with the mayor's office over the inevitable dust from the public road running the length of the pond. Each morning he had a specially trained gardener gently dip the petals of his water-lily flowers beneath the surface of the water to remove all traces of sediment. Eventually, to avoid the nuisance of this daily routine, Monet personally paid to asphalt the stretch of road that crossed his property.

Only twice after enlarging the pond did Monet paint the water-lily pond from a distance and include the Japanese bridge. The two paintings have the same title, *Bassin aux nymphéas, le pont (Water-Lily Pond*

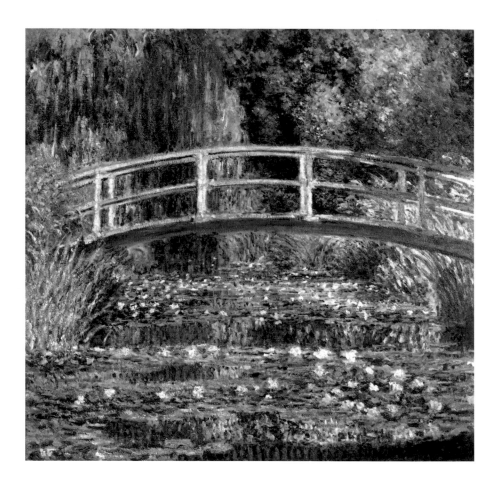

Claude Monet, *Waterlilies and Japanese Bridge,* 1899. Oil on canvas, 35 5/8 x 35 3/8 inches.

with Bridge). One is the Bellagio Gallery's picture, the other a more loosely painted work in a private collection abroad. Thus, the Bellagio picture is unique among Monet's works of this period. We cannot know why Monet drew back to give us one last look at the full vista of his remarkably beautiful source of inspiration. We only know that in *Water-Lily Pond with Bridge* we are confronted with an echo of nature, tangible, but still its own timeless universe.

—Robert Gordon

Photograph of Monet's studio, 1900.
Document Archives Durand-Ruel, Paris.

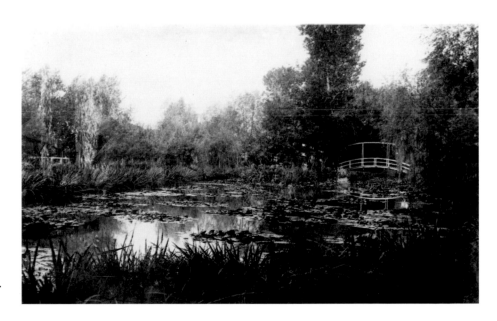

Photograph of the water-lily pond, 1904.
Photograph: Bulloz, Paris.

57

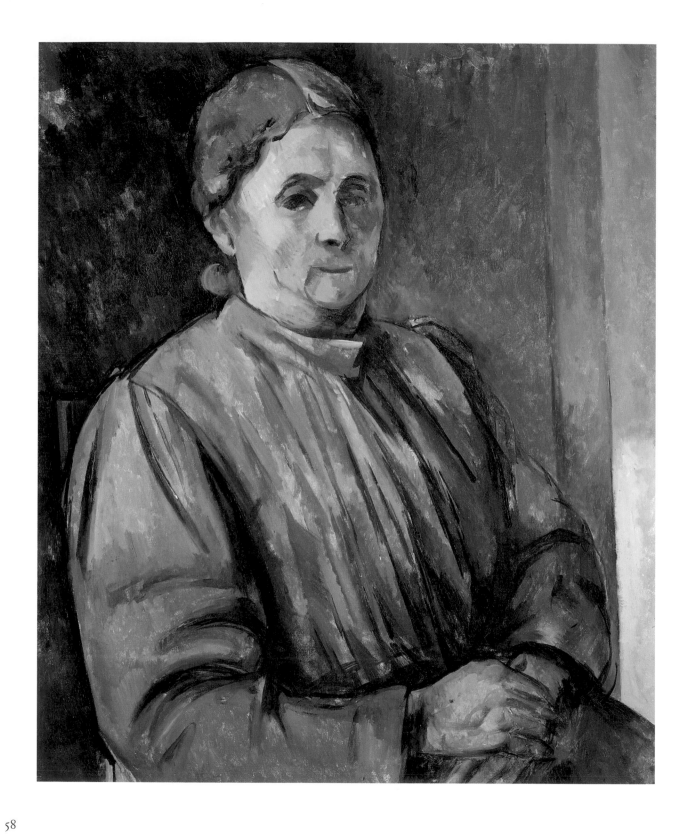

Paul Cézanne

Portrait of a Woman

Circa 1900. Oil on canvas,
25 5/8 x 21 1/4 inches.

For many years Paul Cézanne worked in obscurity, but late in his career, around 1900 when he painted *Portrait of a Woman,* he was exhibiting regularly and attracting sophisticated collectors. He had made no compromises, and his was an unlikely success story. Shy, irritable, even misanthropic, Cézanne shuttled between Paris, its environs, and his native Aix-en-Provence, painting obsessively and never quite satisfied. At any given moment very few people knew either his mood or location. He was mysterious: like "a wise man from the Levant," said Paul Gauguin, an admirer, in 1885. It was only with Cézanne's first commercial show in 1895, at age 56, that he began to receive significant public notice. Yet by 1910, four years after his death, one observer estimated that "at least two hundred" artists in the season's Paris exhibitions were imitating him. Not all this attention was benevolent: the somewhat reluctant Cézanne acquired infamy as much as fame, with reviews decidedly mixed. Critics, nevertheless, often agreed as to which features of his art merited discussion.

One frequent remark was that Cézanne gave his human figures the look of inanimate objects, that his portrait subjects were impassive, with no more personality than the painter's plates of apples or pears. As compositions of form and color, however, these same figures were vibrantly alive and "emotionally moving" (in French, *émouvante,* a term frequently invoked). So, too, his apples and pears began to move. In fact, Cézanne was praised for giving all his subjects such intense scrutiny that their images came alive on the canvas in every little detail of paint, compensating for those instances when the total configuration seemed thematically mystifying or simply incoherent.

Cézanne had a way of explaining this effect: it was the result of his "strong sensations." His concentration on the immediate presence of his model prevented him from "finishing" his painting in the conventional manner—filling in all the surfaces of color, smoothing over rough edges, normalizing a figure's gesture according to some cliché of human content. The artist's most sympathetic critics understood the link he implied between his immediate sensation and his mark or touch of color: each discrete stroke of paint represented a moment of concentrated visual attention, that is, a "sensation." If there was always

more to be seen, it would also seem that more marks should be added. From Cézanne's point of view, this meant that he could never finish; to terminate a motif would be a counterintuitive, unnatural action. But viewers could assume the opposite position, recognizing that every detail was charged with energy and interest so that full aesthetic satisfaction could be found in the slightest fragment. Auguste Renoir remarked: "Cézanne can't put two strokes of color on a canvas without it already being very good."

The model for *Portrait of a Woman* was probably one of the domestics whom Cézanne, independently wealthy, employed in Aix (he was always uncomfortable with professional artists' models). *Portrait of a Woman* is recorded in a stockbook used between 1899 and 1904 by Cézanne's dealer, Ambroise Vollard, indicating that it left the painter's possession while he was still living. Presumably Cézanne considered it finished enough to be exhibited and sold, even though it was "incomplete" like virtually all his late works. The painting has characteristics typical of its period: heavy strokes of pigment beside patches of the thinnest washes (usually blues),

Photograph of Paul Cézanne (1839–1906) by Émile Bernard, Aix-en-Provence, 1904.

abrupt contrasts of hue (green against pinkish violet, for instance), contours repeatedly shifted by multiple outlining (see the folds of the dress or the summarily indicated hands). In many respects Cézanne's composition appears to have been suspended in a state of its own becoming. We might find this troubling in such a straightforwardly representational image had not so many modernist followers, including Henri Matisse and Pablo Picasso, imitated Cézanne's effects. They recognized how well his style met the demands of both direct vision and spontaneous expression. Cézanne's technique kept its objective and subjective elements in creative tension indefinitely.

In *Portrait of a Woman,* juxtaposed strokes of color—olive, violet,

mauve, bits of brilliant red and orange—blend atmospherically. Because the colors harmonize so thoroughly at a normal viewing distance, the painting manifests a uniform illumination analogous to that of an outdoor scene. Yet, as marks, these same colors remain separate and distinct, and rather aggressively so. This quasi-Impressionist effect is paradoxical: the viewer perceives atmospheric luminosity (a light that virtually breathes) while also recognizing the fundamental density of physical things and even of the atmosphere itself. Cézanne's use of his medium allows the painting to become at once thin and thick, like the sensitive layers of skin and flesh that cover a human body. In his experience the density of physical sensations matched the density of physical matter. His process of painting penetrated into the substance of things through the device of tactile marking—one mark after another, without end. This art of refined observation was intensely physical, as expressionistic as it was analytical.

Cézanne's interest in joining observation to expression is captured in a statement reported by Joachim Gasquet, a young poet inspired by the painter's near-religious devotion to nature. While Joachim was watching Cézanne portray his father, Henri Gasquet, in 1896, he supposedly said: "We must live in harmony—my model, my pigments, and myself—blending into the same passing moment." Could Cézanne actually achieve such instantaneous harmony, or need he have been resigned to perpetual "incompletion"?

Cézanne's brushstroke, the characteristic patterning of marks seen in *Portrait of a Woman* (especially across the front of the dress), represents his sensation, his model or motif, and his intense painter's "touch"—all in one, all at once. It is significant that neither *Portrait of a Woman* nor most other of Cézanne's paintings (particularly the late works) bear a signature. This reinforces the impression that his works remain in progress. In fact he exercised little control over which paintings left his studio to be sold, as if to say that the status of each was equal—all of them equally "incomplete."

Cézanne's most astute critic of the 1890s, Gustave Geffroy, offered a supportive explanation: "The works are signed, better marked than by a signature." Geffroy meant that Cézanne's touch was distinctive

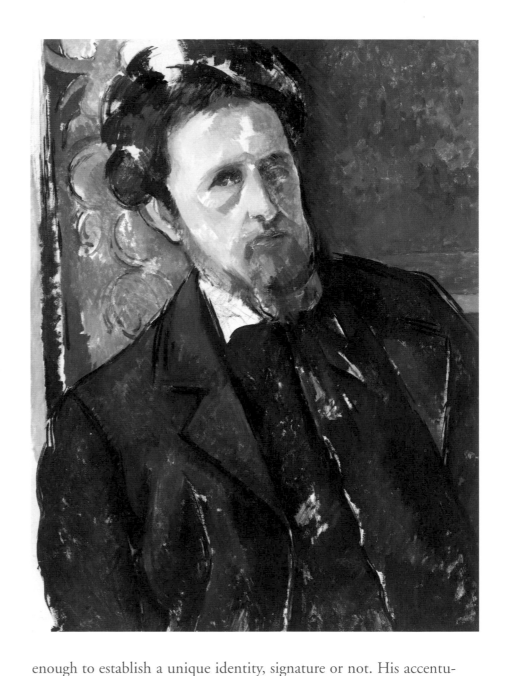

Paul Cézanne, *Portrait of Joachim Gasquet,* 1896. Oil on canvas, 25 5/8 x 21 1/4 inches.

Národní Galerie, Prague.

enough to establish a unique identity, signature or not. His accentuated mark recorded and even enhanced the "strong sensation" that could only be his. Later Geffroy added, just as perceptively: "Art doesn't proceed without a certain incompletion, because the life it reproduces is in perpetual transformation." That life belonged not only to nature and to the woman seen in *Portrait of a Woman* but also to

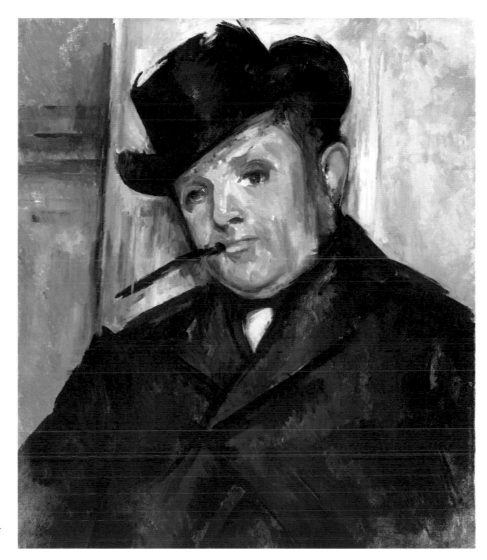

Paul Cézanne, *Portrait of Henri Gasquet,* circa 1896-1897. Oil on canvas, 22 1/8 x 18 1/2 inches.

The McNay Art Museum, San Antonio, Bequest of Marion Koogler McNay, 1950.22.

Cézanne, the artist. Painting was his life, his animating "sensation." His art—inherently incomplete—kept him alive.

—Richard Shiff

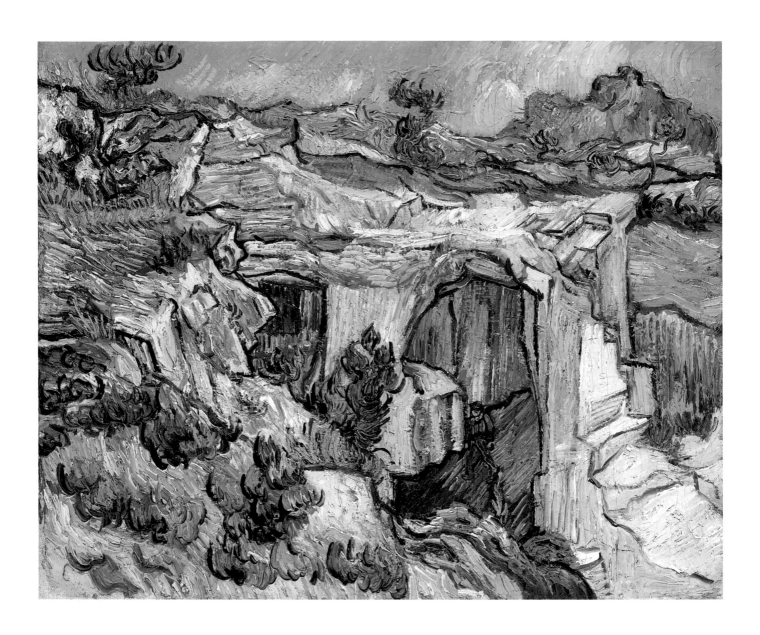

64

Vincent van Gogh

Entrance to a Quarry

October 1889. Oil on canvas,
20 1/2 x 25 1/4 inches.

In a letter written to his brother Theo in the autumn of 1889, Vincent van Gogh described a number of recently completed canvases of rocky, mountainous scenes in the vicinity of the Saint-Rémy asylum. One of these paintings, according to the artist, was a "harsh study," showing little but "clods of earth" and a "background of parched land, then the rocks of the Alps. A bit of green-blue sky with a little white and violet cloud. In the foreground a thistle and some dry grass."[1] Another work, entitled *Ravine,* was even "sterner," revealing "a very wild ravine where a small stream winds its way along its bed of rocks. It is all violet, I could certainly do a whole series of these Alps," he explained to Theo.[2] Such grim scenes may well have appealed to his temporarily depressed spirits, which were still recovering from a nervous relapse in the summer. All was not gloom, however; in the same letter he added, "this week I have also done the 'Entrance to a Quarry,' which is like something Japanese: you remember there are Japanese drawings of rocks with grass growing on them here and there and little trees."[3]

The picture in question, *Entrance to a Quarry,* might not strike us today as Japanese in appearance, but we should be wary of underestimating van Gogh's erudition in such matters. The representation of picturesque crags and mysterious caves was a long-established tradition in oriental art, both in brush-and-ink painting and in the Ukiyoe woodblock prints that Vincent and Theo had amassed so enthusiastically for their own collection. Two celebrated works by a master of this very genre, Hiroshige, had already been copied by van Gogh in Paris, while a print by Utagawa Yoshitora, which formerly belonged to the two brothers, shows just such a conjunction of boulders, foliage, and "little trees" with the distinctive plunging foreground and high horizon of *Entrance to a Quarry.*[4] From the beginning of his two-year stay in Provence, van Gogh had insisted on the affinity between the region and his vision of an exotic, light-filled Japan: "We like Japanese painting, we have felt its influence, all the impressionists have that in common; then why not go to Japan, that is to say the equivalent of Japan, the South?" he asked Theo soon after his arrival in Arles in 1888.[5] By now sufficiently confident of his own accomplishment to move beyond mere imitation of the Japanese manner, van Gogh seems to have found nour-

Vincent van Gogh (1853-1890), *Self-Portrait,* 1889. Oil on canvas, 17 1/4 x 22 1/2 inches.

Estate of Betsy Cushing Whitney.

ishment in its graphic vigor and the free and imaginative use of color by Japanese draftsmen.

Apart from its rugged and unusual subject, it is the color of *Entrance to a Quarry* that first demands our attention. Although van Gogh was capable of painting in the most strident hues, as such canvases from the previous year as the green and scarlet *Night Café* and *The Yellow House* demonstrate, he was increasingly drawn to the shifting, ill-defined tones of the Provençal autumn. Immediately after describing *Entrance to a Quarry,* the letter continues:

> From time to time there are moments when nature is superb, autumn's effects glorious in color, green skies contrasting with foliage in yellows, oranges, greens, earth in all the violets, heat-withered grass among which, however, the rains have given a last energy to certain plants, which again start putting forth little flowers of violet, pink, blue, yellow.[6]

This cascade of colors, mingling the primary hues of yellow and blue with secondary oranges, greens, and violets, is everywhere visible in *Entrance to a Quarry,* where many of the resulting passages of paint seem to defy our chromatic vocabulary. In the clifflike form half-way up the left edge of the canvas, for example, van Gogh has woven repeated streaks of color into the still-wet grays, silvers, and pale mauves, intertwining lemon with pewter, turquoise with brick-red, in a shimmering, elusive plane of light.

It is a mark of van Gogh's considerable sophistication as a painter in oils that, by this date, he could balance such localized richness with the overall dynamic of his composition. In *Entrance to a Quarry,* a complex series of rhythms runs through the foreground foliage, the arching rocks of the quarry itself, and beyond into the distant fields and hills, all united in a flowering tapestry of textures and tones. This lyricism is

Vincent van Gogh, *Ravine,* 1889. Oil on canvas, 28 3/4 x 36 1/8 inches.

almost at odds with the subject itself, a deep pit carved into the landscape whose scale is accentuated by the tiny, mysterious figure at the mouth of the tunnel. There is a visionary—rather than a documentary—quality about the image that recalls the artist's interest in the work of such contemporaries as Paul Gauguin and Emile Bernard, both former colleagues who were currently evolving a more decorative, synthetic art in Brittany. In a letter written to Bernard in early October 1889, van Gogh told him about his new picture, describing the "pale lilac rocks in reddish fields, as in certain Japanese drawings. In the design and in the divisions of the color into large planes there is no little similarity to what you are doing at Pont-Aven."[7] Though van Gogh's canvas has only an indirect resemblance to the work of Bernard and Gauguin, his broader ambition to capture the "inner character" of the landscape and give the "scorched and often melancholy fields their delicate aroma of thyme," even if the work becomes "somewhat abstract," was distinctly in sympathy with theirs.

The existence of two canvases from 1889 with similar titles has created some confusion about the links between the Bellagio Gallery's picture and a number of remarks in van Gogh's letters. As Ronald Pickvance has pointed out, references to *Entrance to a Quarry* in the artist's correspondence of mid-July concern another work, whose "broken greens and reds and rusty yellow ochre" are eloquently summarized in a letter to Theo.[8] Van Gogh also specifies that it was while working on this earlier painting that he felt one of his nervous attacks coming on, adding that he was able to finish the picture "in spite of it."[9] Curi-

X-Ray of *Entrance to a Quarry,* (page 64).

ously, recent examination of the Bellagio canvas shows that it, too, was interrupted part-way through and that another set of personal circumstances may have contributed to its final appearance. Even with the naked eye it is possible to see an independent pattern of marks *beneath* the final layer of paint. For instance, in the area immediately to the left of the walking figure near-horizontal striations are covered over with vertical pink and gray brushstrokes. X-ray photographs have confirmed the presence of these earlier marks at several points in the composition. Interestingly, they form a network of hidden structures that is oddly appropriate to the subterranean nature of the scene.

Certain details of the x-ray and its relationship to the visible picture surface help us to speculate about the significance of this recent discovery. Since the initial marks correspond in general terms to the final design, there is no question of the artist's having painted over another subject, as he had frequently done during his years in Holland. Similarly, because the hidden brushstrokes were already dry enough to be unaffected by the later additions, several days or even months must have elapsed between the two phases. Given that van Gogh's outdoor painting activities were always at the mercy of his health and the vagaries of the weather, it is likely that the canvas was begun on one occasion, then taken up and vigorously reworked somewhat later. More prosaically, we find the artist—at this very moment—urging his brother to send much-needed paints and other materials, telling him "at present I have absolutely no canvas."[10] Whatever the reason for the abandonment of his first attempt, therefore, he would have been obliged to paint over it rather than begin a new picture. In any event, the artist appears to have taken further measures, restretching his original canvas and extending it about an inch at the top edge, increasing the area available for clouds and sky.[11] Returning to the site, van Gogh was thus able to begin his encounter with this "Japanese" subject afresh, reemphasizing the twisting forms of the rocks and in some

places (such as the "stepped" rock face at right) modifying the original design as it remained on the canvas. Even by the standards of the artist, the finished picture is densely and sensuously worked, a tour de force of continuous painterliness that contrives to be austere and exquisite, terrestrial and slightly fantastic, at the same time.

—Richard Kendall

Utagawa Yoshitora, *A Pleasure Trip to the Flowers and Waterfalls,* 1869. Woodblock print in polychrome colors, 14 5/8 x 10 inches.

Van Gogh Museum, Amsterdam (Vincent van Gogh Foundation), N486 V/1962.

1. *The Complete Letters of Vincent van Gogh,* 3 vols. (London 1958), Letter no. 610, p. 222.

2. Ibid., p. 223.

3. Ibid., p. 222.

4. W. van Gullik, *Japanese Prints Collected by Vincent van Gogh* (Amsterdam, 1978), no. 398.

5. *The Complete Letters,* Letter no. 500, p. 589.

6. Ibid., Letter no. 610, p. 222.

7. Ibid., Letter B20, p. 520.

8. Ibid., Letter no. 610, p. 196; the work in question is Hulsker no. 1802; see Ronald Pickvance, *Van Gogh in Saint-Rémy and Auvers* (Metropolitan Museum of Art, 1986), pp. 119-20, 149-52.

9. *The Complete Letters,* Letter no. 601, p. 195; Letter no. 607, p. 216.

10. Ibid., Letter no. 610, p. 223.

11. The work was examined out of its frame by the author in April 1998, and x-rayed soon afterward. The extra strip of canvas, presumably reclaimed from the tacking edge, is clearly visible on the front surface. A regular pattern of fine vertical cracks in the paint throughout the picture is characteristic of works that have been removed from stretchers and "rolled." This may have occurred before the picture was restretched by the artist or, more probably, when it was sent, as was the artist's habit, to Theo in Paris.

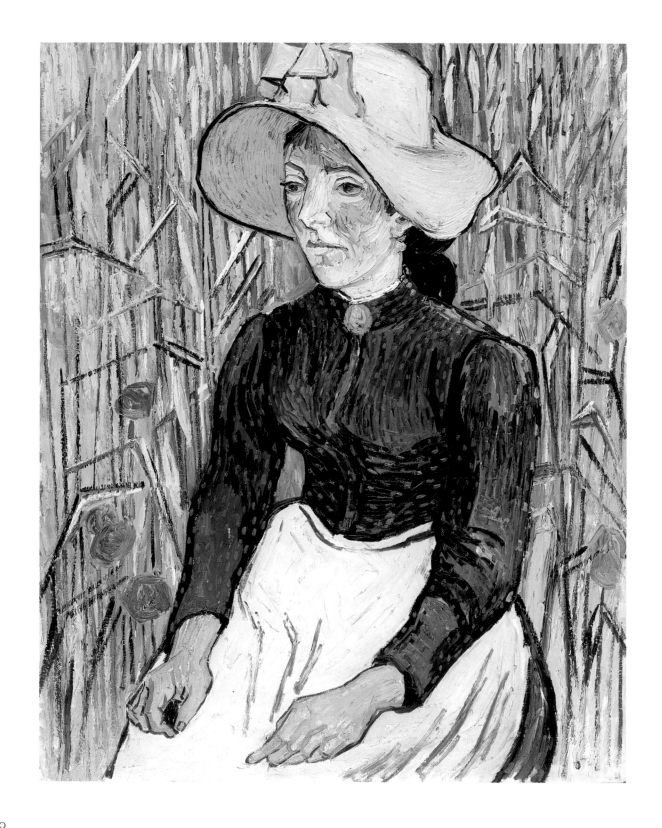

70

Vincent van Gogh

Peasant Woman against a Background of Wheat

June 1890. Oil on canvas,
36 1/4 x 28 3/4 inches.

Vincent van Gogh's images of peasants and ordinary people are among the greatest portraits ever painted. Each is a compelling work that reflects his admiration for the individual depicted and his deep commitment to portraiture as a principal aspect of his oeuvre. During the six weeks that he spent in the village of Auvers-sur-Oise at the end of his life, he painted two of the most exceptional portraits that he produced during the course of his ten-year career. The first is *Portrait of Dr. Gachet,* an image that has achieved the status of an icon in the history of art. Less well known but equally astonishing is *Peasant Woman against a Background of Wheat.*[1]

On June 3, 1890, about three weeks before he began the portrait of a young peasant woman in a straw hat seated in the middle of a wheat field, the artist included the following passage in a letter that he wrote to his sister:

> What impassions me most—much, much more than all the rest of my metier—is the portrait, the modern portrait. I seek it in color, and surely I am not the only one to seek it in this direction. I *should like*—mind you, far be it from me to say that I will be able to do it, although that is what I am aiming at—I should like to paint portraits of people which would appear after a century to the people living then as apparitions. By which I mean that I do not endeavor to achieve this by a photographic resemblance, but by means of our impassioned expressions—that is to say, using our knowledge of and our modern taste for color as means of arriving at the expression and intensification of the character.[2]

Indeed, the use of color in *Peasant Woman against a Background of Wheat* is extraordinary. The fluidity and richness of the paint, the boldly executed brushwork, and the vibrancy of the colors themselves are exceptional even in van Gogh's work. The execution of this painting provides an indication of the nature of the advances that would have characterized his work had he not died within a few weeks.

The paint handling seems even to have impressed the artist himself. On July 2, 1890, he offered a brief description and a pencil sketch of

71

the painting in a letter to his brother Theo: "here are three sketches—one of a peasant woman, big yellow hat with a knot of sky-blue ribbons, very red face, rich blue blouse with orange spots, background of ears of wheat. It is a size thirty canvas, but I am afraid that it's really a bit coarse."[3] The French word that van Gogh used for "coarse" is *grossière*,[4] a word that means coarse or rough but also connotes thickness and substance. It is likely that the artist used the word in order to

Vincent van Gogh, Sketch from Letter No. 646 for *Peasant Woman against a Background of Wheat,* July 2, 1890. Black chalk on paper, 7 1/2 x 5 3/4 inches.

Van Gogh Museum, Amsterdam (Vincent van Gogh Foundation).

indicate to his brother that the surface was especially bold and heavily laden with paint and strong color. Indeed, the treatment of the face is exceptional in its modernity and pronounced touch, and it anticipates the surfaces of German Expressionist canvases. Indeed, in 1890 *Peasant Woman against a Background of Wheat* would have shocked the average viewer, and by using the word grossière Vincent seems to have wanted to mitigate the reaction that he expected even from an individual as sophisticated as his brother, a successful dealer of modern art with the prominent firm Boussod & Valadon.

Vincent did not discuss the meaning of the painting when he wrote to Theo on July 2. Very likely he believed that the significance of the composition and the subject were obvious and needed little explanation. In a letter to Theo written in early September 1889, he identified peasants and wheat as key elements in his life and work, as important to him as he hoped a family would be to Theo:

> Well, do you know what I hope for, once I let myself begin to hope? It is that family will be for you what nature, the clods of earth, the grass, and the yellow wheat, the peasant, are for me, that is to say, you may find in your love for people something *not only to work for,* but to comfort and restore you when there is need for it.[5]

Wheat had long played an important role in van Gogh's lexicon of imagery symbolizing the cycle of birth, death, and regeneration. In a letter written in the summer or fall of 1887, he specifically equated wheat with the procreative force in man: "In every man who is healthy there is a *germinating force* as in a grain of wheat. As so natural life is germination. What the germinating force is in the grain of wheat, love is in us."[6] Since the artist chose to depict the

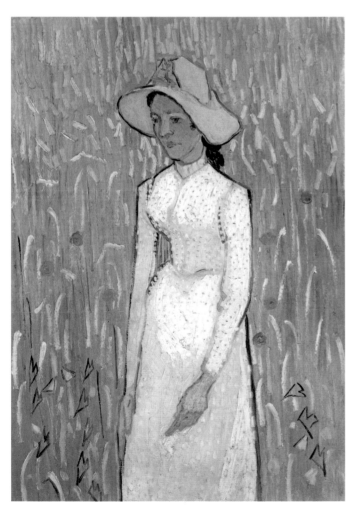

Vincent van Gogh, *Girl in White,* 1890. Oil on linen, 26 1/8 x 17 7/8 inches.

National Gallery of Art, Washington, D.C., Chester Dale Collection, 1963.10.30. Photograph © Board of Trustees, National Gallery of Art, Washington, D.C.

Vincent van Gogh, *La Mousmé*, 1888.
Oil on canvas, 28 7/8 x 23 3/4 inches.

young woman as if she were seated in the middle of a ripening wheat field, it is tempting to suggest that he was in love with her, but unfortunately we know nothing about her, not even her name. Nonetheless, it is clear that her simple, unpretentious beauty inspired him. Moreover, it is likely that he painted her surrounded by wheat because she appealed to his strong interest in secular subjects with quasi-religious significance. About two years earlier he had remarked:

> And in a picture I want to say something comforting as music is comforting. I want to paint men and women with that something of the eternal which the halo used to symbolize, and which we seek to convey by the actual radiance and vibration of our coloring. [7]

Indeed, *Peasant Woman against a Background of Wheat* seems to be a modern interpretation of iconography that first appeared centuries earlier. The composition recalls the northern Renaissance images of the Virgin seated in a *hortus conclusus* (closed garden) surrounded by a *millefleur* (thousand flowers) motif. In addition, wheat is a standard iconographical device in Christian art symbolizing the bounty of the earth and bread of the Holy Communion.

Although the exact circumstances surrounding van Gogh's death are vague, it seems that about three weeks after completing *Peasant Woman against a Background of Wheat* he went to a wheat field near his lodgings in Auvers and mortally wounded himself with a pistol shot. He literally walked into one of the most important symbols in his personal mythology in order to take his own life. But his own understanding of what he was doing was probably a little different, as he indicated in a letter that he wrote to Theo on September 19, 1889:

even if I [do] not succeed [as an artist], all the same I [think] that what I have worked at will be carried on…. I feel so strongly that it is the same with people as it is with wheat, if you are not sown in the earth to germinate there, what does it matter?—in the end you are ground between the millstones to become bread.[8]

—Charles Moffett

Vincent van Gogh, *Lullaby: Madame Augustine Roulin Rocking a Cradle,* 1889. Oil on canvas, 36 1/2 x 28 11/16 inches.

1. J-.B. de la Faille, *The Works of Vincent van Gogh, His Paintings and Drawings* (Amsterdam: Reynal & Company in association with William Morrow & Company; copyright Meulenhoff International, 1970), pp. 296-297, no. F 774; Jan Hulsker, *The Complete van Gogh, Paintings - Drawings - Sketches* (New York: Harry N. Abrams, Inc., Publishers), p. 470, no. 2053, and pp. 466, 468; Charles S. Moffett, *Vincent van Gogh* (New York: The Metropolitan Museum of Art, 1979), pp. 15-16, no. 17; Ronald Pickvance, *Van Gogh in Saint-Rémy and Auvers* (New York: The Metropolitan Museum of Art, Harry N. Abrams, Inc., Publishers, 1986), pp. 242-243, no. 68; Evert van Uitert, Louis van Tilborgh, and Sjraar van Heutgen, *Vincent van Gogh, Paintings,* ex. cat., (Amsterdam: Rijksmuseum Vincent van Gogh, 1990), pp. 272-273, no. 124; Dorothy M. Kosinski, Joachim Pissarro, and Mary Anne Stevens, *From Manet to Gauguin, Masterpieces from Swiss Private Collections* (London: Royal Academy of Arts, 1995). pp. 135-136, no. 72.

2. Vincent van Gogh, *The Complete Letters of Vincent van Gogh* (Greenwich, Connecticut: New York Graphic Society, 1959), W 22, vol. 3, p. 470.

3. *Letters III,* no. 646, 289-291.

4. *Letters of Vincent van Gogh, 1886-1890,* A Facsimile Edition (London: The Scolar Press Ltd., in association with Amsterdam: Meulenhoff International BV, Amsterdam, 1977), p. 646.

5. *Letters,* no. 604, 5 or 6 September 1889, 205.

6. *Letters,* no. W1, pp. 425-426.

7. *Letters,* no. 531, September 3, 1888, p. 25.

8. *Letters,* no. 607, p. 218.

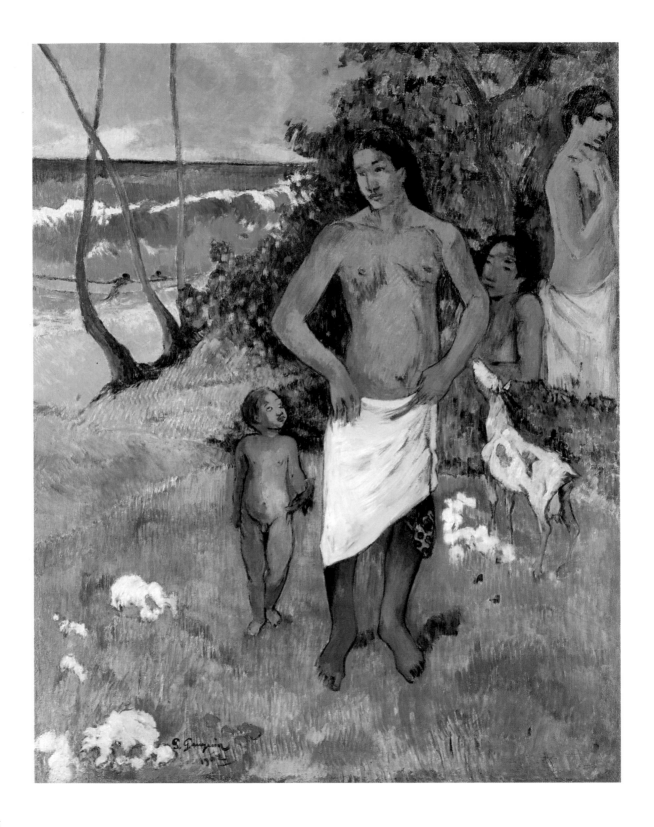

Paul Gauguin

Bathers

1902. Oil on canvas,
36 1/4 x 28 3/4 inches.

Bathers was painted in the last full year of Paul Gauguin's life, 1902. He had known the islands of Polynesia for over a decade, having first arrived in Tahiti in 1891. In 1893 he had gone back to France, hoping to enjoy recognition of the paintings that he had been sending home. But, forever restless, he was back in Tahiti by July 1895, determined to end his days there. On his first visit he had been buoyed up by optimism and a belief, largely derived from literature, in the existence of a primitive Eden. But his mood on his return was darker. He had been frustrated in Paris. He had no illusions about the actualities of life in Tahiti. He loathed the French colonial system, even though he was in a sense part of it. He blamed the missionaries, Catholic and Protestant, for destroying native culture.

Gauguin was a complicated man, often at odds with himself. Again and again in his writing he proclaims that he is half-civilized, half-savage. Tahiti reflected all the contradictions within himself. After six years there, he was contemplating another move, to the smaller and more remote islands of the Marquesas, where he believed cannibalism still existed and life was truly primitive: "There the savage atmosphere and complete solitude will give me a last burst of enthusiasm before dying," as he put it to his poet friend Charles Morice.

Bathers was first seen in 1903 at the Paris gallery of Ambroise Vollard, with whom Gauguin had formed a connection. It was displayed with a companion painting of the same dimensions, evidently as a pair. No titles for the two paintings were recorded. *Bathers* has been known at various times as *Walk along the Seashore* and as *Tahitian Family;* the companion, which hangs in the Musée d'Art Moderne et d'Art Contemporain, Liège, has been known as *The Enchanter* and as *The Sorcerer of Hivaoa.* In the catalogue of the National Gallery of Art, Washington, show, of 1989, the companion was called *Marquesan Man in a Red Cape.*

The two pictures complement each other in interesting ways. Both are dominated by a standing figure, apparently the same model, whose sex is at first sight ambiguous. Gauguin hardly ever painted Polynesian men, and here the long hair and somewhat feminine features, coupled with the sketchy definition of his body, causes one to hesitate before

Photograph of Paul Gauguin (1848-1903), with one of his paintings in the background.

deciding that he is a man. Bengt Danielsson, who has done more than anyone to research Gauguin's life in the Marquesas, identifies the figure as a one-time priest of the native religion who had renounced his calling and was, when Gauguin knew him, "a master of ceremonies at festivals and celebrations."[1] According to Danielsson, effeminate men who wore their hair long were known as Mahu and had an accepted place in Marquesan society.

The Liège painting is dark and claustrophobic. The man wears his scarlet cloak like a ceremonial robe and he steps forward out of the forest darkness with the look of one who is at home among mysteries. Behind him a group of hooded women crouch among the deep greens and purples of the forest foliage. In the foreground an orange dog and black raven converse unnaturally. In complete contrast, the Bellagio Gallery's painting celebrates the open beach in superb chords of gold and pink set against the deep blue of the sea and sky. This is color working as only Gauguin can make it do, working directly upon us like music, singing here in praise of nakedness.

Richard Brettell has pointed out that the man's gesture, which suggests that he is about to take off his loincloth, echoes the action of the central figure in the *Bathers* compositions that Cézanne made in 1875 and 1876, all of which Gauguin could have known. "In former times," Gauguin had written a year or two earlier, when he was playing the unlikely role of yellow journalist in Tahiti, "the sky of Cythera was pure, the women had the joy of living naked in the pure air, being caressed by soft grasses, bathing voluptuously."[2] And from his new retreat in the Marquesas he wrote with contempt that soon the natives "Will be incapable of climbing up coconut trees" and the children "Have all begun to wear shoes and their feet...will not be able to run along the rugged paths."[3] But if he had become cynical about the islands and their inhabitants, he kept faith with his dream of a primitive utopia and with

Paul Gauguin, *Marquesan Man in a Red Cape,* 1902. Oil on canvas, 35 7/8 x 28 1/2 inches.

Collection du Musée d'Art Moderne et d'Art Contemporain de la Ville de Liège.

that part of himself that the dream answered to. The two paintings are like a final testament to the dual aspects of that dream, *Marquesan Man in a Red Cape* embodying his allegiance to mystery, his disdain for the literalism and material practicality of bourgeois life, the *Bathers* embodying magnificently his surrender to 'savagery' and the delight of a tropical Cythera, where the sky was pure and the women bathed voluptuously.

Gauguin practiced an extraordinary range of media, from sculpture and ceramics to painting and printmaking. A technique that he used toward the end was transfer drawing, in which his paper was worked over a surface covered in printing ink. This gave him a crude reversed image. Probably in emulation of his hero Degas, he used these transfer drawings as a means of extending his compositional experiments, placing figures in different contexts and groupings, reversing them or changing their scale. The transfer drawing that now resides in the Musée des Arts Africains et Océaniens, Paris, is clearly connected with *Bathers,* though whether as a study for the painting or as an experiment deriving from it is not certain.

The background to the left—the beach and sea with the boat—seems to be derived from an earlier painting, *Landscape with Two Goats*

Paul Gauguin, *Sister of Charity*, 1902. Oil
on canvas, 25 5/8 x 29 7/8 inches.

The McNay Art Museum, San Antonio, Bequest of
Marion Koogler McNay, 1950.47.

Paul Cézanne, *Baigneurs au Repos, I*,
1875-76. Oil on canvas, 15 x 18 inches.

Fondation Jean-Louis Prévost. © Musée d'Art et
d'Histoire, Ville de Genève, 1985-17. Photograph:
Yves Siza.

Paul Gauguin, *Landscape with Two Goats*, 1897. Oil on canvas, 36 1/4 x 28 3/4 inches.

Hermitage Museum, Saint Petersburg, Russia (Federation).

of 1897. This picture might explain the presence of the goat in *Bathers,* but nothing in Gauguin is without a possible symbolic intention. Is the goat here to remind us of the sexual freedom among the islanders that Gauguin so ambivalently responded to? We are reminded of his confession in *Noa Noa* of having been aroused by the androgynous beauty of his young male friend.[4] Clearly the painting touches on a whole cluster of feelings related to nakedness and shame, prudishness and its opposite. This impression is intensified when we recognize the presence of our central figure (reversed) and his rightmost compan ion in *Sister of Charity,* a confrontation of some sort between Gauguin's 'primitive' Marquesan friends and the Catholic Church in the person of a nun.

—Andrew Forge

1. Bengt Danielsson, *Gauguin in the South Seas,* trans. R. Spink (London, 1965).

2. Paul Gauguin, "Gentle Progress," *Les Guêpes,* no. 12 (January 1900), quoted in *The Writings of a Savage,* ed. Daniel Guérin (New York, 1978).

3. Gauguin, *Avant et après* (1903), trans. Van Wyck Brooks as *Paul Gauguin's Intimate Journals* (New York, 1923, 1949).

4. Gauguin, *Noa Noa* (1893).

82

Constantin Brancusi

Mademoiselle Pogany II

1920-25. Polished bronze, 17 1/4 inches high, 24 1/2 inches high with base.

© 1998 Artists Rights Society (ARS), New York/ADAGP, Paris. Photograph courtesy Christie's, New York.

Though relatively limited in quantity, Constantin Brancusi's oeuvre is quite diverse. His architectural forms, and above all the structures of the bases he designed for his sculptures, derive from permutations of a variety of more or less geometrical forms. A number of his wooden sculptures further open up to dimensions of humor and playful allusion, the fabulous, the fanciful, and even the grotesque. More than anything else, however, Brancusi is the master of "essential" sculptural form. This type of form is not pure in the sense associated with Purism, but a gestalt that combines a "reductive" element—the abandonment of an array of detail—with a "productive" quality of formal concision, a complexity that springs from variations and irregularities.[1]

Brancusi's work is centered on themes of life, above all, feminine and animal life. In this it reflects a general tendency of European sculpture of the first three decades of this century to reject the masculine figure, and the active, dynamic language of heroism, in favor of the more tranquil, enclosed, contemplative beauty generally associated with females and with the self-containment of animals, a tendency that arose in response to the "crisis" precipitated by male-dominated culture. The leitmotif of femininity in Brancusi's work is epitomized by the figure of *Mademoiselle Pogany*—"la féerique grand-mère de la sculpture abstraite" (the fairy grandmother of abstract sculpture), as Hans Arp memorably called her in a poem.[2] More than any other work at this stage of Brancusi's career, *Mademoiselle Pogany* is like a culmination of the earlier forms of the feminine—such as *Baroness R.F., Narcissus, Danaïd,* and *A Muse*—that he had developed in the process of detaching himself from the influence of Auguste Rodin. It was a theme that would run through the artist's work for more than two decades.

Brancusi made three versions of *Mademoiselle Pogany*—in 1912, 1919, and 1931—from which bronze sculptures were cast. These show the evolution of the work: the pronounced eye forms, which give the first version its portrait likeness, and the two arms are amalgamated into a single form; the hair, which at first seems a mere addition, in the 1919 version turns into a constituent expressive element in the form of a cascading arch that links the horizontal and vertical dimensions. The formal idiom is thus clarified, unified, and tightened in *Mademoiselle*

Self-portrait of Constantin Brancusi
(1876-1957) in his studio, 1915.

Pogany II, so that the work seems less fragmentary; the unpolished
"breaks" in the first version are replaced by precise contours.

The Bellagio Gallery's sculpture is a bronze cast of *Mademoiselle
Pogany II.* But it is not easy to situate it within the sequence of formal
changes since it differs markedly from the other bronze versions

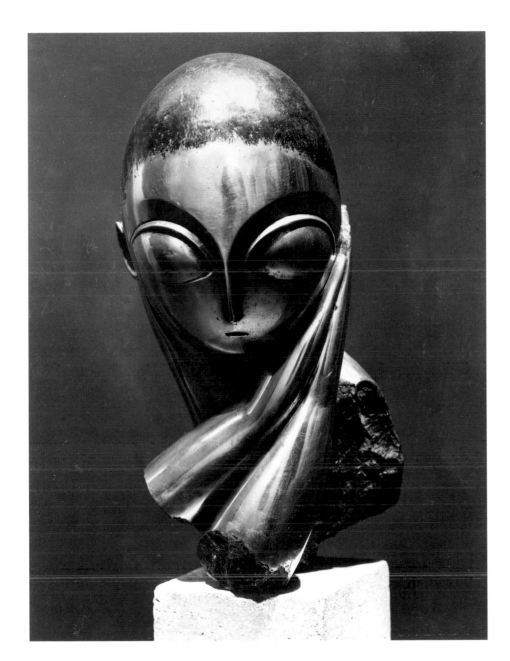

Constantin Brancusi, *Mademoiselle Pogany* (version *I*, 1913, after a marble of 1912). Bronze, 17 1/4 x 8 1/2 x 12 1/2 inches, on limestone base, 5 3/4 x 6 1/8 x 7 3/8 inches.

The Museum of Modern Art, New York. Acquired through the Lillie P. Bliss Bequest. Photograph © 1998 The Museum of Modern Art, New York. © 1998 Artists Rights Society (ARS), New York/ADAGP, Paris.

hitherto known: there are distinct variations in the inner curve of the ear; in the line of the left eyebrow, which slightly overlaps the outline of the hand; and, above all, in the length of the lower section, which is markedly greater than in any comparable cast, as well as in the increased area of the cut end of the arm (which bears the signature). As a

Margit Pogany in 1910.

Photograph courtesy Andrew Forgas, Melbourne.

View of Brancusi's studio with
Mademoiselle Pogany II, 1920.

Photograph by the artist. Brancusi-Archive of the
Musée National d'Art Moderne, Centre Georges
Pompidou, Paris. © 1998 Artists Rights Society
(ARS), New York/ADAGP, Paris.

result the sculptural effect of the stance of the figure is noticeably
changed, and the question of the dating of this cast must remain open.[3]

The conception of sculpture as "essential" form inevitably raises the
problem of the presentation of such a form in real space. Brancusi dealt
with this by making his own bases, which he built up from elements
such as cubes, cylinders, and truncated pyramids. These bases serve to
prepare the viewer for the sculptures they support, both through their

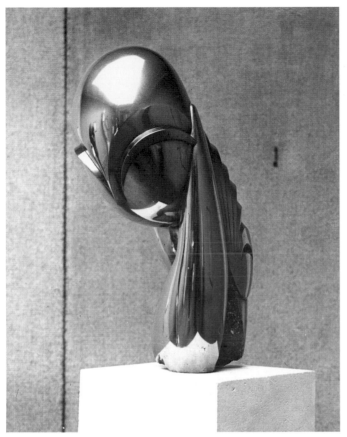

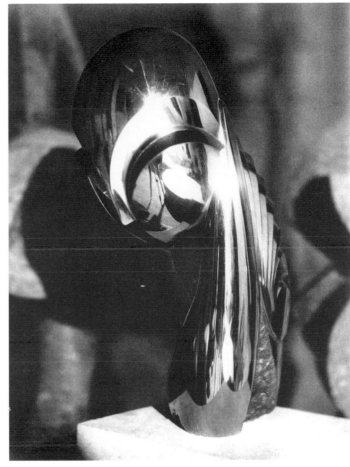

Above, left: Constantin Brancusi,
Mademoiselle Pogany II, circa 1921.
Bronze, 17 1/4 inches high.

Photograph: UPI/Corbis-Bettmann. © 1998 Artists
Rights Society (ARS), New York/ADAGP, Paris.

Above, right: Constantin Brancusi,
Mademoiselle Pogany II, 1920.

Photograph by the artist. Brancusi-Archive of the
Musée National d'Art Moderne, Centre Georges
Pompidou, Paris. © 1998 Artists Rights Society
(ARS), New York/ADAGP, Paris.

own rhythmic syntax and by playing on affinities and contrasts in material, surface texture, and color. For the Bellagio Collection's *Mademoiselle Pogany II,* no base designed by Brancusi is extant. However, the artist's own photographs taken in his studio convey an impression of the range of possible figure-base combinations with which Brancusi experimented over the years in connection with this sculpture. A photograph, probably taken in 1920, shows a version of *Mademoiselle Pogany II* on a composite wooden base, which—though admittedly also used by Brancusi for other sculptures—incorporates segments of circles that echo the formal vocabulary of the curves in the sculpture. The wooden block that projects farthest from this figure-base combination acts as a central horizontal to mark the axis of symmetry of the whole.

The lowest element of the base, below the three central rectilinear elements, echoes the figure on top: its curves prepare the eye for those of *Mademoiselle Pogany II,* which cap them by being more differentiated and more individual. The sculpture proper is set apart from the "energy" of its dark, wooden substructure by a plain, light-colored, squared stone block. The base structure as a whole functions as a body, a figure-surrogate for the head form that it bears. Brancusi's photographs illustrate another feature of presentation that is of great importance for the understanding of this work: they exemplify the ways in which the piece can be "transformed" by changing its lighting. The artist took a series of photographs of *Mademoiselle Pogany II* in which the effects of light and reflection undermine the "definiteness" of its outlines, displaying the form as an embodied interplay of light and shade that projects itself into the space surrounding it.

The diversity of Brancusi's sculpture lends itself to a variety of critical responses: *la délicatesse de Brancusi* (his refinement); the capacity of his forms to play an architectural role in public spaces; the importance of the working process; or the language of geometry evident in his bases and in works like *Endless Column,* which aroused such interest in the context of the "neo-avant-garde" of the 1960s and 1970s. Critical judgments of a form such as *Mademoiselle Pogany* range from euphoric celebration of its sensitivity and finesse at one extreme to downright skepticism at the other, depending on which of these qualities is stressed. For all its fame, *Mademoiselle Pogany* is nonetheless a problematic work: its very simplicity and formal essentialism verge on the elegance—even the stylishness—of Art Deco, with which it possesses a clear affinity. Bird, fish, and turtle—creatures that resist the projection of human qualities onto them and conform to a notion of untouched, animal vitality—answer well, in our imagination, to the topos of simplicity and essentiality. Applied to the human figure, this same topos is altered in both quality and credibility. The problematic dimensions of *Mademoiselle Pogany* need to be pointed out, not least because this is the only way to make sense of Brancusi's determined pursuit of the theme over a period of more than twenty years: from 1910, when he first met the Hungarian painter Margit Pogany in Paris, through 1933,

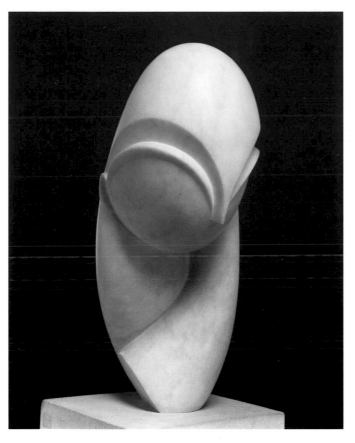

the year of *Mademoiselle Pogany III,* the last small female figure he ever made. The delicate simplicity of *Mademoiselle Pogany* conceals an undercurrent of extraordinary obsession.

—Friedrich Teja Bach

Translated from the German by David Britt

Above: Constantin Brancusi, *Mademoiselle Pogany III,* 1931. Marble on limestone base, 19 inches high; base 9 1/4 inches high.

1. Compare Brancusi's two statements: "La simplicité c'est la complexité résolue," and, "Simplicité est la complexité elle-même." ("Simplicity is complexity resolved," and "Simplicity is complexity itself.") See Friedrich Teja Bach, *Constantin Brancusi, Metamorphosen plastischer Form* (Cologne, 1987), p. 16.

2. Jean Arp, "La Colonne sans fin," in Christian Zervos, *Constantin Brancusi. Sculptures, peintures, fresques, dessins* (Paris, 1957), 30.

3. The signature on the Bellagio Gallery's *Mademoiselle Pogany II* is that of the cast now in the Albright-Knox Art Gallery, Buffalo, New York. Having become almost illegible, it was reworked for the present cast. This means that the sculpture in the Albright-Knox (or the mold from which it was cast) was used to prepare an intermediate plaster, which was reworked stylistically and extended at the lower extremity, where a new signature was impressed. When this was done is an open question. It could very well be that Brancusi made the cast after the 1925 casts, working toward the style of *Mademoiselle Pogany III.*

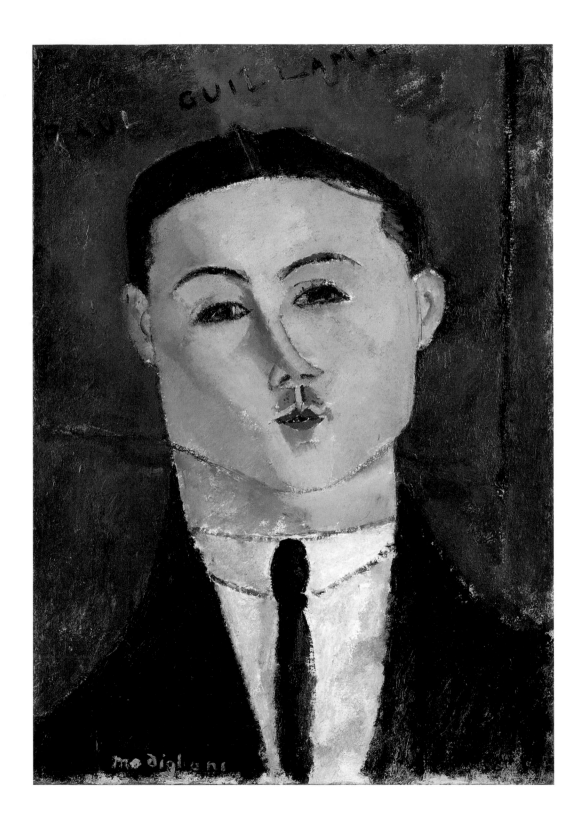

Amedeo Modigliani

Portrait of Paul Guillaume

1916. Oil on board laid down on cradled panel, 22 x 16 inches.

The *Portrait of Paul Guillaume* in the Bellagio Gallery is one of four portraits that Amedeo Modigliani made of the young art dealer. Paul Guillaume had already become well known in avant-garde circles, partly by becoming expert in the exotic artifacts he imported from Africa. The Bellagio portrait of the twenty-five-year-old dealer, like so many other portraits that Modigliani produced during his career, reveals not only the personality of the sitter but also something of the personal relationship between painter and subject. We may even discover there some tension between the artist and his dealer, stemming from animosities intruding upon their formerly close friendship. On the face of it Modigliani depicts Guillaume much as he appears in contemporary photographs, that is, as the urbane gallery owner, elegant in his white shirt, necktie, and dark suit. The unusually puckered red mouth only heightens the personality profile, while the expression reflects a certain open-mindedness, mixed, in the slight tilt of the head, with naïveté. Beyond these traits of personality one senses a cool distance between the artist and his subject, expressed mainly in color and form.

Most accounts of Modigliani focus on his legendary scandals and the bohemian life he adopted after moving to Paris from his home in Leghorn, Italy.[1] To be sure, his untimely death from tuberculosis at the age of thirty-five is tragic; he fell victim to dissipation and an indifference to his own health. And yet his work is best understood not in terms of biography, but rather in the context of pronounced changes in philosophical outlook developing at the turn of the century.

The loss of faith in the scientific conquest of social problems led to a search for knowledge in the realm of aesthetic ideas outside of measurable reality. Modigliani, who grew up in an ancient Jewish family known for its liberal intellectuals, embraced these radical new ideas. He was particularly affected by the German philosopher Friedrich Nietzsche's influential notion of the *Übermensch,* or superman, and he believed himself to have been chosen to reinstate in the visual arts the lost synthesis between the individual and society that Nietzsche had proposed in his writings.

In 1906, after attending art school in Florence and Venice, Modigliani

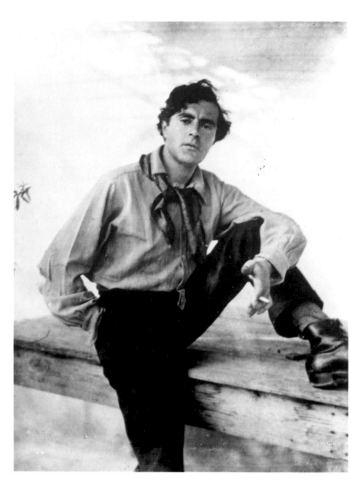

Modigliani (1884-1920) in his studio, 1919.

Photograph: Archives Marc Vaux. Centre Georges Pompidou, Paris.

left for Paris to set up practice as a sculptor. Although he produced refined sculpture greatly admired for its synthesis of tribal African structure, medieval elongation, and Greek purity of form, he abandoned the making of sculpture for painting around 1914. He decided that portraiture would be the ideal medium for artistic reflection. Although the lyrical female nudes painted during the last three years of his life, from 1917-1920, are much acclaimed, his portraits constitute by far the major part of Modigliani's oeuvre, and they include his most memorable works.

Why did portraiture hold such deep significance for Modigliani when the Cubists had degraded the genre through their formalist experimentation? Because the genre allowed him to intensify and express his most profound emotions. Emotion was an aspect of painting that held little fascination for the followers of Cézanne, painters who were always more interested in the process of perception. In this sense Modigliani's approach retraces the expressionist footsteps of Vincent van Gogh.

Modigliani was introduced to Guillaume by the poet Max Jacob in 1915. Guillaume already handled the work of several important avant-garde artists, including Pablo Picasso, Giorgio de Chirico, and André Derain. The savvy dealer recognized the potential in Modigliani's work and made arrangements with the struggling artist, who constantly found himself in poverty, to finance his studio. Modigliani expressed his appreciation with a truly masterful portrait.

The first portrait of Guillaume, the *Novo Pilota* portrait, depicts the art dealer as an elegant gentleman complete with stylish moustache and gloved hand (the cigarette adds a note of urbane sophistication).[2] The painting includes two marked inscriptions: *Novo Pilota,* meaning literally "new pilot," and *Stella Maris,* less literally translated as "guiding light." Thus Modigliani explicitly signals the great admiration and re-

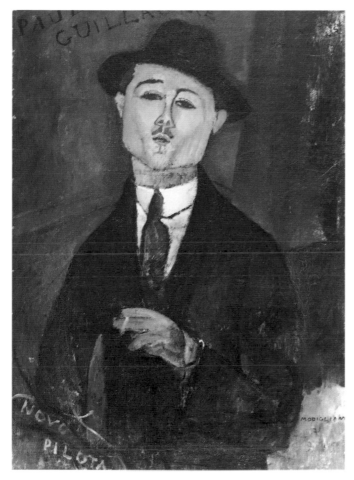

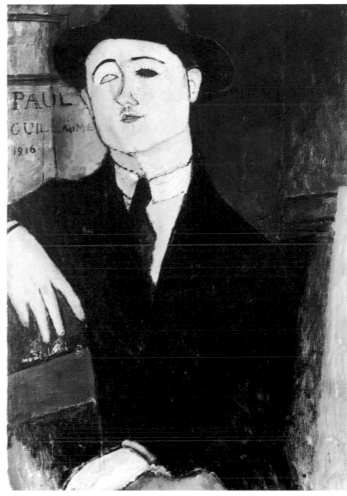

Above: Amedeo Modigliani, *Portrait de Paul Guillaume (Novo Pilota)*, 1915. Oil on canvas, 41 3/8 x 29 1/2 inches.

Musée de l'Orangerie, Paris, Donation Walter-Guillaume, RF 1560-14. © 1998 Réunion des Musées Nationaux, Paris.

Right: Amedeo Modigliani, *Portrait of Paul Guillaume Seated*, 1916. Oil on canvas, 31 7/8 x 21 1/4 inches.

Civico Museo d'Arte Contemporanea, Milan. © Canali Photobank.

spect in which he holds his new friend, feelings embodied in the composition as well. Modigliani has arranged the perspective so that Guillaume is viewed from slightly below, and the beholder must look up to the man just as the painter does.

Modigliani's second portrait of Guillaume, painted in September 1915, is a more intimate depiction than the first but never achieves the same brilliance of personality.[3] It shows Guillaume in his library, and the details of the furnishings and articles of clothing distract from Modigliani's characteristic concentration on the figure itself.

The fourth portrait of Guillaume, dated 1916 and now in Milan,

suggests a far different attitude toward the art dealer.[4] It reveals the cool distance of the strained relationship and makes a clearly negative statement. Painted just before the two men would end their business relationship, it portrays Guillaume with both arms propped up and wearing an expression of arrogance and presumption.

The Bellagio *Portrait of Paul Guillaume,* which also dates from 1916, was probably painted before the Milan portrait. It is the first portrait in which we see evidence of the dissolving friendship. Guillaume is no longer positioned above the viewer, as he was in the *Novo Pilota* portrait. Instead he is presented at the same level, as if confronting the artist in an almost provocative manner. Remarks by Guillaume made after Modigliani's death reveal the dealer's own mixed feelings of admiration and frustration:

> In 1915 he left Montparnasse to set up a studio that I rented for him…. From then on he gave up sculpture, drew less frequently, and began to paint—to paint as he lived, sentimentally, violently, erratically, wastefully. I use this last word advisedly because it characterizes accurately Modigliani's extraordinary life. The painter in fact was a poet. He loved and judged poetry not with the cold partiality of a university professor, but with a spirit mysteriously equipped to appreciate all that was sensitive and adventurous.[5]

In many ways the Bellagio *Guillaume* is typical of Modigliani's manner of portrait painting during the years 1914 to 1917. Neither the devastation of World War I nor the conceptual changes of the period dissuaded him from depicting the human being in his subjects. Apart from the series of portraits of Guillaume, the artist produced a number of portraits of his companion, Jeanne Hébuterne, and also of the dealer who replaced Guillaume, Leopold Zborowski. He also produced many remarkable portraits of well-known artists and poets—among them Beatrice Hastings, Max Jacob, Jean Cocteau, Jacques Lipchitz, Chaim Soutine, Juan Gris, and Henri Laurens.

Modigliani often began his portraits with rapid sketches which he

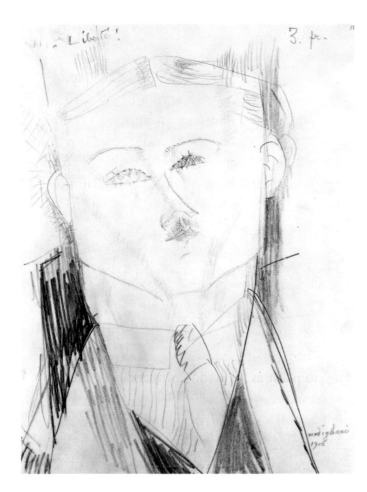

Amedeo Modigliani, *Paul Guillaume,*
1916. Pencil on paper, 13 7/8 x 10 3/8
inches.

The Museum of Modern Art, New York, Gift of
Mr. and Mrs. Richard Rodgers. Photograph
© 1998 The Museum of Modern Art, New York.

drew in cafés and bars; he always carried paper and pencil with him in case opportunity arose. At the Académie Colarossi in Paris, Modigliani had trained in what were called "five-minute courses," in which students were required to capture the essential characteristics of their subjects in only a few well-executed lines. There are several such sketches of Guillaume, each marked by his characteristic puckered mouth and pointed nose.[6]

The Bellagio *Portrait of Paul Guillaume* represents Modigliani's unique style. It embodies a typical tension between tradition, particularly the heritage of classical painting that Modigliani brought with him from Italy, and the avant-garde styles he encountered in Paris. Here as elsewhere he marries contemporary style to conventions of portraiture dating back to sixteenth-century Venice. Just as Renaissance artists often inscribed upon their canvases names, abbreviations, or other information related to their sitters, Modigliani writes the name *Paul Guillaume* across the top of his composition. Although Cubists had introduced letters, words, and numbers to early twentieth-century painting, they did so primarily in an effort to break up the illusionistic space common to classical-style painting. Modigliani's use of inscription, on the other hand, precisely followed the examples of the Italian masters, using names and words to characterize in detail the person depicted. And, unlike the Cubists, Modigliani did not fracture the planar surfaces of his subjects but instead separated the elements of his composition by emphasizing linear contour, a contemporary variation on traditional style.

In the Bellagio portrait, the artist focuses attention on the head of the figure in order to eliminate distracting decorations and naturalistic details in the background. Borrowing the technique of his Renaissance predecessors, he uses a dark background, here in deep browns and greens, to give radiance to the lighter flesh tones in the foreground.

The black vertical line on the right and the horizontal line behind his head frame and accentuate the face. Although the reduced palette suggests the influence of the predominately brown and gray Cubist canvases of Picasso and Braque, it also carries psychological overtones that the Cubist paintings do not. The intense application of color and the harsh contrast between the dark and light tones suggest an emotional coldness. Meanwhile, the dark eyes of Guillaume lend the portrait both a psychological edge and a touch of sentimentality. The anatomical distortions of the nose and eyes reveal a formal affinity with Cubist works influenced by tribal African art. Like so many artists of the time, Modigliani acquainted himself with tribal "primitivism" by visiting Parisian museums featuring collections of sculptures and masks from Africa and South America. He shared the interest with Guillaume, who had an extensive private collection. Only the slightly tilted posture he imposes upon his subject, which he may have learned from studying the figure paintings of Cézanne, softens the severity of his forms.

In sum, *Portrait of Paul Guillaume* emblematizes the fundamental contradiction embodied in all of Modigliani's works. It speaks at once

of conservative bourgeois taste and of modernist experimentation. If Modigliani was not the pioneer of a formal breakthrough, he nonetheless created a unique personal style. In Paris he chanced upon a narrow path that led him down a middle way between the formal developments of the avant-gardists and the classical art of his Italian heritage. In his independent way he embraced that which was new and challenging even as he acquiesced to the bourgeois taste for romantic sentimentality. Modigliani made the last great contribution to the long-standing Western tradition of anatomically correct figure painting and left behind a gallery of many of the most important figures of bohemian Paris.

—Anette Kruszynski

1. The exceptions that prove the general rule include the exhibition catalogue of John Russell, *Modigliani* (Edinburgh and London: The Arts Council of Great Britain, 1963); and Carol Mann, *Modigliani* (New York: Oxford University Press, 1980).

2. Collection Musée de l'Orangerie, Paris. Ambrogio Ceroni and Leone Piccioni, *I Dipinti di Modigliani* (Milan: Rizzoli, 1981), 92, no. 100. Osvaldo Patani, *Amadeo Modigliani, Catalogo Generale, Dipinti* (Milan, 1991), 128, no. 103.

3. *Portrait of Paul Guillaume* (1915), in Ceroni and Piccioni, *Dipinti*, no. 101; in Patani, *Modigliani*, no. 102.

4. *Portrait of Paul Guillaume* (1916), in Ceroni and Piccioni, *Dipinti*, no. 108; in Patani, Modigliani, no. 112.

5. Quoted from Werner Schmalenbach, *Amedeo Modigliani: Paintings, Sculptures, Drawings* (Munich: Prestel-Verlag, 1990), 194. For further discussion of the early friendship between artist and dealer, see John Richardson, *A Life of Picasso,* 2 vols. (New York: Random House, 1998), 2: 360; and Colette Giraudon, *Paul Guillaume et les Peintres du XXe Siècle* (Paris: Bibliothèque des Arts, 1993), 30-31.

6. See, for example, the two portrait drawings of Guillaume in Christian Parisot, *Modigliani,* 2 vols. (Paris: P. Terrail, 1992), 1, no. 2/16 and no. 3/16.

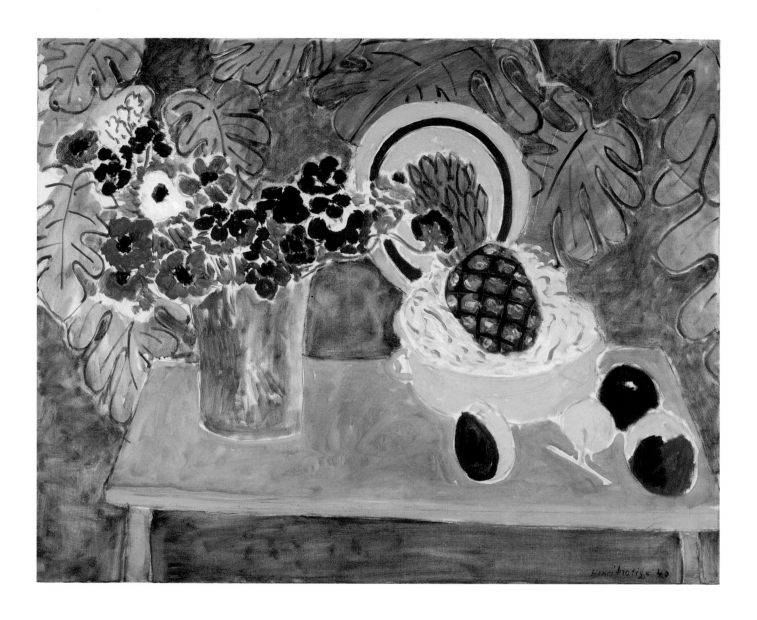

Henri Matisse

Pineapple and Anemones

1940. Oil on canvas,
28 3/4 x 36 1/4 inches.

© 1998 Succession H. Matisse, Paris/Artists
Rights Society (ARS), New York.

Pineapple and Anemones was painted at Henri Matisse's apartment in the Hôtel Régina in Nice-Cimiez, between February 20 and 24, 1940. During that first winter of the war, a number of items had already become scarce and the weather on the Côte d'Azur was unusually cold.[1] The unexpected gift of a pineapple, given to Matisse by an admirer, seems to have entered his life like a burst of sunshine. Shortly after he received it, he began this painting, which clearly reflects his excitement in possessing the radiant and luxurious tropical fruit.[2] *Pineapple and Anemones* is a quintessential work of this period and relates to a number of Matisse's concerns at the time.

As is often the case with Matisse's works, the painting appears at first to be a simple and charming domestic image: a bouquet of anemones and some fruit set on a table next to a pineapple, still nestled in its gift basket. But almost immediately, we become aware of a number of contradictions. The leaves behind the table, for example, have no stems and appear to be afloat in the luminous, thinly painted magenta background. The perspective of the tabletop suggests depth, but only the front legs of the table are visible, so that it too appears to hover in the broad, translucent plane of color. Although we are supposed to be looking into the depth of a room, the whole space is disembodied, abstracted, unreal.

The interaction between the real and the visionary constitutes one of the essential paradoxes of Matisse's art and is clearly reflected in the way he used objects in his paintings. Matisse was deeply attached to the things he surrounded himself with, and he spoke of seeking new objects in the same way that he might seek out a new woman as a model, looking for what he called "a shock."[3] The pineapple, with its exotic radiance and rough surface, no doubt supplied just such a "shock." (As if to emphasize its importance, the pineapple is painted more thickly than anything else in the picture.) But at the same time that Matisse was deeply appreciative of objects for their own sake, the process of representing them frequently entailed a radical transformation of what they actually looked like and how they acted in the world. Objects, as the poet Louis Aragon remarked, formed a kind of palette for Matisse, just as colors did, but one of a very particular sort:

99

Portrait of Henri Matisse (1869-1954) in 1939.

© Lipnitzki-Viollet, Paris.

The palette of objects is quite another thing from the palette of colors. It is closer to the poet's palette of words. It is not a technical thing. The mistake that is made in those general comparisons between poetry and painting...is to mix up the realm of technique (by confusing words and colors) with that realm of choice which is the great mystery of art, of all the arts: I mean, the mystery of man.[4]

The ways in which Matisse explored the choices presented by objects varied a good deal throughout his career and were related to his notion of technique in the deepest sense—that is, how the act of representation was also an act of transfiguration. The same kinds of objects often appeared in his paintings but they did not have fixed meanings like

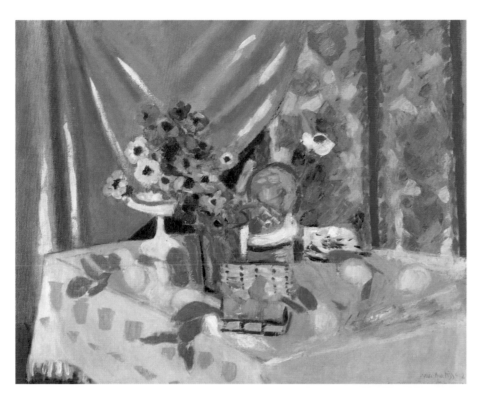

Henri Matisse, *Still Life, Pink Tablecloth, Vase of Anemones, Lemons, and Pineapples,* 1925. Oil on canvas, 32 3/8 x 39 3/4 inches.

Private Collection. © 1998 Succession H. Matisse, Paris/Artists Rights Society (ARS), New York.

words. In his Fauve paintings, for example, the objects are so deeply embedded in complex networks of brushstrokes that they sometimes can barely be made out. During the 1920s, he rendered objects distinctly and with realistic textures, and he set them in tangibly rendered spaces. This can be seen in a group of still lifes he did in 1925 in which he also depicted a pineapple on a table with a vase of anemones, but in a much more materialistic and matter-of-fact way.[5] It was not until the late 1930s that Matisse developed the more condensed, signlike rendering of objects that is evident in *Pineapple and Anemones,* and which eventually led to his late cutouts.

In *Pineapple and Anemones* the various objects seem to respond actively to their surroundings, and to each other, with a willfulness that makes us very much aware of their being situated in the "realm of choice." The communion between the various objects suggests a vision of the world as a fluid continuum in which individual entities are constantly exchanging energy with each other, and also altering each other's significance. The leaves in the background, for example, act as a kind of orchestral commentary on the inner force of the objects on the table, in relation to which they function as symbols of growth and vitality. The anemones at the far left seem paradoxically both to grow up from their transparent vase and to spill down from the leaves above them. The flowers near the center of the bouquet carry this movement laterally across the painting and then seem to reach out to caress the crown of the pineapple. And as they do so, they also signal a chromatic shift that is consistent with the contrasts that dominate the color

harmony of the painting as a whole. It is a color scheme at once simple and daring, based on the complementary oppositions of reds and greens set against brilliant oranges and yellows, punctuated by accents of blue and violet.

The gesture of those three anemones reaching out toward the pineapple is made all the more breathtaking by something else that is characteristic of Matisse's best paintings—the way that the interactions of forms and objects create complex metaphorical and symbolic overtones. In *Pineapple and Anemones* the top of the basket encompasses the crown of leaves on the head of the pineapple like a halo, which further enhances its celebratory enshrinement. At the same time, this yellow disc with the red circle also suggests the sun itself, and this gives added poignancy to both the tropical lushness of the fruit below it and to the gesture of the flowers, which seem to be groping toward the radiant sunlight.

Pineapple and Anemones is an excellent example of one of the guiding principles of Matisse's late still lifes: his desire to animate the inanimate and invest the objects he represents with a strong sense of spiritual presence. This kind of transformation of simple objects into a spiritualized, symbolic image is something that was very much on Matisse's mind at the time he did this painting. Only a few weeks before he painted it, he wrote to Pierre Bonnard about what he felt was the increasing separation between his painting and his drawing, and spoke of his desire to achieve a new synthesis in his work. He told Bonnard:

> My drawing suits me because it renders the sense of what I feel about the specific. But my painting is held in check by the new conventions of flat areas of color, which I must use exclusively to express myself, with local colors only, without shadows or modeling…in order to suggest light and spiritual space.[6]

The great strength of *Pineapple and Anemones* lies precisely in the way it creates "light and spiritual space" by balancing and synthesizing a number of complex oppositions. It is also a painting that lights up

the room. So much so, that one is tempted to see it as a response to a letter that Bonnard wrote to Matisse shortly before this picture was painted, in which he remarked on how cold the weather was and hoped that "soon the sun will warm us a little again."[7]

—Jack Flam

1. The specific days that Matisse worked on the painting are given by Lydia Delectorskaya, *Henri Matisse, Contre vents et marées: Peintures et livres illustrés de 1939 à 1943* (Paris, 1996), p. 83. In response to a letter from Matisse complaining about the cold in Nice, Pierre Bonnard remarked: "It is also quite cold in Cannes, the kind of cold that jars and weakens." Bonnard to Matisse, February 9, 1940; as cited in Antoine Terrasse, ed., *Bonnard/Matisse, Letters between Friends,* trans. Richard Howard, (New York, 1991), p. 60.

2. Matisse also did a number of pencil drawings of the pineapple, but these were done in March, after he had finished the painting (see Delectorskaya 1996, pp. 80, 82). This was an unusual procedure for Matisse at this time, for his paintings were usually preceded by study drawings rather than followed by them. His starting with the painting in order to capture his fresh responses in color indicates just how excited he was about receiving the pineapple.

3. Matisse in conversation with Louis Aragon, March 18, 1942; as cited in Louis Aragon, *Henri Matisse, a Novel* (New York, 1972), vol. 1, p. 72.

4. Louis Aragon, "Matisse-en-France," 1943; as reprinted in Aragon 1972, vol. 1, p. 72 (translation slightly modified).

5. In these paintings, the pineapple is also set within a padded basket. See, for example, *Still Life with Pink Tablecloth, Vase of Anemones, Lemons, and Pineapple,* 1925 (Private Collection); *Still Life (Pineapple, Compote, Fruit, and Vase of Anemones),* 1925 (Philadelphia Museum of Art); *Pink Tablecloth, Lemons, and Pineapple,* 1925 (Private Collection). In the famous *Interior with a Phonograph* of 1924 (Private Collection) there is also a pineapple in a basket, set next to some fruit and a small vase of flowers. And in 1926 Matisse did a small painting of just a pineapple in a basket (Collection Mme Jean Matisse). These paintings are all reproduced in Jack Cowart and Dominique Fourcade, *Henri Matisse, The Early Years in Nice, 1916-1930* (New York, 1986), pp. 178-180, 188, and 182, respectively.

6. Matisse to Bonnard, January 13, 1940; as cited in Terrasse 1991, p. 58 (translation modified).

7. Bonnard to Matisse, February 9, 1940; as cited in Terrasse 1991, p. 60.

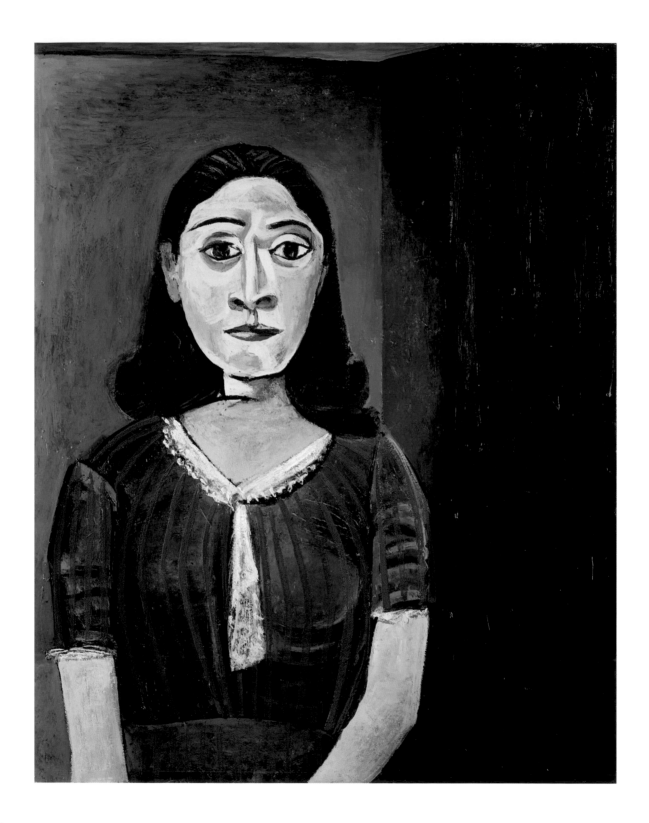

Pablo Picasso

Portrait of Dora Maar

Paris, October 9, 1942. Oil on panel,
36 1/4 x 28 3/4 inches.

The numerous stylistic periods of Pablo Picasso's career produced many
masterpieces, and it would be fruitless to attempt to determine which
period or which masterpiece most profoundly characterized this
uniquely protean artist. There can be no argument, however, with the
fact that the period coinciding with World War II was one of the most
inventive, grave, and masterful. It was, moreover, a period when Pi-
casso himself felt at the height of his powers, because, as he frequently
remarked, despite the environing Nazi nightmare he had been able to
work in complete peace. Denounced by the occupying forces as "de-
generate," forbidden to exhibit, he labored undisturbed. Consequently
the works he produced during this period reflect the intimate circum-
stances of his daily life, as it had been intensified by knowledge of the
peril weighing upon the culture to which he had dedicated his exis-
tence for half a century.

Throughout this crucial era Picasso's daily life was centered almost
entirely upon one individual, his mistress Dora Maar. It was his custom
when deeply involved with a woman—and there were to be seven dur-
ing his long lifetime—to draw and paint many portraits of her. Among
the hundred or more portraits he made of Dora the most dramatic,
powerful, intense, and compelling is without contest that which depicts
her full-face, half-length, in a green dress with orange stripes, posed
strikingly off-center in a bleakly darkened room. As an image of a
woman presumably beloved by the artist, this portrait is unforgettable
and deeply disturbing, which is its power. Indeed, I know no other
portrait in Picasso's oeuvre that can compare with this one as an image
of the uncanny ability of genius to see the true constitution of human
reality behind appearances or as a vision which is both hypnotic and
beautiful. Maybe this is why Dora so disliked this portrait. To be sure,
it has a curious history.

During the war years Picasso renewed his friendship with Jean
Cocteau, who had been a witness at his long-ago wedding, but with
whom, as with so many people, he periodically quarreled. Cocteau was
not only an author of exceptional talent but also a skillful draftsman,
especially adept at drawing portraits. He had often drawn Picasso. It
was the painter who in the autumn of 1942 suggested—insisted, in

Dora Maar. Mougins, 1937.
Photograph by Lee Miller. © Lee Miller Archives.

fact—that the author should portray his mistress and specified that the portrait should be a purely linear painting on a primed canvas of good size. Cocteau idolized but two people in the world, Picasso and Stravinsky, and was therefore delighted to oblige. On the appointed day he arrived at Dora's apartment with a large canvas and promptly set to work. As the portrait was actually but a drawing in oils, it took only the better part of one afternoon to complete. Before nightfall the work was done. Picasso pronounced it a masterpiece, and Dora herself was pleased, feeling that for once she had been represented in a tranquil and attractive manner—more so than was usual in portraits by her lover. So they all had a drink and Cocteau departed, highly gratified. No sooner had he gone, however, than Picasso said, "The portrait is very good; it's true. But there's one little detail that could be made better. It's nothing. Jean will never notice." So he took a paintbrush and altered just a line or two. Dora could never remember where. But then, of course, he said, "Now it's an entirely different picture. To make things right, it has to be changed just a little bit more." He worked on it for half an hour, after which there remained next to no trace of what Cocteau had done. Then he said, "Well, it was a perfectly terrible picture anyway. I'll have to take it to my place and finish it properly." Which he did.

It so happened that Dora and her mother were not congenial. They had appalling disputes. One evening not long after the Cocteau-Picasso portrait was undertaken, though before Picasso had finished it, the mother and daughter were talking on the telephone, arguing violently, as usual. The mother abruptly ceased speaking, Dora kept on talking but could not induce her mother to say another word. This was after the hour of curfew, and therefore she had to wait until the next morning to go to the Right Bank to the maternal apartment. There she found her mother lying dead on the floor, with the telephone still in

her hand. Needless to say, she was profoundly traumatized and felt agonizing guilt. She received little consolation from her lover, who was terrified of death and wanted nothing to do with the rituals concerning it. However, he had never hesitated to depict in his art the grim transience of human life or the anguish attending its termination. Much of this made its mark upon the somber portrait of Dora in her dark room, her face virtually the color of death itself, a mortuary mask, her dark eyes gazing straight ahead, not at the viewer but into the void.

Picasso made a gift of this portrait to his mistress. She disliked it, understandably, and hung it behind the door of a parlor containing half a dozen other por-

Jean Cocteau and Pablo Picasso at Vallauris, August, 1955.

Photograph: Jacques-Henri Lartigue. © Ministère de la Culture, France/A.A.J.H.L.

traits of her by her lover. The other portraits were more pleasing to the eye, though not one so magisterial in its psychic penetration and plastic intensity. Dora insisted that the painting was a fraud because she had never in her life owned a green-and-orange striped dress and her features, though seemingly representational, did not come close to a likeness. Besides, she said, Picasso himself was not above altering works of his own in order to suit someone else's view. In his finished version of the painting there had been at the upper right a small window, to which she objected saying that it made the room look like a prison cell, and Picasso had painted it over to please her.

Dora was a highly intelligent, subtle woman, but I felt that this protest against the portrait (still hanging unframed behind the door in her apartment when I first became friendly with her) was sadly superfi-

Pablo Picasso, *Weeping Woman,* October 26, 1937. Oil on canvas, 23 5/8 x 19 1/4 inches.

The Tate Gallery, London. Photograph: Art Resource, New York. © 1998 Estate of Pablo Picasso/Artists Rights Society (ARS), New York.

cial and anecdotal. We were not talking about a likeness, after all, but about a very exceptional work by the most remarkable artist of our century, a work, in point of fact, which I feel sure she recognized no less than I as a masterpiece. But she had been beautiful, aged only thirty-four, when it was painted, and she was vain as well as proud. Our conversation took place only a decade afterward.

"All his portraits of me are lies," she insisted. "They're all Picasso's, not one is Dora Maar."

Infared Reflectogram of the *Portrait of Dora Maar,* imaged at 1.6 Microns by John Twilley, June 1998.

© 1998 Estate of Pablo Picasso/Artists Rights Society (ARS), New York.

I knew perfectly well that to take a place in the history of art as one of the women most important—and probably the most important—to the dominant creative genius of the era was to her a matter virtually of life and death.

"But they live," I objected, referring to the portraits of her. "All over the world they hang in museums, thousands of art books and magazines are filled with them, and people say, 'That's Dora Maar.' They recognize you. In a hundred years they will see you still. You will never be forgotten."

"Do you think I care?" she exclaimed. "Does Madame Cézanne care? Does Saskia Rembrandt care?"

But she did care. She cared so sincerely, so unforgettably, so passionately that having been abandoned by that artist who portrayed, and then betrayed her, she could not bring herself to acknowledge it. And that magnificent, haunting painting was the constant reminder of her loss and suffering, Picasso's most intolerably vivid and lifelike representation ever. The series of so-called weeping women, that prefigure and subsequently recall Picasso's *Guernica,* and that are presumed to be effigies of Dora, are only flights of formal bravura by comparison.

Little more than a decade after its creation Dora sold this portrait of herself to Nelson Rockefeller. She was glad to be rid of it, she had said. In fact she was ridding herself little by little of the bitterness and rage she had felt against the artist, not against the works of art. The painting affected her too deeply for her to endure living with it. When we look at *Portrait of Dora Maar* today, we do not, and, thank goodness, cannot, see it as she did. What we see is one of the supreme representations in all of art history of what it must mean to be held in the thrall of genius. Thus, it is more than a formal masterpiece. It is an emblematic milestone in the history of human feeling.

—James Lord

Pablo Picasso

The major exhibition *Picasso & Things* (1992)[1] proved beyond a doubt that without a single living person depicted, the master's still-life painting and sculpture could cover the widest spectrum of human experiences, from joy and sorrow to lust and violence. Throughout his long career, Pablo Picasso never stopped making still lifes; and they reflect, much like his paintings of real and mythical people, not only the restless changes of his style but also the circumstances of both his personal life and the world events around him.

It is no surprise then that the still lifes he made during the Nazi occupation of Paris, when he lived in his large and often unheated studio at 7, rue des Grands-Augustins, have been interpreted as mirroring the ambiance of claustrophobia, deprivation, and death that had pervaded the city until its liberation by the Allies in August 1944. But like all generalizations, this one is both true and false, at least on the evidence of the two Bellagio Gallery paintings that date from the middle of the war years, *Still Life with Basket of Fruit and Pitcher of Flowers and Cattails* (August 2, 1942) and *Still Life with Flowers and Fruit Dish* (September 14, 1943).

The earlier of the two canvases displays, among other things, the extraordinary way in which Picasso could make the simplest of still-life objects—here a wicker basket of fruit and a crude pitcher filled with two blossoming red flowers (perhaps poppies) and two cattails—convey a drama unexpected on the neutral stage of a tabletop. Here, the pitcher becomes animated to the point of attack, as if it were about to engage in a cockfight. The spout, in fact, is almost like the silhouette of a bird's sharp beak, against which the basket seems to rise protectively, guarding its seven round fruits (three circled in white, four in black) as if they were eggs in a thatched nest.

It is, of course, impossible to prove that this is anything more than a basket of fruit and a pitcher of flowers; but Picasso's familiar genius for evoking one thing from another is particularly fertile in his still lifes, which are usually anything but still. Here, these commonplace household utensils seem to be pitted irrevocably against each other. The pitcher, whose sharp contours and chilly gray-and-white modeling give the vessel a harsh, metallic quality, is clearly the aggressor; and its spiky

Portrait of Pablo Picasso (1881-1973) in his studio at 7, rue des Grands-Augustins, Paris, 1948.

© Herbert List/Magnum Photos, Inc.

forms are so contagious that even the botanical life they enclose seems potentially dangerous, a bristling tangle of cutting edges that look more like weapons—swords and arrows—than a decorative bouquet. And with his ability to create from the form of a particular object a widening pattern of abstract rhythms, the long stems of the flowers and

*Still Life with Basket of Fruit and
Pitcher of Flowers and Cattails*

August 2, 1942. Oil on
canvas, 28 3/4 x 36 1/4 inches.

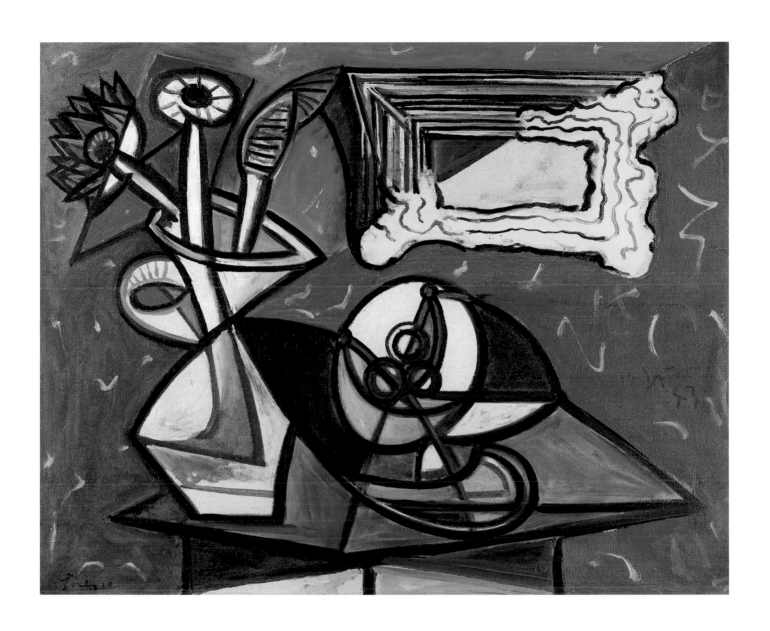

*Still Life with Flowers
and Fruit Dish*

September 14, 1943. Oil on canvas,
31 3/4 x 39 1/2 inches.

Pablo Picasso, *Flowering Watering Can*, 1943-44. Bronze, 31 1/2 x 16 7/8 x 15 3/4 inches.

Museum Ludwig, Cologne. Photograph © Rheinisches Bildarchiv, Cologne. © 1998 Estate of Pablo Picasso/Artists Rights Society (ARS), New York.

weeds generate a taut network of jagged, intersecting planes which, like a patchwork quilt, weaves the whole together, spreading across the tilted brown tabletop up to the prismatic shafts of glowing blue and white light that animate the backdrop to this strange drama. One of these triangular planes, in fact, seems joined to the basket's handle, suggesting a metal blade raised in defense.

Throughout, we feel a shrill tension, as if the forces of nature were in peril, an image Picasso made even more emphatic a short time later in his bronze sculpture *Flowering Watering Can* (1943-44). Here, beginning with an actual metal watering can and his magical green thumb, he made an equally metallic flower grow from this gardener's utensil, crowning the spiraling blossom with actual nails, a mixture that powerfully plays the forces of life against those of death. The effect is of something green bursting through shrapnel. We sense a comparable tug-of-war in the painted still life. Here, the two flaming red blossoms are shaped like sharply pointed triangles that rhyme with the cutting edges of the angular background and the spearlike forms of the stems below. Such menacing shapes offer a polarized contrast with the circular, egglike fruits that, covered by a purple shadow, seem to be maturing within the womblike fortress of the basket.

Characteristically, Picasso was to make several other variations on the theme of this still life. In these subsequent paintings he further distilled their complex shapes into even more abstractly crystalline patterns set against the circular fruits, an evolution illustrated in the first publication of this still life in Harriet and Sidney Janis's landmark study of 1946, focusing on the war years.[2] And it should be added that Picasso would later re-create the harsh confrontation between these two inanimate objects in a still life of 1950, in which the wicker basket of 1942

becomes a tattered, cagelike form and the birdlike pitcher becomes an actual rooster, on the threshold of kitchen sacrifice.

The second still life from the war years, dated September 14, 1943, again sets up an opposition between two familiar household objects, a pitcher with three flowers and a fruit bowl with three circular fruits. The simple dialogue, however, is made far more complex by the conspicuous presence of a mirror, one of the artist's favorite motifs. Its magical nature is instantly apparent here; for the clear axis that separates light from shadow in its reflection is also the dividing line between two kinds of frame; one, a simple, rectilinear black frame and the other, a gilded, baroque frame that offers a luxurious complement to its alter ego. This double identity extends throughout the painting, so that the continuous plane of the background, covered above and below with a rapidly brushed pattern of decorative white flecks, seems to represent both the dark wallpaper against which the mirror hangs and the extension of a tabletop covered with a red cloth that shares this torrent of impulsive brushstrokes. Here, as in the earlier still life, we intuit a tense duality between the energies of life and some darker force. The warmth of the red cloth (or wallpaper) pertains as well to the red that stems from and surrounds the two flowers at the left; and the three egg-shaped fruits that sprout green stems are enclosed by red circles that give these abstract forms a vital pulse. Once again, nature's energy seems to be cracking through an imprisoning mold, here defined by the bone-dry containers of the pitcher and fruit bowl. It should be mentioned as well that this still life uses one of Picasso's most recurrent palettes, a contrast of red and yellow that evokes the Spanish national colors and that is further intensified by an equally Spanish contrast between extremes of light and shadow, a duality that is often conspicuous in many Spanish still lifes of the seventeenth century, such as those by Zurbarán.

As a relaxing postscript to this pair of somber, wartime still lifes, there is the sunshot display of a far more agreeable assembly of table objects created by the master two decades later, in 1963-65, at his home in Mougins, Nôtre-Dame-de-Vie, one of his many residences on the Côte d'Azur. There, from 1946 on, the pleasures of life on the Mediter-

Still Life with Fruit Dish and Yellow Vase

1963–65. Unique ceramic; hand-decorated white terra-cotta, 36 1/16 x 48 1/16 inches.

ranean replaced the complexities of urban life in Paris, and this still life registers the change. Exploring as he often did in these postwar years the medium of ceramics, he turned here to an almost Islamic decorative fantasy of painted terra-cotta tiles. The leanness and austerity of the wartime still lifes have now vanished in favor of a hedonistic abundance. Predictably sensitive to the ornamental potential of the square tiles, Picasso reiterates this foundation in the red-and-blue checkered tablecloth below and the rectilinear patterns of the shuttered window at the left. A sunlit cheer radiates throughout this bounty, reflected in the brilliant yellow of the pitcher with its profuse and healthy bouquet as well as in the assorted ripe fruits of diverse shapes and colors. Faced with this cornucopia of Mediterranean delights, it is hard to remember how in the earlier still lifes of 1942-43 the harmony between man and nature appeared to be so threatened.

—Robert Rosenblum

1. See Jean Sutherland Boggs, *Picasso & Things* (The Cleveland Museum of Art, 1992).

2. See Harriet and Sidney Janis, *Picasso: The Recent Years, 1939-1946* (Garden City, N.Y.: Doubleday & Company, 1946), plates 25-27. Incidentally, the title given to this series here is *Still Life, Basket of Fruit and Pitcher of Spice,* but it now seems apparent that the "spice" consists of flowers and seed pods.

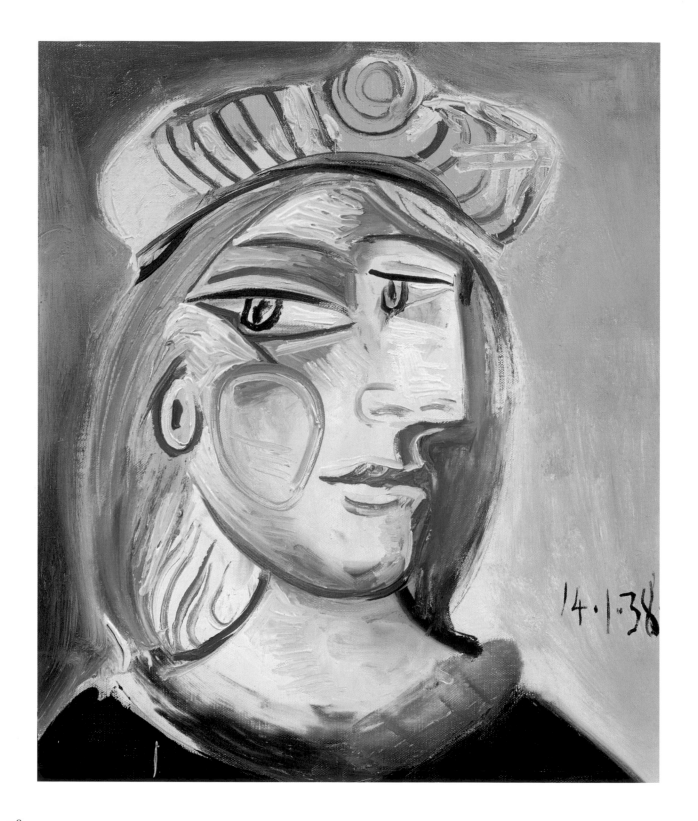

Pablo Picasso

Woman with Beret

January 14, 1938. Oil on canvas,
18 1/8 x 15 inches.

During the first part of the 1930s Pablo Picasso multiplied the effigies of a mysterious fair-haired presence in his life. She was a young girl whom he had met by chance, and whose generous curves and opalescent complexion exalted his lyricism. To magnify the sensuousness and eroticism of the nudes he made of her, he appropriated the discoveries of Fauvism. He also employed different sets of complementary colors, along with the arabesque line, to create a live space entirely rid of the intellectual asceticism of his Cubist and Neo-Cubist styles. The large compositions of this period are, for the general public, among the most memorable and lovable icons in his work.

Apart from these well-known masterpieces, there is a wealth of more intimate depictions in which an object—such as a red armchair or a curvilinear straw hat or a certain girlish "col Claudine" around the neckline—appears and reappears with fetishistic regularity. Picasso often spoke of "attributes": these were fragments of reality that became for him trademarks in his progressive discovery of a person. In the same way that St. Sebastian can hardly be visualized without being pierced by arrows, Picasso could hardly envision the portrait of his fair-haired beloved without a small Basque beret slanting backward from the top of her head. In France the beret was a feminine and informal type of headgear. Perhaps Marie-Thérèse, for that was her name, was wearing one when they first met or wore one during subsequent encounters during the beginning of their relationship. Or it could have been a reminder of a shared memory, a visible emblem replete with positive connotations. The beret recurs in the oil paintings of Picasso from 1928 onward, in purple, in sap green, in yellow; it is even present in many simple black-and-white drawings. More than one such hat, moreover, became an attribute. For example, in *Woman at the Window* (April 13, 1936) Marie-Thérèse wears a Scottish knit bonnet in yellow, red, and green wool. Picasso liked it so much that he later appropriated it for himself. He used it to protect his bald head from the cold when working in his studio during the war years, and I saw him wearing the same tam-o'-shanter in 1944.

The general composition of *Woman with Beret* is centered and symmetrical. The bust of the young muse appears to be facing us. The

shoulders confront the viewer in a black dress, the color of the Spanish court, which lends a regal formality to the crownlike bonnet, and also to the green-gold hair mass, which suggests her sadness and melancholy. It is also interesting to notice that the color blue has expanded beyond the boundary of her eyes to become the local tone of the entire face, which only adds to its intensity and significance.

The face manages to display itself in full profile as well as from a frontal view. If we observe the face from left to right we see an eye Egyptian fashion, looking left and with a touch of nostalgia. This eye is placed in a location coherent with the profile to the right. The straight nose descends in classical elongation of the forehead toward a pronounced cleft beneath the nostrils, which leads in turn to the arc of a brooding mouth. The chin is willful, held sturdy by the steadiness of the neck. But if instead we look at the face from right to left, next to the nose (or rather right on the nose), we see another eye drawn in profile looking left. In a traditional painting, this eye would be hidden, since it is located behind and not in front of the nose.

Here the artist is manipulating our habits of perceptions. If we see two eyes, we naturally assume that we see a full face, and we expect the nose to be in the middle, especially when the eyebrows are arranged in their usual location, below the cupola of the forehead. The almost equal amount of green-gold hair on each side acts to further persuade us that we are looking at a frontal view stabilized by a very static depiction of the neck and shoulders. Willy-nilly we see both profile and frontal view at the same time. This is a magic trick performed by Picasso, of course, wizard-in-chief of twentieth-century art. He liked to stipulate that he was fooling the mind, not the eye: "This is not a *trompe l'oeil,* it is a *trompe l'esprit,*" he would say. Again and again I heard him insist that any transposition in color had also to be sustained by an equal departure from naturalistic form. In other words, a face could not be painted pale blue unless its structure was no longer imitative, a problem he discussed with Henri Matisse during the spring of 1946.

Let me finally come back to the global feeling generated by this painting, the way it achieves unity, so that the viewer is not burdened

by unwanted details. There is a good balance between positive and negative space, and that balance lends a stability and even a formality to the whole composition. The muse is enshrined in the canvas as if forever; it is as if nothing could threaten her timelessness. And yet, the fact that the face gazes in one direction while the profile is willfully directed toward another, bespeaks a latent anxiety, a lack of trust, an absence of confidence, and a self-contained sadness. It nonetheless remains a regal portrait, full of dignity. Picasso's *Woman with Beret* remains a formal testimony to a love-that-had-been, if not to a love still at the zenith of its intensity.

—Françoise Gilot

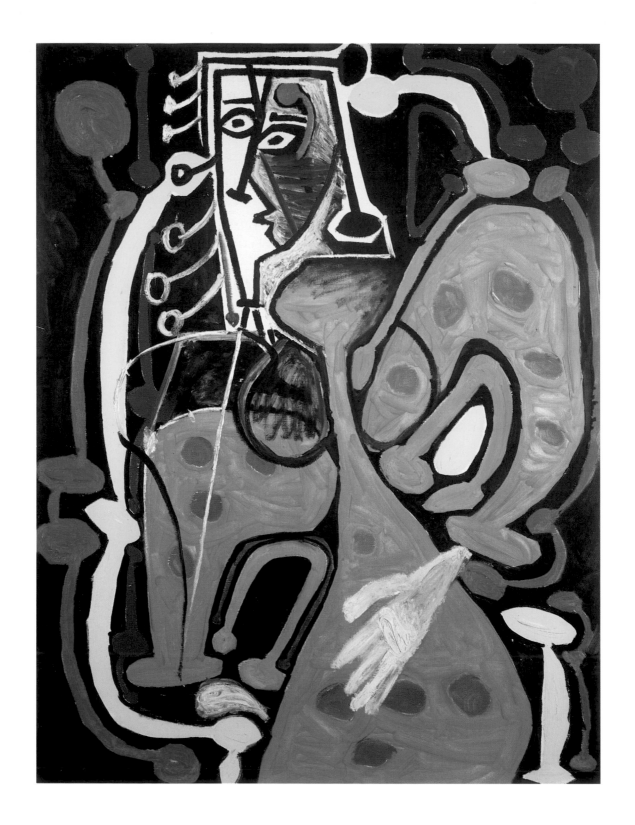

Pablo Picasso

Seated Woman

March 18, 1949. Oil on canvas,
51 x 38 1/4 inches.

© 1998 Estate of Pablo Picasso/Artists
Rights Society (ARS), New York

In September 1948 Pablo Picasso went to Poland for a meeting of the Peace Movement, where he was treated with utmost discourtesy by the members of the Soviet delegation. When he went back to Vallauris, he was no longer in the mood to continue his work in ceramics. He found the medium ridden with too many limitations to satisfy his need of constant experimentation.

I was also out of sorts, being pregnant with the future Paloma. We soon decided to return to Paris and to spend the winter there.

Picasso had brought back from Poland two embroidered folkloric jackets of leather and fur. They looked quite nice, but they made Claude and me smell like ram and goat. But Picasso was enchanted by the "authenticity" of the design (including fragrance) and began making lithographs of me, and also a painting of Claude, dressed in the new clothes.

The result being very encouraging, he ordered from Castellucho-Diana, his Spanish canvas supplier, a good number of canvases of the standard format called "sixty figure" in Europe. He also ordered other formats, of course, but meant to concentrate on actual-size, semi-abstract depictions of me as seen from head to hips. I would be enshrined, rather than merely seated, within vigorous arabesques suggesting the idea of an armchair.

The first paintings carried a strong echo of the lithographs he had been working on at Mourlot. Then they started to find their own density, rhythm, and color scheme. Some were fairly spontaneous and easily completed, whereas he worked assiduously on others. Most of the time they were a reflection of his moods rather than an evocation of my state of mind; Picasso himself thought that his paintings were like the pages of an autobiography. But they could also reflect purely pictorial preoccupations. Again and again, he came back to the dialectic relationship of positive form to negative space. He once said:

If one occupies oneself with what is full, seeing the object—a breast for example—as a positive form, the space around it is reduced to almost nothing. If one occupies oneself primarily with the space that surrounds the object, the object is reduced to al-

Portrait of Pablo Picasso and Françoise Gilot, 1951.

© Robert Capa/Magnum Photos, Inc.

most nothing. What interests me most is to discover what is outside or inside a given form. When I look at Cézanne's apples, I see that he has not painted apples as such, but has depicted so well the weight of space on their circular form. The shape itself is only a hollow area with sufficient pressure applied around it so as to make the apple seem to appear, even though in reality it does not exist. It is the rhythmic thrust of space on form that counts.

I answered by retelling an anecdote about Francisco Goya. As he was making a portrait of a lady, she told him that she wished he could give painting lessons to her son who was sixteen years old. Unwilling to give in, Goya asked her what the boy was already able to achieve. Happily she affirmed that he was quite excellent with backgrounds. "In that case," answered Goya, "he doesn't need me, since I have never been able to solve that problem myself. He already knows more than I do!"

In *Seated Woman* of March 18, 1949, the yellow, red, and green arabesques of the background are intended to exert pressure on the convoluted figure of the woman. However, here the efforts of the negative space are doomed to fight a losing battle. The pneumatic dress, which is blue with pink polka dots, balloons as if to insert itself in each nook and cranny. Its mostly upward motion is resisted only by the austere downward drive of the schematic head, which is treated in black and white.

In fact, there is a stark contrast between the head, with its graphic lines rationally organized along vertical and horizontal vectors, and the dress below it; the head appears to worry about keeping control over the unruly dress and over the unruly body carrying an unknown promise for the future. There is a great dissymmetry to the body, one shoulder too high, the other too low. The straight line of the nose tries in vain to impose some kind of order, while the eyes look askance at the darkness around them. The hair is disheveled, as if standing on end, and the mouth, in profile, opens as if to utter a shout of terror. Yet a very white right hand rests on the stomach of the figure, as if to reassure the child to be, if not the expectant mother. The picture is indeed a far cry from the serenity of earlier portraits of me, such as *Woman Flower,* of May 1946.

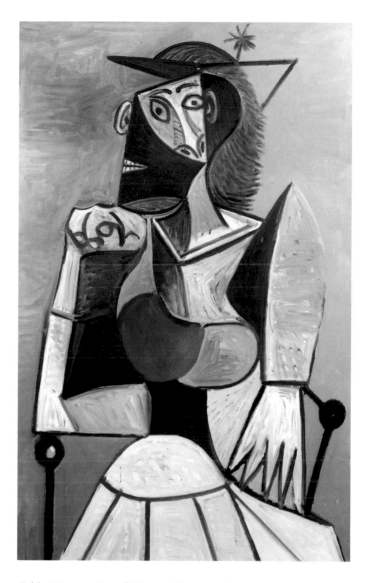

With its component parts all striving for dominance, the picture achieves high drama. It expresses with *maestria* the existential dilemma that the woman, who is me, is experiencing at the time. On one side we see the biological forces at work, seeking to create a new human being and plotting against the control and dominance of a well-trained mind absolutely unwilling to accept defeat. On the other side, amid all this chaos the yellow curlicue (the color yellow symbolizing the intellect) appears to come to the rescue of the dumbfounded figure, bringing a measure of support and comfort.

When I saw *Seated Woman* at the time of its completion, I was struck by the depths of Picasso's psychological intuition apropos of my feelings. But, because of the innate sense of humor that has always been my salvation, I could not help thinking that since his work was like the pages of a diary, this painting told as much about his own anxieties and misgivings as it expressed mine. It reminded me of a famous quotation from Gustave Flaubert. When he was asked how he could have so truly described the character of Madame Bovary, he observed simply: "But Madame Bovary, it is myself."

—Françoise Gilot

Pablo Picasso, *Seated Woman (Françoise),* March 5, 1945. Oil on canvas, 51 3/4 x 31 7/8 inches.

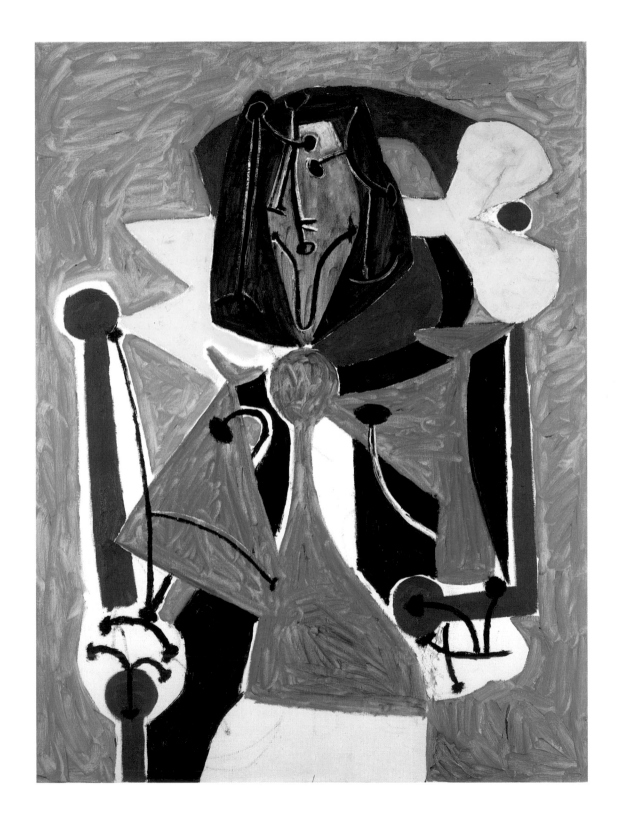

Pablo·Picasso

Woman Seated

March 29, 1949. Oil on canvas, 51 1/4 x 38 1/4 inches.

© 1998 Estate of Pablo Picasso/Artists Rights Society (ARS), New York.

From a very recent exhibition, at the PaceWildenstein Gallery, Los Angeles, Mr. Steve Wynn acquired two magnificent wartime still lifes by Pablo Picasso: *Still Life with Basket of Fruit and Pitcher of Flowers and Cattails,* of 1942, and *Still Life with Flowers and Fruit Dish,* of 1943. He also purchased a canvas by Picasso titled *Woman Seated.* This painting, which dates from March 29, 1949, is an evocation of me. It belongs to a group of canvases all of which are devoted to me as the subject. Some of these were begun during the autumn of 1948, when, as usual, Picasso and I and our son Claude came back from the South of France to spend the winter in Paris. Others were undertaken during the early months of 1949. Some are quite spontaneous, others more elaborate or more abstract. But they all share an interest in calligraphic elements in different sizes and colors, elements that establish the rhythmic qualities of the composition. At the time *Woman Seated* was painted, I was expectant with our daughter Paloma, and therefore at the center of Picasso's preoccupations. And yet I didn't have to sit for these pictures, because Picasso didn't want to make a series of descriptive portraits. Instead, by using a highly symbolic and poetic language, he attempted to create a forceful icon. Its meaning would spring more from the feelings I inspired than from a naturalistic depiction of my person. Therefore, during his working hours I would draw or paint in a different room until we came down from the upper floor around ten in the evening to share a late dinner, after which we often resumed work until midnight. That autumn and winter we remained in Paris, without making even short trips to the South of France. In those days Picasso was very focused. Besides making lithographs, he completed the two still life canvases (the "Kitchens"), both fairly abstract and of an exemplary simplicity, with their dynamic linear force-fields ending in bulbous circles.

Picasso liked to talk with me about his work-in-progress, in both personal and aesthetic terms, the latter mostly concerning their emblematic quality. Apropos of the figurative compositions, the recurrent question was to know to what extent each of them revealed my character and reflected my personality.

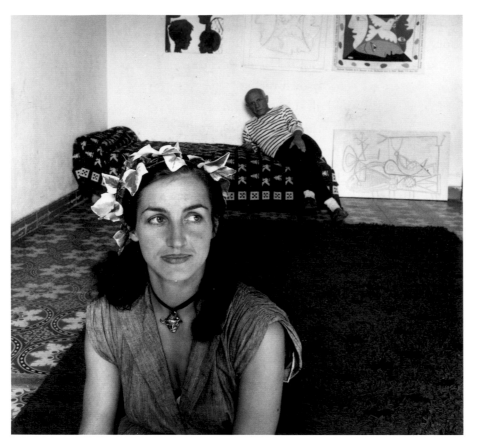

Portrait of Pablo Picasso and Françoise Gilot, September, 1952.

© Robert Doisneau/Rapho, Paris.

It was quite an exciting game. Even though I liked the first paintings in that series, I thought most of them evoked my mother rather than myself. Pablo, who had never met my mother, was delighted. "This is the proof," he exclaimed, "that I am on the right path. I had to invent the mother before I can imagine the daughter!" Invent the daughter he did soon thereafter. Even though we never spoke of it, his earlier portrait of me, *Woman Flower* of May 1946, was an archetype of my essence that would be hard to surpass. He went on with his usual flamboyant vitality and verve, and progressively my mother's persona vanished and my own character mysteriously began to appear, no longer the evanescent young girl of *Woman Flower* but a more affirming yet still youthful being. One composition on which he worked with an almost obsessive concentration looked almost like a map. "So now that you have drawn the map of my territory," I said jokingly to him, "everything will be easy for you!" And indeed in *Woman Seated* of March 29, 1949, all the forms and colors that Picasso had investigated for months would culminate in a spontaneous synthesis. It was as if the virtualities present before had now fully bloomed.

The relation of a certain blue to a vibrant green, the color that was his leitmotif for me, was balanced by a bright yellow and vermilion red. In some areas where the absolute contrast of black and white set off the red and the yellow, the white was simply the canvas left bare, a virgin white affording more breathing space for the stronger tonalities. The vivacious and uneven brushstrokes of the leaf green background gave a

sense of the reawakening of nature in early spring, when new vegetation unfolds. In the blue dress only one breast was visible. In Picasso's mind it probably foretold the head of the child to come rather than what was stirring in my own breast.

Interestingly, amid all this explosion of joy, a melancholy calligraphy restores to the ovoid gray-green space the usual features of a face: the forehead, eyes, nose, mouth, chin, and neck of an introvert personality. At the same time, the thoughtfulness of the young woman's face, curtained or protected by a mane of reddish brown hair, may be interpreted as a moment of intense concentration of maternal feeling for the child about to be born.

The interaction of these different forms, all in bright colors, especially in their contrast with the meditative aspect of the face, produces an impact at once forceful yet sensitive. Its inventiveness and spontaneity creates not only a shock but also, I think, a lasting emotion in the viewer.

It is important to understand that Picasso reacted in different ways to his different muses. His responses were appropriate to the temperament and wishes of his muse at the time, and also to the nature of the personal attachment. In his portraiture the individual features are not a goal in themselves, but a means of approaching the ultimate inner truth of a human being beyond any visual symbol. His human figures are always the result of a dialogue. A trip to Pompeii reminded him of a classical style that he could use to communicate with his wife, a ballerina brought up in conventional high culture; yet his style could also become more sensuous with one model, or more dramatic with another. He followed the movements of his own heart, his torments, his joy or happiness, his doubts, his nihilism, his fervor, his sound and fury. Picasso is finally never the same because he was always trying to live the dictum of the poet Arthur Rimbaud: "Love must be reinvented each time, we know it." And so he will continue to enchant us, and occasionally to set our teeth on edge, which is another a way of seducing us.

—Françoise Gilot

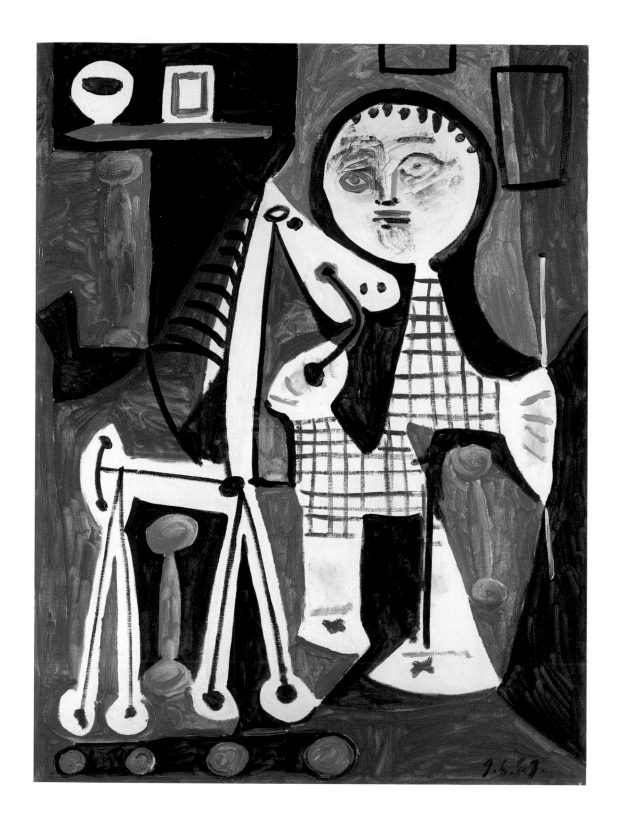

Pablo Picasso

Child with Horse on Wheels

June 9, 1949. Oil on canvas,
51 1/4 x 37 3/4 inches.

© 1998 Estate of Pablo Picasso/Artists Rights
Society (ARS), New York.

One morning in February 1996 Charlie Rose came with his television team to my studio in New York to interview me. During breaks in our discussion, a friend of his, whom I had not identified as yet, kept interfering with the interview by asking me questions. I thought he was a member of Charlie's team. I was astonished when, at the end of the session, he asked me if I wanted to see a painting by Pablo Picasso that he had purchased that very morning. As I acquiesced, he placed a call on his cellular phone. A young man came in carrying a large painting, and soon I was confronting a portrait of my son Claude at the age of two. As I stood looking at Claude's effigy, Mr. Steve Wynn was introduced. Soon I learned that he had become a passionate collector of modern art. Not liking the dark wooden frame, Mr. Wynn asked me to have it replaced by another, more typical of the frames that I use myself. Then he left my son's portrait in my hands for a few weeks. So began the friendship between Mr. Wynn and myself. And with it has come the opportunity of remembering the circumstances surrounding the creation of the picture of Claude.

At the time of my daughter Paloma's birth, on April 19, 1949, Claude, who is Picasso's second son and my first, was almost two years old. When I came back from the clinic holding the new baby in my arms, Claude summarized his discontent in the following manner: "Mamma went to a bad hotel and she came back with a little sister who is much too white. I wanted a red one!"

Everyone laughed, but the little king sulked and brooded as if dethroned. Picasso was probably reminded of his own anxieties at the birth of his younger sister Lola, and was thereby inclined to empathize with his young son's displeasure. Thus he focused his creative powers on making a portrait of Claude, to soothe the traumatized ego of his son!

The portrait, *Child with Horse on Wheels,* is dated June 9, 1949. It is very ideographic; though the layout is spontaneous it is very sophisticated and elaborate in its conception. In the painting we find no imitation of nature; rather, a fine sense of humor guides the ordonnance of the icon. First of all, at that time Claude didn't possess a hobbyhorse. In Spain social power is symbolized by the horse and by its rider, the *caballero.* It also refers to me, Claude's mother, since I was known to be a

talented horsewoman, interested in jumping and dressage and so on. In this painting the calligraphic horse is there as an emblem of myself; it echoes my pleasure at the birth of a daughter. But the moonlike face of the child is wistful, almost sad, even though he holds the bridle of the horse in one hand and a stick in the other. The scene is set indoors, in Picasso's bedroom. The black, red, and blue space behind the figure evokes not the room's actual colors—it was white—but rather the parsimonious light entering through dormer windows. In the background to the left, the brown wooden columns of a writing desk support a square alarm clock and a cup. The cup seems full of ink, ready to be used for drawing. In contrast, the face of the clock is without hands, thus placing the viewer in an anxious timelessness. Two frames visible at the upper right side of the canvas remain virtual; they do not reveal their content. The child is presented frontally. He seems to step forward while his eyes remain directed to the left, as if looking toward a lost paradise. In sharp contrast to the frontal view of the child the hobbyhorse is displayed in profile, and with its head nestling close to the head of the child, as if it were full of positive purpose. Its silhouette is quite schematic, if also ironic and inventive. The nicely finished green wheels that increase in size from left to right form a clear sign of progress toward the future. Traditionally the left side in a painting is the spiritual side, dedicated to dreams and to the past, while the right side is the field of action, dedicated to what will be.

So, the picture masterfully expresses the ambivalence of the child. He is surrounded by red, his favorite color, but it remains slightly out of reach, and the darkness of the unknown is adjacent to him almost on all sides. This gives the picture, which at first seems lighthearted, incredible psychological depth. Fortunately, as soon as we went back to Vallauris for the summer, Claude recovered his usual joy in life. And he soon realized that his young sister Paloma, even if she was "too white," far from threatening his kingdom, enriched it with her beatific personality, and that in time she would become a playmate.

There were many other paintings depicting one of us, or two, and even the three of us. But since it was Picasso's intention to paint a picture, not a portrait in the conventional sense, the titles always remained

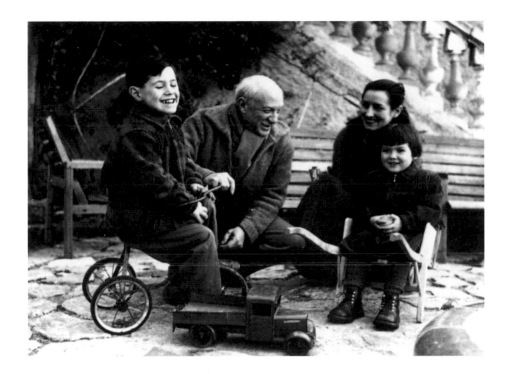

Picasso and Françoise Gilot with their children, Claude and Paloma, La Galloise, Vallauris, 1953.

Photograph by Edward Quinn. Musée Picasso, Paris, Picasso Archives. © Réunion des Musées Nationaux, Paris.

generic, such as *Woman Seated* or *Child with Horse on Wheels*. He did not want to create for the viewer a link to his family around him. And yet when Steve Wynn showed me the present canvas of 1949, I could not prevent myself from exclaiming: "Oh, it is Claude!" It was as if Claude had actually entered the room with his moonlike face, once again an appealing two year old!

—Françoise Gilot

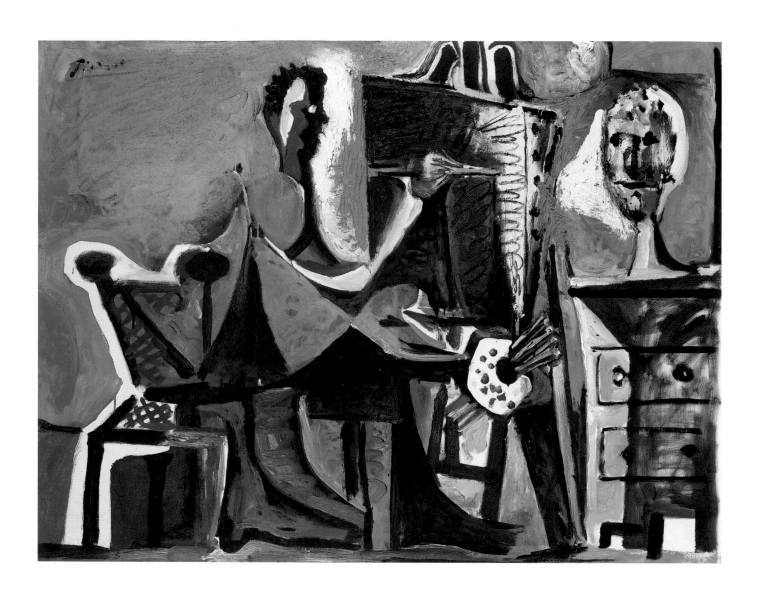

Pablo Picasso

The Painter in His Studio

1963. Oil on canvas, 35 x 45 5/8 inches.

The subject of "the painter in his studio" is not unique to Pablo
Picasso. The same theme, with and without an artist's model present,
has interested artists as diverse as Francisco Goya, Gustave Courbet,
Paul Gauguin, Vincent van Gogh, and Henri Matisse—to name but a
few! Pablo Picasso first broached the theme in his etchings and graphic
works of the late 1920s and early 1930s. In these works, he often de-
picted himself as a sculptor rather than as a painter, and the visual
metaphor establishes the primacy of form as his chief concern. Over
the years the introspection afforded by the subject became more and
more a central creative concern. Soon it began to pervade his oils, as
well. Picasso began *The Painter in His Studio* on February 22, 1963, and
completed it seven months later, on September 17. Although the artist
was by then eighty-one years old, the painting displays a youthful zest,
freedom, and verve. It shows Picasso's incredible love of life. It may be
one of the finest achievements of its kind.

Why should this be? The well-rehearsed and unsurprising theme
might easily result in routine answers and ennui, or lead to the addi-
tion of unnecessary anecdotal or redundant detail. Here there is no
such thing. With joy, the artist engages the subject as if for the very
first time. What gusto there is in the impasto! What boldness in the
color scheme! What elliptical rendering of the seated figure, and shock
in the unusual proportions of the body! And what imagination there is
in the way each part relates to the whole. If the paintings of Picasso do
not always give us pleasure, the Bellagio Gallery's *Painter in His Studio*,
with its great whimsy, certainly does.

It surely doesn't lack a sense of humor. Looking at the canvas from
left to right, as in reading a letter, one notes that the chair at the ex-
treme left, although rendered schematically, is curiously endowed with
an aggressive diagonal that makes it resemble the muzzle of a beast in-
tent on grabbing the painter from behind. The threat doesn't disturb
the artist in the least. With his pyramid-like shape, he resists attack
from any direction, so purposeful is his creative quest. The upper part
of his torso is small and partly cast in shadow. The painting hand looks
rather like a bird's head. The other hand is lyrical and imprecise, and
its baroque form links the painter's body to the palette. The gathered

brushes focus attention on the palette, which seems to advance toward the beholder in the shape of a horseshoe and is made pretty by the bright dots of color. The most disproportionate and unexpected features of the figure are the huge boots that serve as the base of the pyramid. Their exaggerated dimensions make the relatively small silhouette of the seated figure truly monumental. And, as in some of Picasso's figures from his Blue Period, the outsized quality of the boots tends to stabilize the whole lower part of the composition.

The artist is looking at a large bust. It is either a sculpture of himself—or of the sculptor who is his alter ego, wearing an ironic grin on his face. Sitting majestically erect atop a chest of drawers to the right, the bust, with its sarcastic presence, appears to defy the artist. Only the gigantic magic boots (probably summoned from a fairy tale) will enable the painter to triumph over the representation of his alter-ego as sculptor-sculpture.

And indeed triumph he does. From the sheer darkness of the painting in progress within the picture, there emerges white light and a bright red color. Red is always the first color one sees, after black and white. According to Picasso's theory, it is the first to appear and may eventually replace the essential black. (In alchemy, it is perhaps worth noting, the three states of matter run from black, to red, and then finally to the transcendence of white.) Also, there are graphic signs inscribed in the red and white zones of the painting in progress. They suggest angelic wings, but wings rising from below rather than descending from above! One might even interpret them as seraphic, red angels with only faces and four wings. Whatever meaning we give to the battle of black, red, and white that takes place on the canvas within a canvas, the conflict is exciting. It is even more thrilling to view the entire scene and discover the vibrant green in the background. This viridian green both aggressively contrasts with and beautifully complements the vermilion red it surrounds.

In traditional art the background, or negative space, is passive. Like water, it allows the whole composition to radiate outward beyond the confines of the picture itself. Here it serves much the same traditional purpose, and more than that. Because of the lush impasto and the in-

tensity of the emerald tone, it becomes active—even hyperactive—turning inward and conquering the other shapes and colors. This green, with its evocations of nature and the countryside, implies that the modern artist believes his studio contains all of nature. Unlike the Impressionist, who planted his easel out-of-doors, the nature that the modern artist wants to investigate and decipher is mainly his own. Thus tension is brought to the highest pitch. Back and forth, back and forth, the eye of the beholder alternates between the push and pull of positive and negative space—between small and large, constraint and freedom. In the end, however, the eye must return to the hand holding the brush. It is after all the hand suspended immobile in time and space, the origin of all the fantastic turmoil. Thus the hand dominates the very chaos it depicts and, ultimately, bestows it with significance.

—Françoise Gilot

Pablo Picasso

Pierrot

1917. Brush and black ink
on paper laid down on board,
24 x 19 1/4 inches.

© 1998 Estate of Pablo Picasso/Artists
Rights Society (ARS), New York.

Head of a Man
page 142

Bust of a Man
page 144

Always a lover of costumes and every other kind of masking, Pablo Picasso never stopped dressing up his sitters and himself in the broadest repertory of historical and theatrical guises. Already as a teenager he could paint a self-portrait as if he were one of Goya's royal sitters, complete with powdered wig; and we have learned, too, that he often presented himself in the persona of Harlequin, one of the characters from the *commedia dell'arte.* In this masquerade, he could turn up as a denizen of a Paris café, as a nomadic circus performer, as a Cubist figure of playing-card flatness, or even as his own son wearing a child's Harlequin costume. This lifelong passion for the masked fictional identities of the stage was particularly heated in 1917, when he joined forces with Serge Diaghilev's glamorous Ballets Russes in order to work on sets and costumes for the avant-garde spectacle, *Parade,* the brainchild of Jean Cocteau. This new affiliation led him to Rome, where he met Igor Stravinsky and the dancer and choreographer Leonid Massine. And while in Italy, with visits to Naples and Pompeii, he was able not only to refresh his memory of antiquity and old-master painting but also to attend popular performances of the *commedia dell'arte* whose characters would later figure once more in his collaboration with Stravinsky on the ballet *Pulcinella* (1919-20).

This powerful ink drawing of 1917, executed after Picasso returned from Italy to his home in Montrouge, outside Paris, depicts a man wearing a Pierrot costume. It reflects the world the artist had just seen, in which traditional stage characters and traditional styles of painting and drawing had far more of a living presence than in the modern city of Paris. After the splintering, often-illegible language of Cubism, the conventional illusions here of volume, shadows, and a specific sitter may be startling. But as usual, Picasso, famous for his chameleon ability to shift styles quickly, is adapting to earlier, pre-Cubist practices while, at the same time, treating them in a post-Cubist way. Despite the immediate effect of what is too easily referred to as realism, the abstract life of Picasso's animated webs of brushed ink begins to take over. Looking backward, the restless ground behind the figure may recall the aureoles of energy that seem to burst from many of Vincent van Gogh's portraits; whereas looking forward, this endlessly animated tangle of

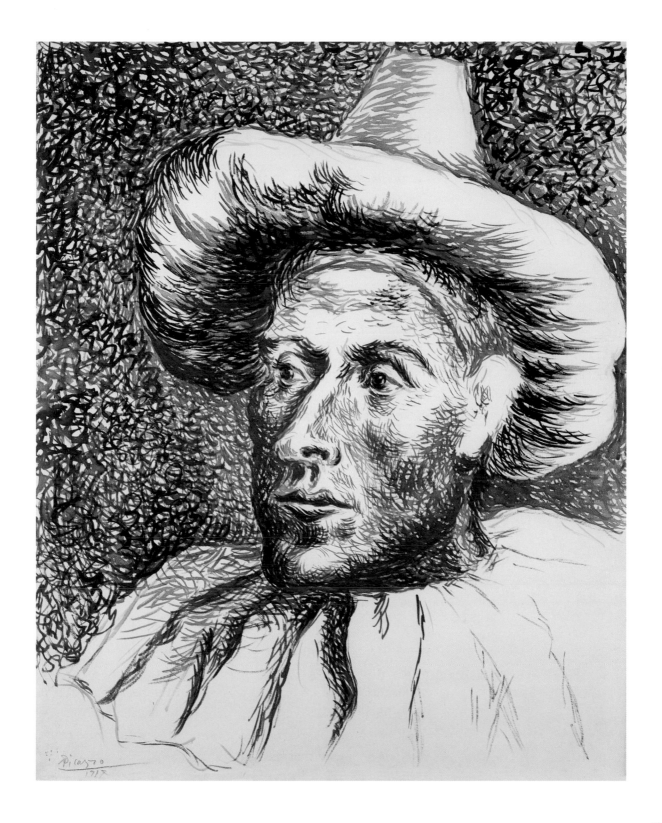

Pablo Picasso, *Pierrot with a Mask
(Pierrot au loup),* 1918. Silverpoint,
14 9/16 x 10 1/4 inches.

Location unknown.© 1998 Estate of Pablo Picasso/
Artists Rights Society (ARS), New York.

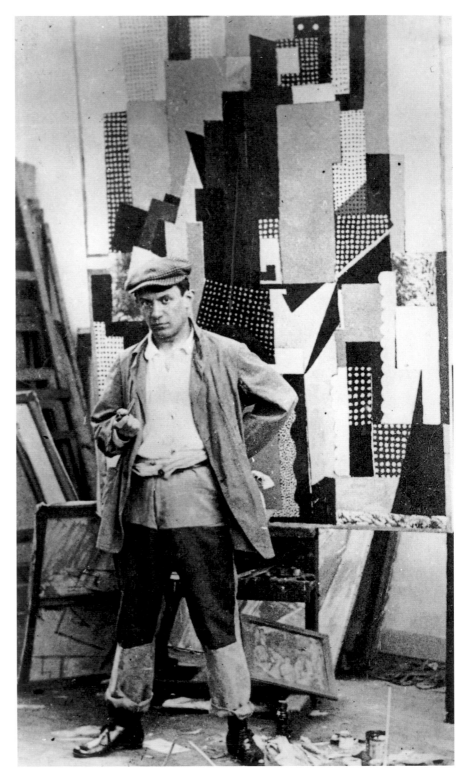

Picasso in his rue Schoelcher studio,
1915-1916.

Photograph: Archives Museé Picasso, Paris.
© 1998 Réunion des Musées Nationaux, Paris.
© 1998 Estate of Pablo Picasso/Artists Rights
Society (ARS), New York.

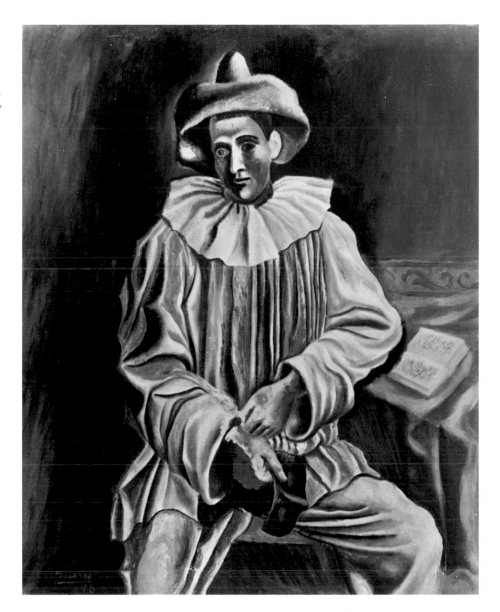

rounded and scribbled patterns almost prophesies the luminous densities of Jackson Pollock's signature style. In this jungle of brushstrokes, the presumed solidity of the figure is threatened, with both the brim of the Pierrot hat and the sitter's cheeks and chin seeming to take fire. What at first looks as firm as stone may well be combustible, once the flickering agitation of Picasso's pen strokes takes over. Later, in a silverpoint drawing of 1918, he would depict a similar Pierrot, but, with a

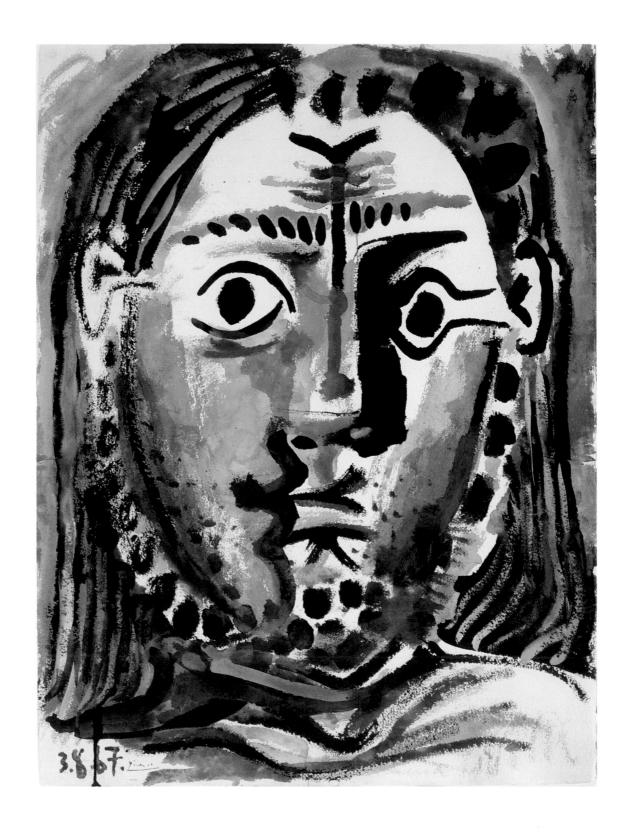

142

Head of a Man

August 3, 1967. Gouache on paper, 29 1/2 x 22 1/4 inches.

© 1998 Estate of Pablo Picasso/Artists Rights Society (ARS), New York.

characteristic switch that focuses on one abstract language after another, he substituted pure, untextured, and unshadowed outline for this totally opposite effect of vibrant light and shadow. And in a closely related oil painting of 1918, in which Pierrot's mask has also been moved from eyes to hand—the better to unveil the real person beneath the costumed character—the traditional modeling techniques of oil painting are revived. But, in each of these works, the ostensible revival of a realist language is presented in what could be called "quotation marks," the equivalent of the paraphrases of eighteenth-century music that Stravinsky sprinkled throughout the score of *Pulcinella.*

As usual with Picasso, generalized types and particularized people merge in shifting proportions; and here it has been suggested that the features are those of Massine, who had done the choreography for *Parade.*[1] Such precise identification, however, is often elusive in Picasso's portraits, especially when ideal or theatrical types are involved. It is clear, though, that the costumed Pierrot here is pitted against an off-stage view of a sitter whose specific features are marked by an unexpected mood of tension and melancholy that adds yet another layer of disquiet to what at first appears to be so simple and so conventional a drawing.

It is a mood that is often resurrected in Picasso's last years, when the artist confronted his own mortality with changing mixtures of close-up psychological confrontations and a huge wardrobe of historical dress. Like the 1917 *Pierrot,* the gouache *Head of a Man,* of August 3, 1967, despite its small dimensions, projects an unusual intensity of feeling. The two radiant, staring eyes of surprisingly different shapes immediately command our attention and empathy, forcing us to share this mirrorlike gaze of worried introspection. This emotional penetration, in which the sitter's eyes seem to move, left to right, from a wide-open fear to a deeper level of anxiety, is countered by our awareness that the figure is, in some way, disguised as a historical personage. The long hair and the glimpse of clothing that suggests the swagger of a cloak, together with the stylized, rounded stubble of a beard that frames both cheeks and chin, evoke the picturesque attributes of the kind of costumed performer, a musketeer, who, beginning in 1966, will become

143

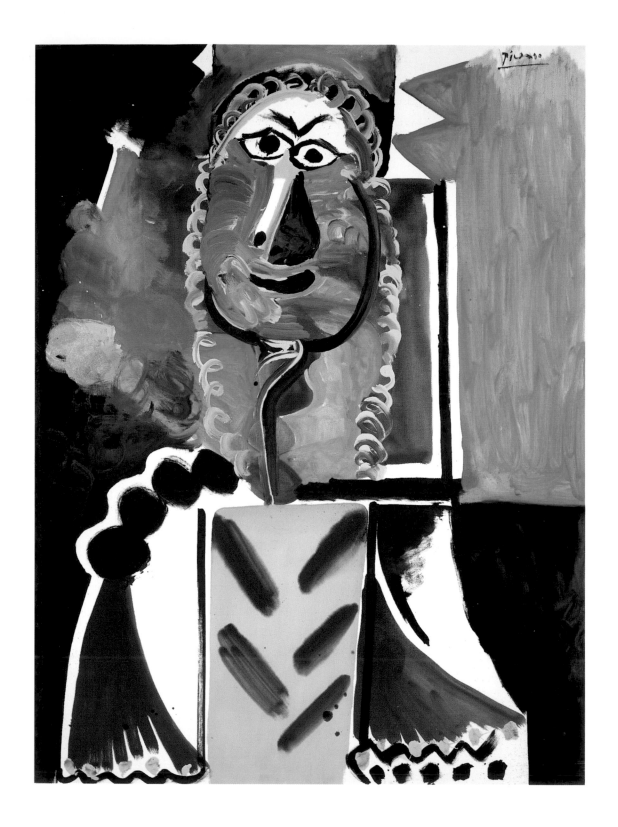

Bust of a Man

September 10, 1969 II.
Oil on canvas, 51 1/8 x 38 inches.

© 1998 Estate of Pablo Picasso/Artists Rights
Society (ARS), New York.

ever more familiar.[2] Yet this actor is clearly seen off the set of theater or history, and we are obliged to confront the man beneath the mask, someone as vulnerable as the artist himself as he approaches his eighty-sixth birthday.

The rapid, almost slapdash application of brushwork here, defining the broadest patterns of light and shadow and the essential structure of the head (with an incisive vertical for the axis that runs straight down from the forehead to the end of the nose) is an earmark of Picasso's late style. To some eyes, this frenetic execution has simply looked sloppy; but a more sympathetic view which has emerged in recent decades would have it that his swiftness of execution is a poignant corollary of the artist's sense that time is running out, of a growing desperation to record every last fleeting image and emotion. This is emphatically the case in the painting *Bust of a Man,* of September 10, 1969, a large canvas that looks as if it might have been painted in minutes rather than hours. Of less psychological force than the gouache of 1967, it offers a richer display of historical costume, a swift evocation of some official character from a seventeenth-century portrait or drama. The long, curling hair of the wig that falls to the shoulders seems to have been executed with only one or two spiraling twists of the master's brush, almost parodying the skills of a Velázquez, just as the hands, with their stubby little nails that rhyme with the braid pattern on the sleeve, seem to emerge from a few speedy ups and downs of the paintbrush. And a pipe that may once may have been attached to a hand that was quickly effaced by a new layer of paint produces clouds of smoke whose disappearing squiggles of white and gray paint contribute to this mock language of old-master virtuosity.

Yet behind these baroque flourishes, there are firmer, almost geometric patterns that surprisingly recall the tectonic language of Picasso's own Cubist figures, then half a century old. The tilted stacking of the two rectangles framed in black (one a chair back, the other a doublet whose distribution of red stripes on a yellow ground becomes an emblem of the Spanish national colors), not to mention the sawtooth silhouettes that clamp the head into place (reminiscent of the diamond

patterns of a Harlequin costume), evoke the memory of such Cubist figural constructions as the *Harlequin* of 1915. André Malraux once referred to this series of Picasso figures as "tarots," and indeed, this one in particular has a playing-card flatness beneath the surface of painterly bravura, transforming the whole into a cartoonlike image of a demented monarch with furrowed brow, cockily seated on his throne. In the blink of an eye, Picasso's genius can conjure up a wide swath of history, including even the aged artist's nostalgic flashback to the Cubism of his youth.

—Robert Rosenblum

Pablo Picasso, *Harlequin,* 1915. Oil on canvas, 72 1/4 x 41 3/8 inches.

The Museum of Modern Art, New York. Acquired through the Lillie P. Bliss Bequest. Photograph © 1998 The Museum of Modern Art, New York. © 1998 Estate of Pablo Picasso/Artists Rights Society (ARS), New York.

1. There are many other variations of this Pierrot figure, using multiple drawing styles. See *Picasso's Paintings, Watercolors, Drawings and Sculpture; A Comprehensive Illustrated Catalogue 1885-1973; From Cubism to Neoclassicism, 1917-1919 (The Picasso Project)* (San Francisco: Alan Wofsky Fine Arts, 1995), nos. 18-024 to 18-034.

2. This identification is suggested in the entry for the drawing (lot 4) in the sales catalogue: Christie's, New York, May 14, 1997, Part I. Picasso later made a literal portrait of Massine (illustrated in *Picasso's Paintings, Watercolors, Drawings and Sculpture*, no. 19-220), which reveals many apparent physiognomic differences from this portrait, especially the profile of the nose.

Fernand Léger

Constructors with Tree

Page 148

Few artists of the twentieth century have responded so directly to the impact of the two world wars, or generally to the radical changes in the modern age, than Fernand Léger. He fought in the fiercest battles of World War I, and his experiences in the trenches transformed his art. Immediately after the war, he produced one of his most monumental works, *La Partie de cartes* (*The Card Game,* Otterlo). Its theme, soldiers who bond over cards in the face of extreme adversity and danger, bears indirectly upon the Bellagio Gallery's *Constructors with Tree* of 1950, whose workers seem united in their optimism for the future.

In the 1920s Léger responded in formal terms to the increasing industrialization and extraordinary urban growth of the postwar era. His works gained a certain *gravitas,* and his figures and objects alike began to resemble one another. The figures became, in the words of the poet Michel Leiris, "lourds comme les viscères" (as weighty as bodily organs) and began to resemble machines. At the same time, the mechanical elements in his paintings—all of them purely his own pictorial inventions—began to appear alive and animated. This cross-fertilization was very much a part of Léger's consciously and clearly articulated aesthetic program: to cancel all hierarchical order among mankind, nature, and the world of objects. The human figure was stripped of any sentimental value and granted the status of an object, a fear of sentimentality that became manifest in a delicate commitment to the human figure, but a figure that remained "voluntarily inexpressive." This denial of any special human value runs like a unifying thread through Léger's entire oeuvre. It echoes some of the aesthetic tenets of his predecessors (Paul Cézanne, in particular) and inspired certain principles of his successors in the New York School (Barnett Newman, especially), all of whom responded to the rallying cry: "Down with sentimentality!"

If density, mass, and mechanical weight defined his art throughout the 1920s, things changed markedly after the early 1930s. Léger visited the United States more frequently than any other European artist of his generation, and, as I have argued elsewhere, his prolonged stays in this country radically changed his work. He came to the United States on four occasions. His first visit was in 1931, and he returned in 1935 for his first solo show, at the Museum of Modern Art, New York. He

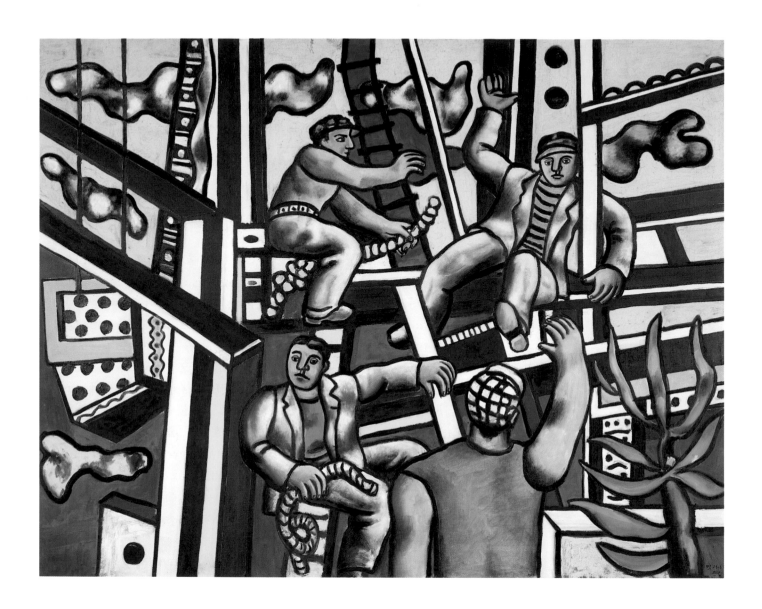

148

Constructors with Tree

1950. Oil on canvas,
42 1/2 x 54 1/4 inches.
© 1998 Artists Rights Society (ARS),
New York/ADAGP, Paris.

visited again in 1938-39 and lived in New York from 1940 to 1945. America offered Léger a living embodiment of the pictorial construction he had articulated during the 1920s—except that its skyscrapers contradicted the law of gravity that had been so much a concern of his earlier aesthetic. It is somewhat paradoxical, however, given Léger's fascination with capitalist achievements in the New World, that he espoused communism. Not only did he become an active member of the French Communist party, but he wired his membership fee to the Party from New York—the cradle of capitalism—shortly before his final return to Europe.

In *Constructors with Tree,* as in most of Léger's later works, ideology on one hand, and more strictly formal concerns on the other, are wedded to one another with more than a little tension, and even some contradiction. During his stay in the United States, Léger's art became less rigorously geometric, allowing room for more free-floating and organic forms, and it manifested new qualities of verticality, airiness, and weightlessness. A perfect illustration of these qualities may be seen in his Divers series, a group of works in which the simple organic forms of divers float in pure chromatic space—a space, that is, established by color. Léger continued to nurture his new "valeurs plastiques" (plastic values) in the decades that followed, as can readily be seen in the present work.

Léger's Constructors series, which consists of numerous paintings, gouaches, and drawings, is one of the most important ensembles of work of this French artist's entire career. Yet it is arguable that it could not have been conceived without his American experience. For even though Léger was immediately inspired to begin the series when in 1950, as he was driving along a highway near Chevreuse, France, he noticed workers building an electric pylon, the poetic imagination that shaped paintings such as *Constructors with Tree* owed a great deal to the artist's earlier experience. In 1931, when he first gazed upon the prospect of skyscrapers under construction in New York City, he was beguiled:

The most colossal spectacle in the world. Neither cinema nor photography, nor even documentary have managed to trivialize

this surprising phenomenon: New York…. This city has stood against all the vulgarizations, against all these inquisitive people who have endeavored to describe her or to give an image of her. She has retained all of her fresh, unexpected surprise for the traveler who sets his gaze upon her for the first time.[1]

Léger warns us, however (and by the same token himself), that New York cannot be copied; no one can give a proper image of its colossal spectacle, of its unexpected surprise. In truth, the building under construction here is not to be read as a New York building; no particular setting is identifiable in the present work. It could be an American building, or it could just as well be a postwar reconstruction of a European building, or even an electric pylon. The fact is, it doesn't matter where it is. Léger does not tell us the precise location because he does not want to. Set against a void made of pure color, resting with all of their weight upon the girded structure which they have produced and which appears to make them weightless, his four *constructeurs* give us a sense of vertigo.

The dizziness derives not only from their immense height—they are far above both the ground and the tree (visible in the lower right

Fernand Léger (1881-1955) in his studio, circa 1945-48.

© Collection Roger-Viollet, Paris.

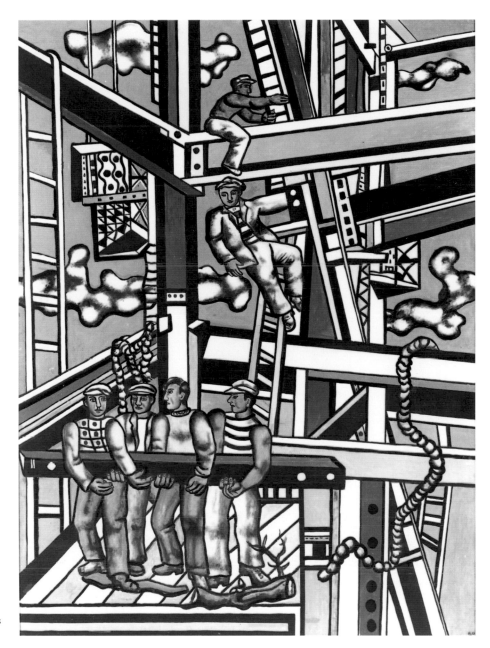

Fernand Léger, *Les Constructeurs, état définitif (Construction workers, final state),* 1950. Oil on canvas, 118 1/8 x 89 7/8 inches.

corner)—but also from the fact that they are standing and sitting nowhere. No horizon can be seen, and no landmark, other than a few indeterminate clouds floating among the intervals of the structure. Two background colors set each other off: blue and yellow. They represent a contest between nature and artificiality. The yellow, it must be noted,

rests above the blue; man's sky is set above God's sky. In a sense, the work may be viewed as a reenactment of the story of the Tower of Babel. The structure being erected by the men extends beyond the edges of the canvas on the right, left, and above, as indicated by the lines of the girders. It has no end. Who then are these *constructeurs?* Their facial features all resemble one another. They are no one in particular, because they are everyone in general. They are neither French, American, or Russian. They are universals, the "workers of the world" evoked in Karl Marx's *Communist Manifesto,* a work that Léger, like all Party members, most certainly knew well.

These *constructeurs,* therefore, share not only similar faces but similar fates. They also share pride in their new *capus operis,* or masterpiece, a work whose endless architectural units are epitomized by the architecture of New York. There is little doubt that the notion of these gigantic architectural units would greatly impress an artist who, beginning in the 1920s, maintained a close friendship with one of the inventors of modern architecture, Le Corbusier, and who throughout his career viewed art and architecture as intimately bound together in a social and ideological program in which color plays an integral role. He once said: "Color is a natural need, just like water and fire," and explained that the idea of color in architecture came to him shortly after the great war:

> The idea of multi-colored cities had come to my mind after WWI, once I was off-duty. I had met Trotsky in Montparnasse. He had been completely taken with the idea, and was even considering the possibility of a multi-colored Moscow. Indeed, if you consider the whole of a city, or of a street, or a house, in relation to an outside coloring program, vast possibilities immediately open up. The cold ground of a building, for instance, becomes much lighter if color is thrown in. Even the volume of a building can be transformed. Gloomy and sinister suburbs can thus turn into a gay and luminous district.[2]

Given that Léger closely identified himself with construction workers and that *Constructors with Tree* heralds the heroic roles of these

"builders of the twentieth century," the painting may be read as a touching homage to the modern idea of a utopia. Léger's work is, in every sense, utopian. Indeed, the original Greek word, *u-topia,* indicates the absence of space. By extension a utopia exists nowhere. By refusing to locate the structure in his Constructors series anywhere in particular, Léger literally creates a utopia that embodies all the fragility, contradiction, and naïveté of all utopias. This is especially true of the particular utopia that nurtures Léger's own art, that of an unachievable socialism.

—Joachim Pissarro

1. Fernand Léger, "New York, New York" (1931), in *Fonctions de la peinture* (Paris, 1965), pp. 186-93.

2. Fernand Léger, "Un Nouvelle Espace en architecture" (1949), in ibid., pp. 123-25.

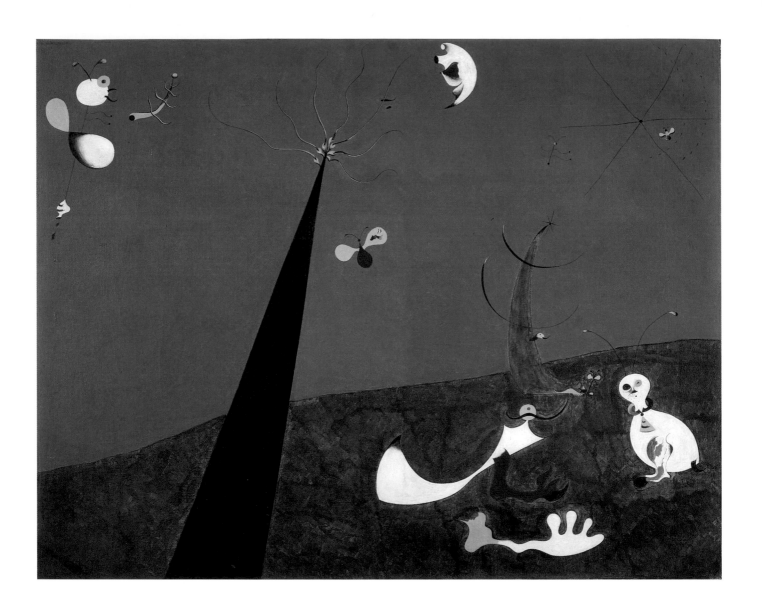

Joan Miró

Dialogue of Insects

1924-1925. Oil on canvas,
29 1/8 x 36 5/8 inches.

© 1998 Artists Rights Society (ARS),
New York/ADAGP, Paris.

Very early in his artistic career Joan Miró displayed a strong predilection for the humble objects and small creatures that populated the rustic world of his family's Catalan farm, near the village of Montroig. In paintings and letters he focused on the grasses, flowers, stones, insects, and birds of the countryside, rather than the large and imposing scenes that artists are more often drawn to. In 1918, at the age of twenty-five, he wrote:

Joy at learning to understand a tiny blade of grass in a landscape. Why belittle it?—a blade of grass is as enchanting as a tree or a mountain.—Apart from the primitives and the Japanese, almost everyone overlooks this which is divine.—Everyone looks for and paints only the great masses of trees, or mountains, without hearing the music of blades of grass and little flowers and without noticing the tiny pebbles in a ravine—enchanting.[1]

Miró's view of nature was paradoxical and egalitarian. His rejection of conventional hierarchies and his unique perception of the world around him would be the source of the humor and fantasy that developed in the paintings of his maturity. Despite the radical transformation in Miró's style that took place upon his encounter with the Surrealists in Paris, the artist remained unswervingly faithful to the earth, to the reality of the rustic Catalan countryside. *Dialogue of Insects* is a testament to his unfaltering devotion to the world of nature that originally inspired him.

The dramatic transformation in Miró's style that occurred in 1923 and 1924, the period immediately preceding the completion of *Dialogue of Insects,* was as sudden as it was clear, as dramatic as it was logical. It happened at the end of a brief period of gestation during which he was nourished by all the current artistic and literary revolutions that followed one another in Europe. Prior to his first exhibition in Paris, Miró had encountered and assimilated Fauvism, Cubism, the abstract art that came from the northern countries, and, above all, the nihilism of Dada, particularly as it was practiced by artists such as Francis Picabia, Marcel Duchamp, and the poet Tristan Tzara. His meeting and

Portrait of Joan Miró (1893-1983) by Man Ray.

subsequent warm friendships with Pablo Picasso and with André Masson, whose studio was in the same building in Paris as Miró's, proved to be decisive.

Masson's studio, at 45, rue Blomet on the Left Bank of the Seine, became the meeting place for avant-garde poets and painters. Miró absorbed the poetry—and poetry is the essential lever for the work of an artist who proposes "to go beyond painting," to explore new territories. He became friends with the intellectuals who formed a group around the author André Breton, whose *Manifesto of Surrealism* was published in 1924. The Surrealist poets often dedicated their texts to Miró, and in return he illustrated their books of poems. These friendships and heartfelt exchanges lasted throughout the rest of their lives.

Although a quiet man not given to rhetorical posturing, Miró actively participated with the Surrealists. Two of his best-known paintings were included in the group's first exhibition, *The Surrealist Painters*, which was held in 1925 at the Galerie Pierre: *Carnival of Harlequin*, which is now in the Albright-Knox Art Gallery in Buffalo, New York; and the Bellagio Gallery's *Dialogue of Insects*.

Despite its element of the fantastic, *Dialogue of Insects* is fundamentally a rustic landscape. It is a scene with several figures, none of which is dominant; no single figure occupies a central role and each is distinct

Joan Miró, Preparatory drawing for *Dialogue of Insects,* 1924-1925. Pencil on paper, 6 1/2 x 7 1/2 inches.

and apart from the others. The dimensions of the protagonists, as well as the metamorphosis that has taken place in their appearance, deny logic and reason. The background is divided between an ultramarine blue sky, which is painted uniformly dense and smooth, and an ocher brown ground, which is mottled, revealing the marks of the paint brush and thus the presence of the artist's hand.

Two entities of the vegetable kingdom extend across the horizon, their sizes inverted proportionally in relation to their importance in reality. On one side an immense black stalk of wheat surges upward from below the bottom of the canvas, its ear of grain almost touching the top. On the other side is an unidentifiable green tree. With its thinly painted trunk, as insubstantial as a projected shadow, and with its simple arcs for branches, the tree becomes a sort of pure abstraction. One of the preparatory sketches for *Dialogue of Insects* reveals Miró's original conception of it. In the drawing the tree is adorned with a bouquet of branches, each crowned with

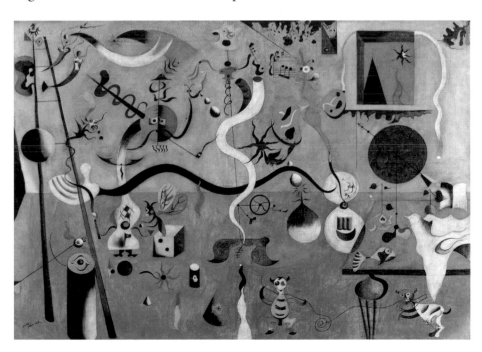

Joan Miró, *Carnival of Harlequin,* 1924-1925. Oil on canvas, 26 x 36 5/8 inches.

Joan Miró, *Dog Barking at the Moon,* 1926. Oil on canvas, 28 3/4 x 36 1/4 inches.

horned fruits. There a serpent coils itself around the bare trunk, whereas in the painted version we see only a portion of the snake emerging from a hole, its black forked tongue protruding from a yellow head attached to a red body.

Miró has organized and stylized the pictorial space in a simple, open design that showcases the humor and invention of the insects. The protagonists need only to make an appearance, to play their games on a stage which is of minuscule dimensions in relation to the world as it is perceived on a human scale. In the upper left corner of the sky Miró has depicted a flying machine that has been enigmatically reinvented as an insect coveting a wormlike creature. This strange insect-machine thinks only of the soft, flavorful insides of its next meal. The harmony in yellow and white of the design belies the pending violence of the capture and devourment. The form of this living mechanism, suspended in air, sums up and articulates the full syntax of Miró's inquiring imagination.

A butterfly, whose red body and yellow wings burst like a brilliant

flower in the center of the composition, hovers alone near the stalk of wheat. Servant to fatal repetition, it starts again toward the light of the white moon above. Projecting from the peculiarly heavy crescent moon, which is as substantial as a woman's body, are the erotically suggestive features of a pseudopodium, red breast, and pointed black tail. This same bright, animate moon is later found in Miró's well-known painting *Dog Barking at the Moon,* of 1926, and a good many other of his subsequent works.

In the upper right corner of the canvas, Miró nonjudgmentally renders the mortal dialogue between the spider and the fly. The fine lines of the web traverse the canvas like one of the thousands of Miró's schematic "stars" (ideogrammatic symbols typically constituted of four fine lines of irregular length that cross at their centers) that recur time and again in the skies of the artist's subsequent works. Here Miró's creatures are tiny in relation to other participants in the scene, their yellow accents just barely marked. The spider is so faintly drawn as to be nearly imperceptible against the deep blue sky. In his sketchbook,

Joan Miró, *Étude,* circa 1924. Pencil on paper, 7 1/2 x 6 1/2 inches.

Collection: Fundació Miró, Barcelona. © 1998 Artists Rights Society (ARS), New York/ADAGP, Paris.

however, Miró renders this imperceptible spider in five different drawings.

The three mostly white protagonists in the lower right of the painting boldly stand out against their murky alluvial backdrop. A larvalike form spreads it self out near the bottom of the canvas. As blind as a white-gloved hand and transformed at one end into a yellow flame, this biomorphic apparition defies explanation. It does not appear in the preparatory drawings, in contrast to the two figures who confront one another above it: a grasshopper and a cricket. These light and humorous characters have been transformed from the original characters we find on the sketchbook page. In the painting they grow in dimension, become more distinct one from the other, feature brightly colored details, and detach themselves from phenomenal appearance, suggesting origination in a dream. The cricket on the right is

Joan Miró, *The Hunter (Catalan Landscape)*, 1923-1924. Oil on canvas, 25 1/2 x 39 1/2 inches.

The Museum of Modern Art, New York. Purchase. Photograph © 1998 The Museum of Modern Art, New York. © 1998 Artists Rights Society (ARS), New York/ADAGP, Paris.

round and white as an egg. One of its eyes is red, the other yellow. It has a variegated leg and it wears a collar around its neck like a precious necklace. Two delicate antennas sprout from its head, the tip of each accented in yellow.

The cheerful humor of the bulbous cricket contrasts with the elastic motion of the grasshopper it faces, who is poised to leap away. In preparing to jump the grasshopper holds one red leg, which contrasts with its white body, in a menacing angle. The two insects skirt one another without taking notice. These figures that speak to us in the present recount the life of insects in the prehistoric past.

André Breton was hardly concerned with the little histories of the Catalan countryside illuminated by Miró. Although he was captivated by Miró's artistic liberation—his pictorial magic—Breton felt the artist lacked sound theoretical support for the course he was taking. Unafraid to state his opinion, the theorist Breton audaciously compared Miró to the most "poetic" insect, if not the most folkloric one, the cicada: "The cicada who works in the fields from midday with eyes big as saucers, accompanied only by his cruel song…this traveler all the more rushed for not knowing where he is going."[2]

There are no cicadas in the paintings of Miró, however, and if this

Joan Miró, *The Tilled Field (La Terre labourée),* 1923–24. Oil on canvas, 26 x 36 1/2 inches.

Solomon R. Guggenheim Museum, New York. Photograph: David Heald and Myles Arnowitz. © The Solomon R. Guggenheim Foundation, New York. (FN 72.2020). © 1998 Artists Rights Society (ARS), New York/ADAGP, Paris.

artist-traveler knew not where he was going, we know how far he would go. Miró brought to his designs a scrupulous treatment of details and the meticulousness of a miniaturist. The figures in *Dialogue of Insects* are carefully formed, stylized, intensified, and metamorphosed from familiar reality—at the elemental level of earth and sky. Carried away by these earthly and cosmic forces, Miró brought the eye and the unconscious together, transmuted into figures representing a fantastic universe, a world like few others. His invented creatures become signs in a unique and explicit pictorial language, signs that can be paired and combined with confounding agility. All the poetry—all the forms, colors, noise, and music—all the inventive audacity of Miró, are present in *Dialogue of Insects.*

—Jacques Dupin

1. Letter to J. F. Rafols, Montroig, August 11, 1918. Joan Miró, *Selected Writings and Interviews,* ed. Margit Rowell, trans. Patricia Mathews (Boston: G. K. Hall and Company, 1986), p. 57.

2. André Breton, *Le Surréalisme et la peinture* (New York, 1945), p. 69.

Alberto Giacometti

Man Pointing

1947. Bronze, height: 70 1/2 inches.

By 1937 Alberto Giacometti had evolved beyond the deliberately dreamlike and cryptic symbolism of his earlier Surrealist work and was devoting himself entirely to the creation of representational figures of nude women. He had anticipated that this work would be easy. On the contrary, he found that it was very nearly impossible. Working directly in plaster, he started with a figure about eighteen inches high, representing a nude woman with her arms at her sides. As he worked, he found to his amazement, and to his consternation, that the sculpture grew smaller and smaller. The smaller it grew the more troubled he became, yet he could not keep it from shrinking. The sculpture seemed to have determined in advance its appropriate size; it would accept no other and compelled the artist to comply. After months of work, the figure had shrunk to the size of a pin, standing in precarious isolation upon a pedestal several times its own height. These dimensions were intolerable to Giacometti, but the likeness he sought seemed somehow attached to the tiny size of the sculpture.

Bewildered, alarmed, he began again with a figure the same size as the first. Again it shrank, growing smaller and smaller despite his reluc-

Alberto Giacometti (1901-1966) in his studio, rue d'Alésia, Paris, 1946.

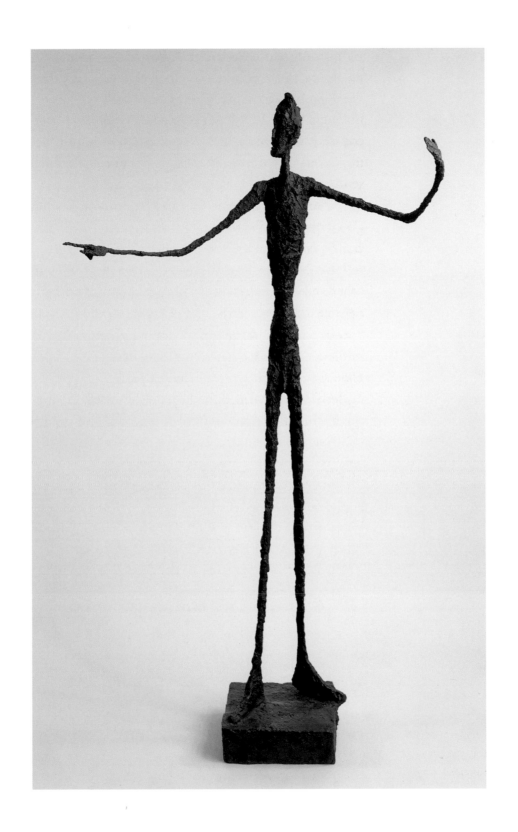

tance and distaste. Again he began, with the same result. Sometimes the figure grew so minuscule that a last touch of the sculptor's knife would send it crumbling into dust. He was working at the limit of being and on the frontier of non-being, confronted with the sudden passing of existence into non-existence, a transition that took place in his hands but over which he seemingly had no control.

Giacometti had long been obsessed by life's frailty. Now it presided over his work. In a very real sense, it *became* his work. "I have always had the impression or feeling," he said, "of the frailty of living beings, as if at any moment it took a fantastic energy for them to remain standing, always threatened by collapse. And it is in their very frailty that my sculptures are likenesses." It seems fitting that very, very few of the tiny figurines survived. Their impermanence was their importance.

Giacometti had wanted to renew his vision after the Surrealist experience, to see with original freshness what stood before him. He had not foreseen that the creations that embodied his vision would be symbols of regeneration. The sculptor's problem had become anthropological. Having determined to make a new beginning in his art by trying to work as if art did not exist, he made sculptures that evoke the origins of creativity, its mysteries and rites. These tiny works have something of the talisman about them, charged with anthropomorphic vitality and magical feeling. They ask to be seen as inhabitants both of actual space, the space of the knowable and living, and of metaphysical space, the space of the unknowable and the dead.

Giacometti's creative difficulty was to become the very substance of his eventual fulfillment. Truth in art and truth in life are not the same. But the two must unite in the creative act if it is to have significant consequences, which is to say that a work of art will be "true to life" when its existence, its very form, embodies the truths of the artist's life. A work of art may then serve the auxiliary purpose of revealing those truths. The artist himself, however, exists inside his truth: he can see what he is only by seeing what he does. What he does remains eternally potential rather than actual, so that he may truly become himself only by dying. No one, it seems, knew this better than Giacometti, and that knowledge must have been at the base of what led him, after nearly ten

years of labor on the tiny figurines, to strike out with renewed vigor and resolve toward his ultimate fulfillment.

The phenomenological experience with the tiny figurines brought Giacometti, in about 1946, to an advance in his perceptual awareness. Space is a basic element of the sculptor's material. He or she either adds to it or subtracts from it; it determines the fundamental aspect of all material existence throughout the universe. We see only as much of any object as our field of vision allows. Viewed objectively from a distance, a figure appears disproportionately thin in relation to the illusory habits of our visual experience. As a result of this singular thinness, the figure will also appear unusually tall. The metamorphosis from the frustratingly tiny figurines of the previous decade to a new liberation in the form of tall, thin figures came about as a consequence of such stylistic contemplation. Giacometti finally was able to break away from traditional sculptural conventions to find a means of expressing a profoundly personal vision of reality.

The first of these large sculptures seems to have been *Walking Man* of 1947, a life-size male figure who appears to be advancing tentatively forward—but does not stride emphatically as his descendants were to. This sculpture led directly to *Man Pointing,* executed the same year. It, too, is life-size but startlingly thin, causing the viewer's vision to encompass the entire work as an entity, not a sum of varied body parts.

Widely and rightly considered to be one of the half dozen indisputable masterpieces of Giacometti's career, the sculpture is unique in many respects. It is the only one in which a figure is meant to be seen engaged in an action other than walking. It is the only one in which the figure's arms are upraised in a specific and meaningful gesture. It is the only one that deliberately insists upon specific interpretation. It is

Alberto Giacometti in his studio, 1960.
© 1960 René Burri/Magnum Photos, Inc.

Alberto Giacometti, *Group of Two Men,* circa 1947-1951. Bronze and plaster, approximately 85 inches high (no longer extant).

Photograph: Éditions Cahiers d'Art. © 1998 Artists Rights Society (ARS), New York/ADAGP, Paris.

the only one which in its admittedly exceptional manner nonetheless invites comparison with the posture of sculptures familiar in the classical tradition. The man stands erect with self-assurance, his large feet set apart on a small base, right arm upraised and forefinger outstretched. The act of pointing is self-evident, but the title given the work by the sculptor in French, *L'Homme au doigt*—literally "man with finger"—is perhaps more meaningful. The head is held high and turned in the direction of the pointing finger, as if to obey its signal by gazing outward in expectation of some sign, event, or arrival.

Sometime between 1947 and 1951 Giacometti incorporated one of the bronze casts of *Man Pointing* (there are six in the edition) as part of a two-figure composition. The man's left arm, raised and bent at the elbow in a protective gesture, encircled the plaster figure of a slightly taller man. The artist, however, abandoned the two-figure arrangement. For legitimate psychic or aesthetic reasons he left the space empty, leaving *Man Pointing* standing eternally, though expectantly, alone. His bearing and signal summon no response save our own, which turns back upon itself to confront the mystery of man's origin and purpose.

In the world to which he enigmatically points with one hand, symbolizing the hopeless yearning of mankind to understand the puzzle of space, while shielding with his other hand a void, he stands naked with a nakedness unique in all of Giacometti's oeuvre, for he possesses an explicit penis. It must be said that the member adds little to the sculpture, but Alberto obviously felt that the sex of his *Man Pointing* was too important to be left to anybody's imagination, including—when we know of difficulties he encountered in consummation of the sexual act—his own.

As we scrutinize the bronze countenance, it begins to be seen that the sculpture resembles the sculptor. It is true that Giacometti's works often looked like him, while he came more and more to look like them, with his craggy, deeply furrowed face and high shock of hair. *Man Pointing,* however, looks more like Alberto than any of his other sculptures, and the resemblance can hardly avoid being regarded as deliberate. Consequently the symbolic content of this work seems to ask to be viewed as autobiographical. At the outset of this artist's great cre-

ative period he appears to be pointing precisely to something about himself. What may it be other than the problem of his own existence, the riddle of genius, and beyond this the enigma of art, humanity, and the infinite continuum of being? A masterpiece can do no less.

—James Lord

Alberto Giacometti setting up an exhibition, 1961.

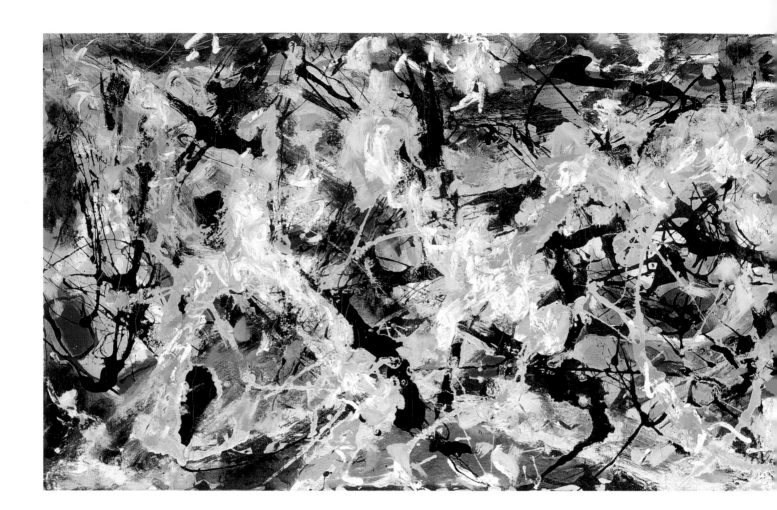

Jackson Pollock

At the time of his death, on August 11, 1956, at the age of forty-four, Jackson Pollock had already achieved mythical status as the most untamed as well as the most original artist since the early twentieth-century heyday of modernism. That he died, drunk, at the wheel of his own Oldsmobile convertible when it crashed on a bend in Fireplace Road on his way home to Springs, Long Island, expanded his myth into the pantheon of short-lived martyrs to art, a category whose chief saint was Vincent van Gogh. And it also meant that the work he produced in the few years before his death inevitably took on the character of the "late style," that is, work that appears to be more retrospective, exploring and synthesizing past achievements rather than opening

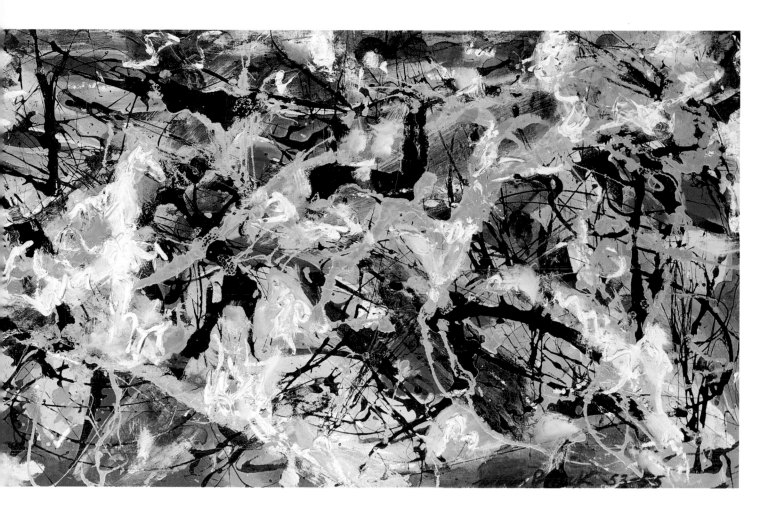

Frieze

1953-1955. Oil, enamel and aluminum paint on canvas, 26 1/8 x 85 7/8 inches.

youthful vistas. Had a terrible fate not taken his life in 1956, we might well have a somewhat different reading of what were to become his last paintings. Similarly, had another master of the New York School, Mark Rothko, not taken his own life in 1970, we might not be so easily tempted to read his dark and minimal canvases of 1968-69 as a kind of last will and testament.

Nevertheless, even if we impose the rhetoric of finality upon what may only by accident be an artist's last works, there is no doubt that between 1953 and 1955 (the dates inscribed with the artist's signature in the lower right-hand corner of *Frieze*), Pollock's work seemed to pause, to slow down, and to look backward. It has often been observed, for

Jackson Pollock (1912-1956) seated on the running board of his Model A Ford, East Hampton, 1952.

Pollock-Krasner House and Study Center, East Hampton, NY. © Estate of Hans Namuth.

example, that several of his very last paintings, such as *Scent* (ca. 1955), look like reprises of works from the 1940s, such as *Eyes in the Heat* (1946), painted just a year before Pollock invented his famous technique of pouring paint onto a canvas lying flat on the floor instead of propped on an easel or hung on the wall.[1] In the same way, *Frieze* recapitulates many of Pollock's earlier achievements.

Its title, in fact, was given to it, not by Pollock himself, but only after his death, on the occasion of its first public showing in *8 American Painters* at the Sidney Janis Gallery, New York (January 5-31, 1959). But even without the artist's approval, it describes quite accurately a format and an ambition that he had often confronted before. The dimensions of *Frieze*—26 x 86 inches—produce a relatively unfamiliar proportional scheme for an easel painting (here more than three times wider than its height) and immediately evoke the character of a long mural painting that obliges us to move our heads or bodies to follow the visual sequence. It should be remembered here that over a decade earlier, in 1943, Pollock had painted what was to remain his largest canvas, a decorative mural for the foyer of Peggy Guggenheim's Manhattan townhouse on East 61 Street. The uncommon size of this oil painting, 97 x 238 inches, forces one to follow it almost as a narrative from left to right (or the reverse), and its function as interior decoration almost makes literal the metaphoric phrase, "apocalyptic wallpaper," that, following its coinage by Harold Rosenberg in his rhetorical essay, "The American Action Painters" (1952),[2] had often been used, in praise or in blame, to describe Pollock's art. In fact, this duality is a constant mix in Pollock's work. On the one hand, his canvases, whether the paint is

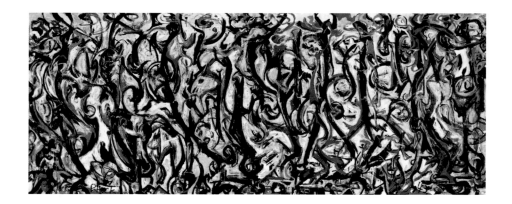

Jackson Pollock, *Mural*, 1943. Oil on canvas, 96 1/4 x 238 inches.

The University of Iowa Museum of Art, Gift of Peggy Guggenheim, 1959.6. © 1998 Pollock-Krasner Foundation/ Artists Rights Society (ARS), New York.

poured, flung, or applied with more traditional brushstrokes, may evoke an apocalyptic world of primal, chaotic energy that can recall anything from the book of Genesis to Hiroshima. On the other hand, such eruptions of unbridled passion are constantly tamed by patterns of rhythmic and chromatic order. The result is often an astonishing fusion of opposites, paintings that appear to burst out of their frames yet, at the same time, maintain the look of sumptuous decoration.

Frieze is the last of Pollock's paintings to provide quite literally this format and this look of "apocalyptic wallpaper," and, as such, it looks back not only to the major mural of 1943 but to many other paintings in the friezelike shape that he used frequently, especially in 1948-49,[3] and that at times, he could even extend to such extraordinary dimensions as 10 x 122 inches, which more closely resemble an unrolled Japanese scroll than a Western easel painting.[4] In the 1950s, the most spectacular example of this mural-like decoration is *Blue Poles* (1952),

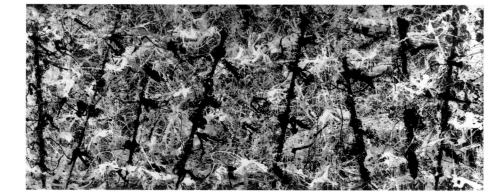

Jackson Pollock, *Blue Poles,* 1952. Oil, enamel and aluminum paint on canvas, 82 5/8 x 191 5/8 inches.

© Collection: National Gallery of Australia, Canberra. © 1998 Pollock-Krasner Foundation/Artists Rights Society (ARS), New York.

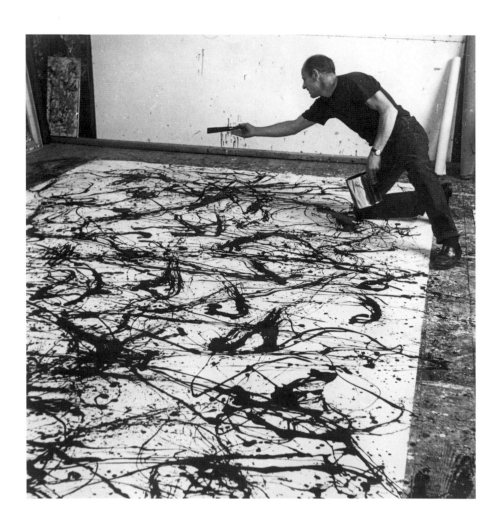

Jackson Pollock dripping paint on canvas, circa 1950.

Photograph © Rudolph Burckhardt.

whose dimensions, 6 x 16 feet, correspond comfortably to a large wall. And its structure now demonstrates more lucidly than ever Pollock's marriage of a *perpetuum mobile* of tangled labyrinths of paint with, in this case, the emphatic rhythmic beat of the eight "blue poles" that, like breakwaters in a rough sea, measure our whereabouts in a repeated, if storm-tossed, pattern.

It was in the following year, 1953, that Pollock began to work on *Frieze,* probably with occasional retouching until 1955, the closing date on the inscription. That Pollock would date a canvas over a three-year period is already a remarkable denial of the myth of spontaneity associated with his work, as it was, for instance, with that of Monet, who, like Pollock, often reworked his canvases in his studio after seizing a

first impression. *Frieze,* in fact, bears the look of cumulative painting sessions, with its dense layers of paint and its great variety of thick and thin. During the years bracketed by *Frieze,* Pollock's production slackened from ten paintings in 1953 to only five in the years 1954-55, a slowdown that resulted from growing depression and alcoholism. (No paintings at all were made in the year of his death, 1956.) *Frieze,* therefore, turns out to be a swan song to this format, which he had explored with such invention throughout his career; and it synthesizes many earlier ideas and techniques. For one thing, it mixes both poured and brushed paint, creating a pictorial maelstrom that seems at one point to congeal into clots of impasto pigment and, at another, to evaporate into delicate webs of spun pigment. And in a way that echoes the overt beats of the *Blue Poles* of 1952, the surface is articulated by emphatic patterns, in this case flamelike golden yellow accents flickering this way and that, but nevertheless giving us some anchors for the storm below, much as the lily pads in Monet's water-garden paintings may look like buoys in an open sea. And the colors, too, offer a surprisingly primary order, verging on red, yellow, and blue, hues that take on particularly luminous intensity when seen through the overlaying skeins of black and aluminum paint.

It is only an accident of fate, of course, that makes this Pollock's last painting in a long series of friezelike formats that fuse oceanic turbulence and decorative control in startlingly unfamiliar combinations. He might well have gone on for decades, but he didn't. As such, *Frieze* can now become a rearview mirror that reflects and brings to a conclusion one of the great themes of Pollock's meteoric career.

—Robert Rosenblum

1. See, for example, Elizabeth Frank, *Jackson Pollock* (New York: Abbeville Press, 1983), p. 102.

2. In *ARTnews* 51, no. 8 (December 1952): 49

3. For some relevant examples, see Francis Valentine O'Conner and Eugene Victor Thaw, eds., *Jackson Pollock; A Catalogue Raisonné of Paintings, Drawings, and Other Works,* vol. 2 (New Haven and London: Yale University Press, 1978), nos. 193, 194, 205, 210, 217, 222.

4. See ibid., no. 227.

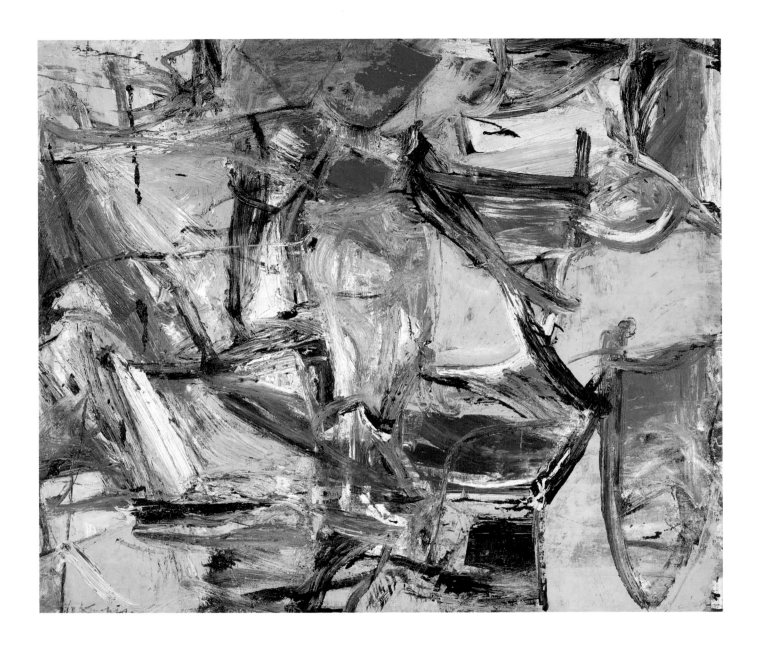

Willem de Kooning

Police Gazette

1955. Oil, enamel, and charcoal on canvas, 43 1/4 x 50 1/4 inches.

© 1998 Willem de Kooning Revocable Trust/Artists Rights Society (ARS), New York.

Willem de Kooning's career was marked by shifts from representational to abstract imagery and back again, repeatedly. *Police Gazette* of 1955, an ambitious abstraction, followed a series of "Woman" paintings inaugurated by the grand figure of *Woman I,* which the artist worked, scraped down, and reworked many times between 1950 and 1952. *Woman I* had itself succeeded de Kooning's abstractions of the late 1940s, a series that culminated in the unusually large picture finished in June 1950, *Excavation.* It is significant that de Kooning began *Woman I* just after completing *Excavation.* These two works, equally monumental, seem to mark opposing poles of the artist's interests.

Poles are known to reverse. *Police Gazette,* riding upon a four- to five-year tide of de Kooning "women," gravitates back toward the abstraction of *Excavation*—but not entirely, for its broad strokes and gritty textures maintain an association with *Woman I.* It could almost be an odd detail of one of the artist's figure paintings, or even a fragment that has been increased to commanding scale. (Later, during the 1960s de Kooning would paint large pictures of legs with broad sweeps of paint—no torsos, no hips, just the legs.)

To advance the tradition of representational figure painting, or to break with it and become an abstractionist: this was the aesthetic dilemma that informed *Police Gazette* in 1955, as well as the work of many other artists during the postwar era. It was a time when an American avant-garde centered in New York sought to divest itself of its inherited pictorial aesthetic, that "European" sensibility exemplified by Italian Renaissance masters and modern French Impressionists alike. However different from each other, both traditional painting and Impressionism depicted the refined beauty of things. Cubists were suspect, too. Their innovations merely redirected the tradition rather than diverged from it; they made even newspaper look beautiful, "elevating" it, as the painter Barnett Newman said. The more radical members of the emerging New York School wished nothing to inhibit their expression of a pioneering, specifically American character: "The American vanguard painter took to the white expanse of the canvas as Melville's Ishmael took to the sea," wrote Harold Rosenberg in 1952, as he named the new movement "Action Painting," an alternative to the more acade-

mic sound of "Abstract Expressionism." De Kooning was Rosenberg's inspiration.

Actually, de Kooning had no objection to tradition. Yet his attitude was anything but traditional: "De Kooning [has] grown from the European tradition into something else," a sympathetic reviewer stated in 1950. Later the artist delighted in admitting, rather mischievously, that he had always been influenced by whatever passed before his eyes, from the classic art of Raphael and Rubens to the popular images of Norman Rockwell and the Sunday comics. (De Kooning had been trained in commercial techniques, used them to earn a freelance living in New York from the 1920s through the 1940s, and had genuine respect for illustrators' skills.) De Kooning's art thus constituted an unwieldy combination of elements—both figurative and abstract, drawn from both elitist and populist sources, even from kitsch. When he painted a woman, the chosen pose might derive from an ancient sculpture of a goddess seen at the Metropolitan Museum or, just as likely, from a pin-up calendar hanging on his studio wall. Because he articulated his figures so freely and energetically, many viewers found that these distinctions hardly mattered; it became more comfortable to think of a de Kooning "Woman" as an abstraction, and simply to enjoy the whiplash line and the impasto. A viewer could take aesthetic pleasure in the turns and swells of masses of paint without needing to de-

Portrait of Willem de Kooning (1904-1997) circa 1950.

Photograph © Rudolph Burckhardt.

cide whether a particularly intriguing form was meant to signify a shoulder or a breast. For de Kooning himself, it could be either or both.

To shift to de Kooning's nominal abstractions is to experience an analogous effect of transference from one genre to another: faced with the painter's diverse array of gestural marks, a viewer begins to see parts of the human body, or to sense certain kinds of movements suggestive

Willem de Kooning, *Woman I,* 1950-1952. Oil on canvas, 75 7/8 x 58 inches.

The Museum of Modern Art, New York. Purchase. Photograph © 1998 The Museum of Modern Art, New York. © 1998 Willem de Kooning Revocable Trust/Artists Rights Society (ARS), New York.

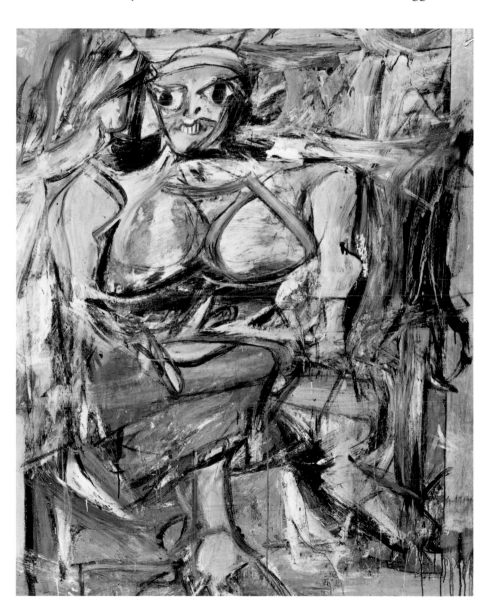

of an organic, human physicality. In *Police Gazette,* many of the larger segments of bright color (yellows, reds, greens) are given shape by thick linear elements (blacks, whites, other greens); they join together in ways that evoke the joints of the body, with a capacity to twist and turn. This is especially true of those typical de Kooning shapes defined at one and the same time by angled and rounded contours: think of how a fleshy arm curves into an angle at the elbow—this is a de Kooning line.

De Kooning was a vigorously expressive painter, and he himself—or at least his arm—was doing its own twisting and turning. In effect, the artist was representing bodily movements as he performed them, movements that belonged to him physically, intimately, but that might also have been observed in others. For de Kooning, abstraction and figuration became interchangeable, with the transition ready to occur at any moment in the painting process, almost unconsciously.

Public recognition for de Kooning's art first came in 1948, in response to an exhibition of a group of his abstractions. Although he was producing figure paintings during the same period, he declined to exhibit the two types of image together. This allowed the critic Clement Greenberg to praise de Kooning for achievements paralleling the more resolutely abstract art of Jackson Pollock. "De Kooning is an outright 'abstract' painter," he proclaimed.

In the early 1950s, however, Greenberg was forced to reevaluate the situation in response to de Kooning's changes, berating him for the return to figuration. In 1953 Pollock himself criticized de Kooning for failing to remove the sense of a figure present in *all* his works. And here Pollock had a point, for a witness to de Kooning's studio remembers that even *Excavation* began as a composition of figures, despite its having ended in abstraction. Residual traces of bright blue and green along the very bottom of this painting indicate it may first have been conceived as an outdoor scene, perhaps with water. As *Excavation* may have begun, so *Woman I* ended—once a woman in an interior with a window, it became a woman seated on the bank of a stream (at its base, blue and green again). Such changes are entirely characteristic of de Kooning: his brush and colors could turn an image as quickly as a

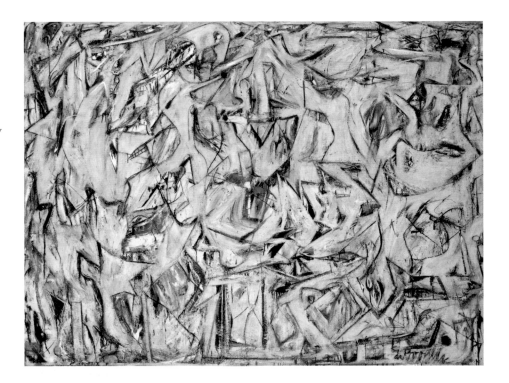

Willem de Kooning, *Excavation,* 1950.
Oil on canvas, 81 1/8 x 101 1/4 inches.

The Art Institute of Chicago, Gift of Mr. and
Mrs. Noah Goldowsky and Edgar Kaufmann Jr.;
Mr. and Mrs. Frank G. Logan Purchase Prize,
1952.1. Photograph © 1998 The Art Institute of
Chicago. All Rights Reserved. © 1998 Willem
de Kooning Revocable Trust/Artists Rights Society
(ARS), New York.

passing mood. "I have very little fixed form.... I can change it over and
over," he told interviewers, boasting.

Like de Kooning's other paintings, *Police Gazette* changed. The sur-
face shows signs of scraping, a normal practice for the artist who would
rework images as soon as he established them, incorporating the physi-
cal trace of his procedure as part of the next image. The title, although
evocative, suggests no motive for the changes. De Kooning assigned ti-
tles only after the fact, usually when works left the studio. He often
collaborated with his wife, Elaine de Kooning (a painter and writer),
and their critic-friend Rosenberg to devise the titles. Rather capri-
ciously, their choices might refer to some memorable contemporaneous
event, a place frequented, an unintended pictorial analogy, or simply
something found in the artist's studio. A pulp tabloid like *Police Gazette*
was a source of interest and amusement to de Kooning and his friends,
whether or not it inspired any particular motif.

According to another critic-friend, Thomas Hess, *Police Gazette* be-
gan as a figure painting that succeeded the very last of the representa-

tional works of the early 1950s. Thus, *Police Gazette* is to *Woman I* as *Woman I* is to *Excavation,* a painting that appears to inaugurate a definitive shift, which later proves not to be definitive. During the 1960s, the artist was painting the figure again.

Who, then, was de Kooning—abstractionist or painter of women? His greatest talent may have been an uncanny ability to generate abstract marks that preserve the flex and tautness of their own gestures— gestures the artist shares with the paint. When an artist's pictorial gestures are without cliché, it hardly matters whether a representational figure is or is not depicted. Somehow a "body" is always there, the honest trace of a human physical presence.

De Kooning believed that, representational or not, real art is never abstract. This was the gist of his statement for a Museum of Modern Art symposium entitled "What Abstract Art Means to Me." The event took place in February 1951, a moment when de Kooning was particularly famous as an abstractionist. *Excavation* was then hanging at the museum, and most were yet unaware of the new work eventually to be titled *Woman I.* True to form, the artist seemed to reverse himself, speaking not for, but against, "abstraction." He seized the occasion to attack pretentious intellectuals; he felt their theories were too "abstract." He complained, as well, about those who speculated on the "abstract," geometric order of the painter's "space," a concept overworked by art commentators at the time. The principle he enunciated was concrete, intended to be the working man's, not the professor's, version of formal analysis: "If I stretch my arms next to the rest of myself and wonder where my fingers are—that is all the space I need as a painter."

This is an image of physical containment. The arms are held tight at one's sides; the "space" extends no farther than one's fingertips. The body remains volumetric and yet suggests, by virtue of its compacted state, the flattened grip of paint to canvas, or perhaps the compact enclosure of a composition like *Woman I,* where peripheral strokes of paint press tight against the central figure. It seems that de Kooning identified so closely with the actual materiality of paintings that the imaginative, conceptual space he required for a figure was never greater

nor more "abstract" than the length and width of the working surface facing him. This space, like that of *Police Gazette,* was entirely real— experienced in the body, never intellectualized, never "abstract." The important thing, de Kooning often said, was just to paint, to "paint so fast you couldn't think."

—Richard Shiff

Willem de Kooning's studio with an early stage of *Woman I* in the background, 1950.

Photograph © Rudolph Burckhardt.

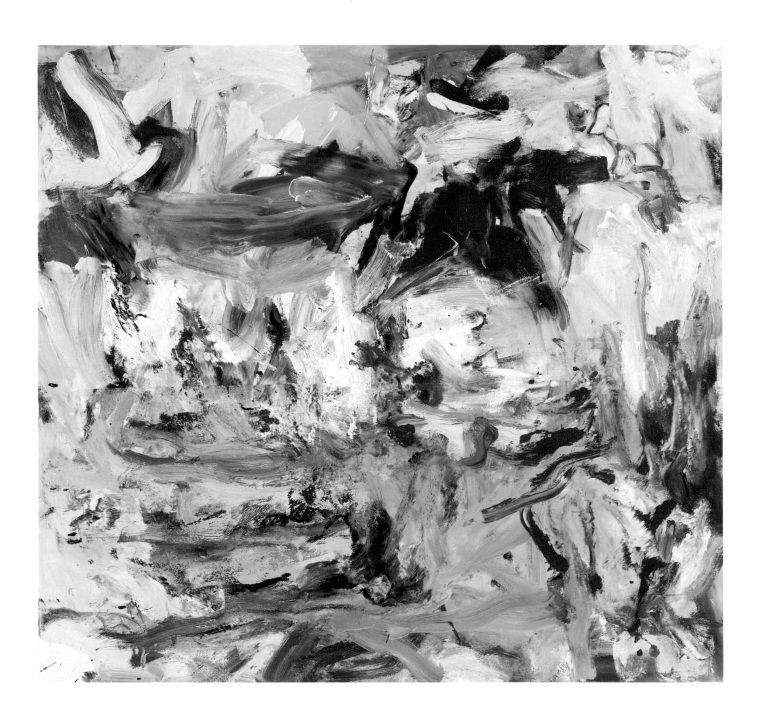

182

Willem
de Kooning

Untitled: (Red, Yellow, and Green)

Circa 1970-79. Oil on canvas,
55 x 59 1/4 inches.

Photograph courtesy Mitchell-Innes &
Nash. © 1998 Willem de Kooning Revocable
Trust/Artists Rights Society (ARS), New York.

Untitled IX
Page 184

A Blue Stroke[1]

In the mid 1960s I was a kid poet in overlapping literary and art circles, and it made sense that I found myself at a party after midnight in a house in the Springs when Willem de Kooning's mistress (at that time one said "mistress") knocked at the kitchen door. I saw her when the door was opened. She looked horrible: beaten up. "Oh my god," someone near me said to someone else, "Bill's been at her again."

I was sickened and excited. Would police be called? I envisioned a posse of men from the party going to confront the great, evidently mad artist, whom I considered a god and had not yet laid eyes on. I would try to tag along.

From body language accompanying an inaudible conversation at the door, whose threshold the battered woman vigorously refused to cross, the true character of the emergency became clear: she and Bill were out of booze. She secured a bottle of Scotch and went back into the night.

I concluded that I would never understand anything.

Years later, having grown to know de Kooning as a brilliant, funny, intensely gracious man when sober, I got a load of him drunk. I dropped in at the studio one snowy morning with Enrique Castro-Cid, a fun-loving and sentimental Chilean artist now deceased. De Kooning was on a round-the-clock bender attended by a strapping young studio assistant who took the chance of our arrival to drive into town for supplies and probably a breather. Enrique accepted de Kooning's offer of Johnnie Walker Red and was immediately plastered. I declined.

In the vast studio that de Kooning had designed with high windows on either side, unsuspecting birds periodically rammed glass with fatal plunks, a baleful percussion in the winter hush.

He showed us work in progress.

"Why do I do all this crap?" he cried, gesturing at dozens of leaning canvases. "I don't need the money. My women will get the money. They have too much money already. What are they going to do? Go shopping forever?"

A beat.

"I'm a great painter, don't you think? Look at that."

184

Untitled IX

1977. Oil on canvas, 70 x 80 inches.

We murmured rapturously.

"What do you know? It's shit. You don't know anything."

Later he appeared to take his first notice of Enrique, who was gazing at him worshipfully.

"Enrique! My friend!" exclaimed the master, embracing him. With one arm around the slightly chubby Latin, he addressed me as if I were the world. "This man is my friend. Enrique here is so important to me. I love this man!"

Enrique wept with happiness.

"But Enrique," de Kooning cooed in a stage whisper tremulous with hurt feelings,
"I want you to tell me one thing. Tell me, why are you so goddamned second-rate?"

As I write this, I am looking at my de Kooning: an accidental monotype. When he used oil paint that he had mixed with water in a blender, he would forestall overnight buildups of gummy surface film by keeping his wet canvases covered with sheets of The *New York Times.* Heaps of peeled-off newsprint littered the floor on a day when I visited.

De Kooning said, "You shouldn't leave here with nothing." Kneeling, he tossed sheets left and right. "That's no good. That's no good. Hey, this one's not bad. You like it?"

"Very much."

"Me too. Which end do you want up?"

"I'm supposed to tell you that?"

"Okay, this way." He signed it "to Peter/Bill de Kooning" in charcoal and handed it over.

Framed behind glass on my wall, the pleasantly smudged sheet, its chance composition oddly stately, might be anybody's lucky debris except for a de Kooningesque palette, starring pink and yellow, and the ghost of one blue brushstroke. I fancy that no one else ever born could have left that specific mark, which I have perused for two decades without using up.

Vertical, the stroke is about 18 inches long and two inches wide. It is sinuous, with two slight bends and an abrupt veer. Though liquid and

speedy, it is tensile, as if musculature and nerves ran within its length. The veer makes space, nipping back into pictorial depth. I don't know how it does this. I must come to a nose's length from the surface, observing the paint's purely lateral course, to make the illusion stop.

That's the spirit, I think as I look at the guided smear. That's how it's done. It could be anything. The stroke tells me to be, in all things, deft and economical and at the same time generous, holding nothing back. It doesn't care if I'm up to its program or not, as I fancy it didn't care if de Kooning was, either. Nothing about him did anybody including himself a lot of good except when he worked. Then everything went into the art as into a bonfire.

He was the last Renaissance painter. Renaissance painting came into its own with Giotto. Now it's over.

We are taught to be embarrassed by nationalist appeals in art, but let's not forget that de Kooning helped wipe out a chronic American inferiority complex regarding Europe. Can we not feel a little lingering gratitude at the European-style mastery that he put in service of "our" yearnings?

He described for me his first vivid take on the United States. Jumping ship from Holland in 1926, he ventured into the Hoboken train and ferry terminal.

"It was early in the morning and a thousand guys in hats ran in. You know, commuters. A guy at the diner counter had all these coffee cups lined up. He had a big coffee pot, like a barrel, and he poured without lifting it, one end of the counter to the other, in the cups. Like this: one pour!"

De Kooning balletically mimed a mighty gesture that seemed to express centuries of Netherlandish punctiliousness dissolving, at a stroke, into a more exuberant, soul-satisfying principle.

"I thought, 'What a great country!' I always remembered that guy with the coffee when my Communist friends in Greenwich Village used to say this is a lousy country. I told them they were nuts."

—Peter Schjeldahl

Postscript 1998

My personal visits with de Kooning all came after 1969 during a
decade-long, rolling explosion of his genius that I believe produced
the world's last great modern paintings, including the two now in the
Bellagio Gallery, *Untitled (Red, Yellow, and Green)* (1970-79) and
Untitled IX (1977). Apart from increasingly infrequent drinking bouts,
work consumed him in this period, as if he were painting against time.
He often seemed amazed by his own fecundity, which did not come
easily (as usual, he labored long over each canvas) but seemed always
on tap. Style modulations—between thick and thin, piled and scraped,
dense and airy, ferocious and lyrical—flashed by like sights seen from a
speeding train. Toward the end of the decade, his memory faltered. "I
don't remember so good any more, d'you mind?" he would say. I
would say that I didn't, and he would say, "Neither do I. Let's talk!" He
would then rumble pleasantly. Meanwhile, his painting arm seemed to
possess a wholly undiminished mind of its own, snatching ideas of
form and nuances of execution from the accumulated memory of
Western painting since Titian or from nowhere, miraculously. If de
Kooning's art lost anything, it was a former air of anxiety. His inspira-
tions poured forth as joyously as birdsong at sunset. He was spending
his creative capital shooting the works, burning the furniture, driving
flat out with no thought, ever again, of checking the oil. The world has
yet to catch its breath, contemplating the profligate splendor of 1970s
de Kooning.

1. The essay, "A Blue Stroke," by Peter Scheldal is reprinted from the April 8, 1997 issue of
The Village Voice.

Franz Kline

August Day

1957. Oil on canvas, 92 x 78 5/8 inches.
© Estate of Franz Kline/Licensed by VAGA,
New York, NY.

Franz Kline is one of the most esteemed members of the Abstract Expressionist movement, a loosely knit group united more by their diversity of style than by their commonality, who were promoted with great fanfare in the exhibition "The New American Painting," organized by the Museum of Modern Art, New York, in 1958. This defining exhibition introduced to European capitals the American avant-garde artists who had dominated the New York art world throughout the previous decade. The Bellagio Gallery's *August Day,* painted one year before the 1958 exhibition, at the zenith of Kline's career, is one of this artist's strongest and most accomplished paintings. It contains the quintessential elements that define his oeuvre and easily serves as a benchmark for his other works.

Despite Kline's success as a member of the avant-garde, his artistic beginnings were inauspicious. Unlike many of his contemporaries, Kline remained uninfluenced by the Surrealists, who had immigrated to New York during World War II and whose painted allegories of the Freudian "unconscious" led such artists as Jackson Pollock, Arshile Gorky, and Mark Rothko to their mature abstract styles. Kline's mature works, on the other hand, emerged directly from the rigorous academic training he first received at the Boston Art Student's League (1931-32) and later at Heatherley's School of Fine Arts in London (1935-38). Kline maintained an unusually long apprenticeship devoted to traditional forms and styles, producing primarily portraits and still lifes and landscapes of the Pennsylvania mining towns near which he had grown up. He has recalled being infatuated in his early career with "the actual and the specific"; the works he made from 1932 to 1946 are filled with nostalgia for his adolescence. It was not until 1946 that he began to experiment with abstract compositions, and for the next three years his painting vacillated between representational pictures and abstractions.

By the time of his first solo exhibition at the Egan Gallery, New York, in October 1950, Kline had determined the direction his work would take for the rest of his career. Initially, his black-and-white abstractions, such as *Giselle* (1950) and *Cardinal* (1950), were characterized by their linear, almost calligraphic reference to Oriental brushwork, an allusion that Kline regularly refuted. In the mid-1950s, his forms became

189

Portrait of Franz Kline (1910-1962),
late 1950s by Peter A. Juley & Son,
New York.

more solid and massive, reflecting his desire to make his images more forceful and monumental. Despite the stark reductionism of these works, Kline continued to rely on his earlier figures and landscapes, now rendered in powerful figural and architectonic forms that evoke the urban milieu. The drastic simplification of forms and the limited black-and-white palette lend a sense of immediacy and directness to the works, giving the impression of their having been executed in one moment of intensity and verve. Nevertheless, Kline's method was often to follow carefully prepared sketches.

By 1958 Kline had been featured in four solo exhibitions in New York. He had a second show at the Egan Gallery in 1952, followed by more highly acclaimed shows at the Sidney Janis Gallery in 1956 and 1958. *August Day* included in the second Sidney Janis Gallery exhibition, is a superb example of the artist's mature style. The composition, typical of his style at this time, is constructed around a central form that appears to push against the four edges of the canvas. For Kline, the placement of forms was critical: first the forms were positioned, then built up, then, finally, pushed out toward the edges. In *August Day,* the complex arrangement of the forms creates a composition within a composition, with two additional compositions appended to either side. Kline was a master at balancing the circles, triangles, and wedges that make up his paintings.

Franz Kline, *Giselle,* 1950. Oil on canvas, 58 3/4 x 49 inches.

Kline prepared the canvas of *August Day* with primer, which was characteristic of his working method. Although it had been his practice to render his pictures in commercial housepaints, in the present work he has mixed the cheaper housepaint with more expensive oil tube paints. The faintly brown patina that can be seen in the white areas, due to the aging of the housepaint, is much less pronounced in the present work than in earlier canvases.

The use of oil paint gave Kline the latitude to experiment with mix-

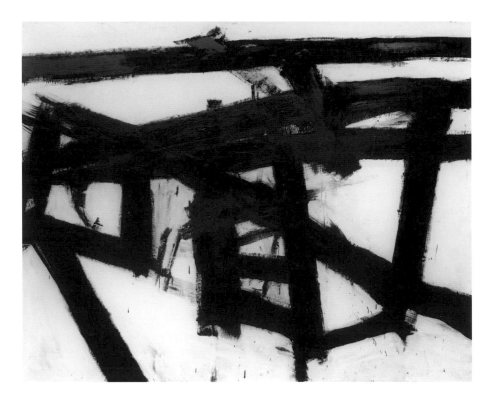

Franz Kline, *Mahoning*, 1956. Oil and paper collage on canvas, 80 x 100 inches.

ing his blacks and whites to create grays. This mixing is hinted at in the swirling areas of blended paint along the bottom of *August Day* and would be seen to great effect the following year in such paintings as *Siegfried* and *Requiem*. To create gradations of tone, Kline layered white on black and black on white, giving neither hue more importance than the other: "People sometimes think I take a white canvas and paint a black sign on it, but this is not true. I paint the white as well as the black, and the white is just as important." Black dominates *August Day*, even though the central form is entirely surrounded by passages of white. By using white to outline the composition, Kline complicated his previously defined relationship of forms and introduced a new direction in his work. His interest in methodically organizing the space generated by the forms here took precedence over hue and texture. Although customarily Kline created surface texture in his paintings by fluctuating thinly and heavily worked areas, in the present work this practice is restricted to the open area at the canvas's center.

We do not know why Kline called the present canvas *August Day*.

His titles are unrelated to any particular aspect of his works and were bestowed upon them as simple identifications. Kline painted mostly at night under strong fluorescent light (often on unstretched canvas pinned to the studio wall, because he liked the hardness of the wall's surface). Thus, it is paradoxical that the title of the present work suggests a late-summer afternoon. It is possible that Kline was remembering the tragic August day one year earlier, when his friend Jackson Pollock died at the wheel of his car.

Kline himself died prematurely from rheumatic heart disease in May 1962, at the age of fifty-two. Buoyed by the financial success he received through his association with the Sidney Janis Gallery, he spent his remaining years working in the same vein. He experimented briefly with painting in colors, but such works were not as well received as his black-and-white paintings. Thus, *August Day* remains a definitive work, a carefully planned and executed painting whose implied scale exceeds its actual scale, and whose simple, bold forms express the uninhibited gestures that emblematize Abstract Expressionism.

—Susan Davidson

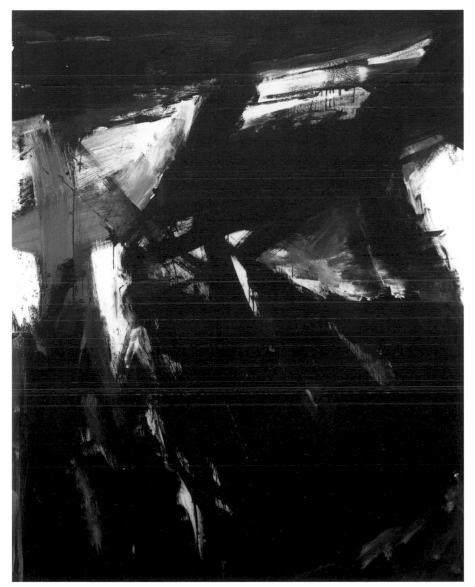

Franz Kline, *Siegfried,* 1958. Oil on canvas, 102 15/16 x 81 1/8 inches.

Carnegie Museum of Art, Pittsburgh, Gift of Friends of the Museum, 59.21. © Estate of Franz Kline/Licensed by VAGA, New York, NY.

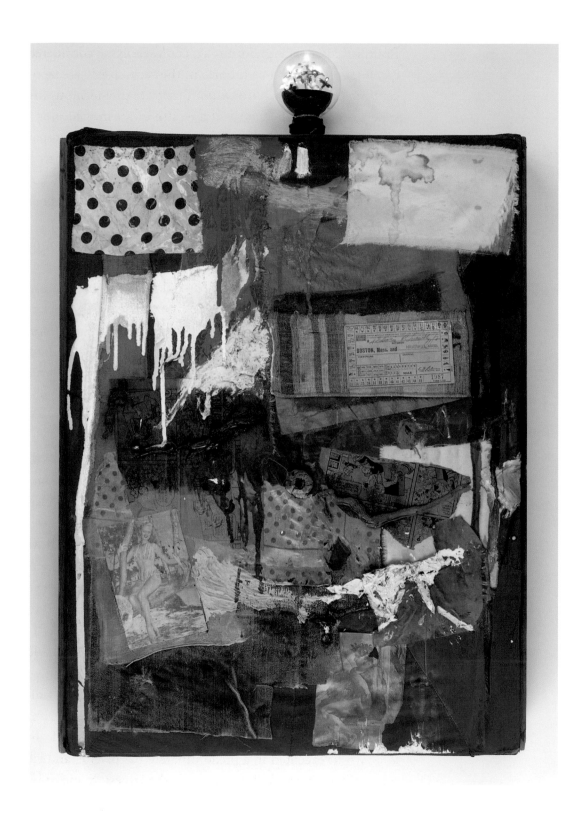

Robert Rauschenberg

Small Red Painting

1954. Combine painting,
27 1/2 x 21 x 4 3/4 inches.
© Robert Rauschenberg/Licensed by
VAGA, New York, NY.

Robert Rauschenberg, born 1925, could easily be considered America's greatest contribution to the arts in the second half of the twentieth century. Over the last fifty years, this artist of enormous invention and experimentation has produced a wealth of art in mediums as diverse as photography, sculpture, performance, printmaking, and painting, inventing new styles and techniques for each. From the first paintings he exhibited at the Betty Parsons Gallery in May 1951, to the Anagrams and Arcadian Retreats he is working on now, Rauschenberg's works have continued to be informed by his belief that "painting relates to both art and life." This belief found expression in the innovative art form that he named "Combines," which are fusions of two-dimensional painting and three-dimensional sculpture that he constructed, in part, out of objects of everyday human existence as diverse as postcards, a stuffed rooster, an old pillow, and a radio. The Combines earned Rauschenberg his international reputation and helped change the course of art history; their inclusion of artifacts from mass culture paved the way for the emergence of Pop art.

Rauschenberg typically works in series, developing new ideas as he progresses. In 1951 he produced a series of paintings in all white, followed by a series in all black, in 1951-53. Then he moved into an exploration of the color red, distinguishing these works from those of the earlier series; in the series of black paintings he had fashioned the works out of collage elements, using them simply as a receptor, or ground, for the black paint. In the Red Paintings, which were produced in 1953-54, Rauschenberg opened the brightly toned red surface to reveal unpainted scraps of newspaper amid the collage components that formed the ground. His seminal Combines emerged from the complex surfaces of these Red Paintings. In the summer of 1954 Rauschenberg made the leap to fully realized Combine paintings in an untitled work (now in a private collection in Paris) in which he added an illuminated stained-glass window at the top of the canvas and a wooden shelf at the bottom. The first Combine paintings were made in the artist's studio on Fulton Street in New York: nine large-scale works executed in a predominately red palette, and eight smaller ones, of which *Small Red Painting* is the largest. Some of the smaller

Combines were made of sections cut from a larger Combine hence destroyed; Rauschenberg often recycled materials in this way.

Combines exist in essentially two formats: Combine paintings and freestanding Combines. The Bellagio Gallery's *Small Red Painting* is designed on a grid format and built upon a red umbrella's nylon cloth that has been stretched over a deep wooden boxlike frame. The painting is divided into four horizontal "bands" divided vertically in half, with the top nub of the umbrella constituting the center point from which all else radiates. The support, which Rauschenberg constructed himself out of woodscrap, is roughly the size and shape of a soda-pop crate and is an early example of Rauschenberg's trademark use of non-traditional supports for his paintings. A short time later he would make *Bed* (1955, The Museum of Modern Art, New York), a work whose ground consists of real bedclothes and pillow, hung on the wall like a picture and smeared with bold Abstract Expressionist-type brush strokes, and the freestanding Combine *Monogram* (1955-59, Moderna Museet, Stockholm), featuring a goat with a tire around its middle who "grazes" on a painted and collaged wooden panel. Ever the practical one, Rauschenberg saw the "readymade" support as a quick and reliable solution when the cost of canvas was at a premium.

The Combine paintings all possess elements bearing autobiographical, art-historical, and mass-media references. Each element—painted or applied—retains its identifiable character. *Small Red Painting* has each of these defining ingredients: a variety of fabrics, a page cut from a girlie magazine, comic-strip fragments, a monthly train pass, and printed art reproductions. These collage elements layer the surface of the painting and add visual stimulation. The fabrics, including silk, satin, polka dot synthetics, velvet, and an Ace bandage, were applied in

Portrait of Robert Rauschenberg (1925–) at Gemini G.E.L., Los Angeles, 1969.

Left: Robert Rauschenberg, *Red Painting*, 1953. Combine painting on canvas, with wood, 79 x 33 1/8 inches.

The Solomon R. Guggenheim Museum, New York, Gift, Mr. Walter K. Gutman, 1963. © Robert Rauschenberg/Licensed by VAGA, New York, NY.

Right: Robert Rauschenberg, *Bed*, 1955. Combine painting: oil and pencil on pillow, quilt, and sheet, mounted on wood, 75 1/4 x 31 1/2 x 6 1/2 inches.

The Museum of Modern Art, New York. Gift of Leo Castelli in honor of Alfred H. Barr, Jr., 1989. © Robert Rauschenberg/Licensed by VAGA, New York, NY.

as many as three layers. The gestural skeins of paint in white, yellow, red, blue, and green, often squeezed directly from the tube, along with skeins of glue, form the topmost layer. Some of the fabrics veil areas of the picture plane and simultaneously establish the grid format. All of Rauschenberg's signature motifs are present in this one painting.

As a final effect, Rauschenberg crowned *Small Red Painting* with a working novelty light bulb, a gesture that reveals Rauschenberg's interest in technology and heralded his unique approach to the picture plane. Previously he had attached an electric light to his Combine *Charlene* (1954, Stedelijk Museum, Amsterdam) and subsequently had

Robert Rauschenberg, (left to right), *Yoicks,* 1954 (detail), unknown painting, circa 1954 (detail), and *Untitled,* 1954. Fulton Street studio, New York, 1954.

Photograph by the artist.

similarly attached a stuffed pheasant to his Combine *Satellite* (1954, Whitney Museum of American Art, New York) and had topped his freestanding Combine *Odalisk* (1955, 1958, Ludwig Museum, Cologne), with a stuffed Leghorn rooster.

It is impossible to determine for certain that *Small Red Painting* was included in Rauschenberg's first exhibition devoted exclusively to Combines, which was held in 1958 at the Leo Castelli Gallery in New York, since no checklist or catalogue has survived. In contrast to the well-received exhibition of his close friend Jasper Johns, held at the same gallery earlier that year, Rauschenberg's show received mostly negative reviews and none of the works were sold. *Small Red Painting* remained with the artist until 1964, when it was exhibited at the Whitechapel Gallery in London. The work then entered a series of private

collections and has not been exhibited publicly for nearly thirty years. Thus, we can delight in the fact that this early Combine painting, which is a perfect example of the artist's gift for inventiveness as well as of his ability to construct aesthetic harmony out of bits and pieces of the everyday world, will once again be in public view, reminding us that with works like *Small Red Painting* Rauschenberg extended the boundaries of what an artwork could be.

—Susan Davidson

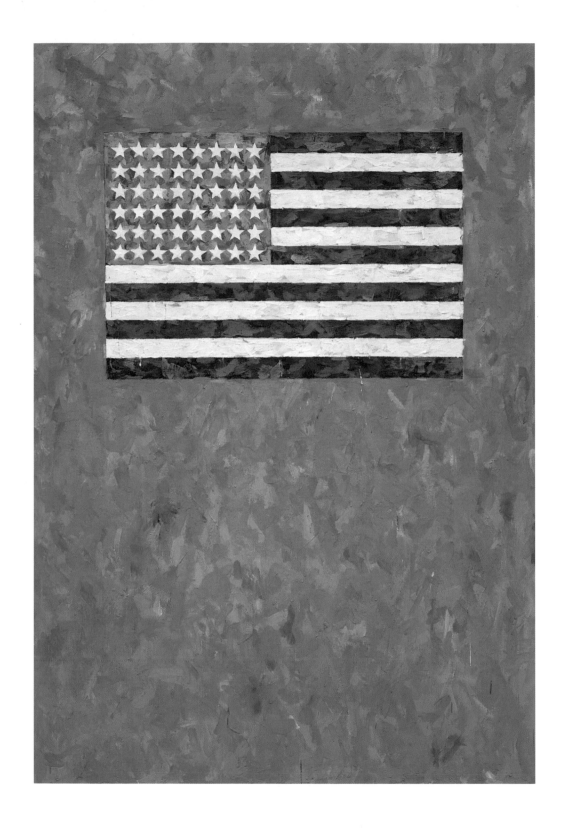

Jasper Johns

Flag on Orange Field II

1958. Encaustic on canvas,
54 x 36 1/4 inches.

Photograph: Thomas Powel. Courtesy, Mitchell-
Innes & Nash. © Jasper Johns/Licensed by
VAGA, New York, NY.

One of the earliest existing photographs of Jasper Johns shows him during his senior year at Edmunds High School in Sumpter, South Carolina, 1946-47. He is standing at attention with a rifle on his shoulder, staring solemnly into the camera. He is dressed in white slacks, a dark blazer and tie, and a military hat. Beside him, a similarly attired young woman presents a large American flag. Johns is "guarding the colors" at some high school occasion, and, in a sense, he may be said to have been guarding the colors ever since. What Giverny was for Monet, or Mont Sainte-Victoire was for Cézanne, the American flag has been for Jasper Johns—a touchstone and a talisman—that iconic subject to which the artist obsessively returns, and to which he was still returning as recently as 1996.

Over the length of Johns's long career, he has used the American flag in over a hundred works of art: in paintings, gouaches, drawings, lithographs, and sculptures. *Flag on Orange Field II* (1958), Johns's painting in the Bellagio Gallery, is one of the eleven breakthrough paintings he made of the subject between 1954 and 1958. Not only did these works establish Johns's reputation, they also mark the beginnings of the art we now call Pop, so it is important to remember the historical circumstances of their creation. In the summer of 1953, when Johns moved into his first real studio at 273 Pearl Street on the Lower East Side of Manhattan, both the New York art world and the American popular media were in a state of giddy excitement over the international triumph of Jackson Pollock's and Willem de Kooning's "American-style" painting. In newspapers and magazines, bars and restaurants there was buoyant, self-congratulatory chatter. American art had, at last, come into its own.

Thus it was, in early 1954, that the twenty-four-year-old painter, Jasper Johns was inspired to make, not an "American-style" painting in the manner of Pollock or de Kooning, but the most *literally* American painting that could possibly be made. As he tells it:

> One night, I dreamed that I painted a large American flag, and the next morning I got up and went out and bought the materials to begin it. And I did. I worked on that painting a long time. It's

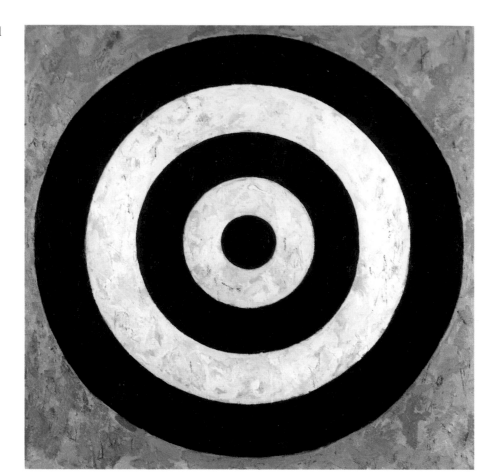

Jasper Johns, *Target,* 1958. Encaustic and collage on canvas, 36 x 36 inches.

Collection of the artist. Photograph: Rudolph Burckhardt. © Jasper Johns/Licensed by VAGA, New York, NY.

a very rotten painting—physically rotten—because I began it in house enamel…and it wouldn't dry quickly enough. And then I had in my head this idea of something I had read or had heard about: wax encaustic. In the middle of the painting I changed to that, because encaustic just had to cool and then it's hard and you don't blur it again. With enamel you have to wait eight hours…. With encaustic you can just keep on.

If Johns did, indeed, have such a dream, it must rank as one of the shrewdest ever dreamed by an artist, because, in one stroke, Johns's inspiration to paint flags solved problems and opened doors that changed the history of Western art. First, of course, the flag paintings wittily ex-

pressed the young artist's generational rebellion. They poked fun at the "America-obsessed" chauvinism of his elders, even as they slyly exploited that chauvinism. Most critically, however, Johns's flags solved a problem that had concerned painters for most of the twentieth century: *How do you make a painting that stands alone in an equitable relationship with the beholder—a painting whose authority derives from that relationship and not from something outside it?* Johns's flag paintings solved this problem succinctly because his paintings of flags are not *pictures* of flags. They do not portray flags that exist somewhere in the world. They are flags, as certainly as Johns's targets are actual targets (for our gaze), as certainly as the words he paints are actual words that we can read, and the numbers actual numbers with which we can count.

Figurative paintings, even at their most advanced, are "pictures." They achieve their authority by referring to originals in the world beyond the painting. Artists began to make abstract paintings to suppress this external reference, but in postwar America abstract paintings were presumed to refer the viewer back to the *artist* as the external "original." If it wasn't a picture of some *thing,* it was presumed to be a picture of the artist's intentions, emotions, and desires. A flag, however, is a general, visual idea, like a target or a word or a number. A flag has no specific "original" outside the beholder's consciousness, nor does it derive its authority from its creator (from the fact that Jasper Johns or Betsy Ross made it). A flag—and an American flag particularly—is invested with power and authority by the faith and commitment of those who salute it.

Johns wished his paintings to have that same kind of simple externality. Thus, when we stand before a Jasper Johns flag painting, there is nothing at issue but the painting itself and the idea of a flag—and since our idea of an American flag and Johns's idea of it are pretty much the same, they tend to cancel one another out, and we are left alone with the physical painting—the true focus of Johns's concern. This, I think, accounts for the extraordinary privacy we feel in the presence of Johns's work. The image of the flag, in its generality and neutrality, functions like the gray paint Johns uses on his "object paintings" that incorporate drawers and windowshades. In Johns's phrase, it "al-

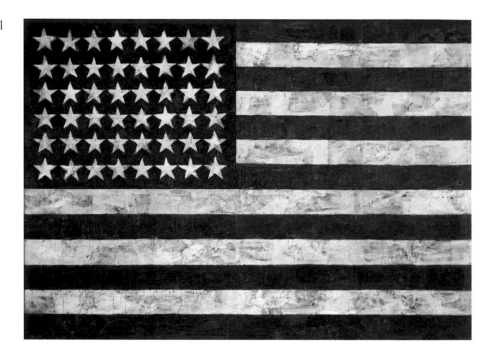

Jasper Johns, *Flag,* 1954-55. Encaustic, oil and collage on fabric mounted on ply-wood (3 panels), 42 1/4 x 60 5/8 inches.

The Museum of Modern Art, New York. Gift of Philip Johnson in honor of Alfred H. Barr, Jr. Photograph: Rudolph Burckhardt. © Jasper Johns/Licensed by VAGA, New York, NY.

lows the literal qualities of the painting to predominate over any of the others." This literalness, then, empowers Johns to paint like an Abstract Expressionist, without being an Abstract Expressionist, or having his paintings read as "expressive" of his inner self.

In this sense, the "American" character of Johns's American flags is more typical of the rural South, where Johns grew up, than the ebullient urban milieu of "American-style" painting. The paintings are silent and almost sullen, manifesting a hard-boiled commitment to the work that people actually do—what they actually make as opposed to what they might mean or intend to make. So it is important to remember that, as "intellectual" as Johns's art might seem, it is not "about ideas." It is more accurate to say that, during this period (1954-60), Jasper Johns paints little ideas to preclude large ones and thus to restore the beholder's sense of the painting's physical presence and complexity. Johns devotes this whole period, in fact, to exploring the different ways in which an artist may use objects and ideas in paintings that are not pictures.

The objects we see in paintings like *Target with Four Faces* (1954),

Target with Plaster Casts (1955), *Canvas* (1956), *Drawer* (1957), *Gray Rectangles* (1957), and *Tennyson* (1958) are all literal—"actual size" and "actual shape." They are either exact plaster replicas pulled from the object itself or objects masquerading as themselves beneath a sheath of gray paint. The *ideas* in these paintings, however—the flags, targets, words, and numbers—-have no determinate size, weight, color, proportion, or

volume. The paintings' colors are arbitrary with relation to the idea. Often, the idea expands to fit the size of its support, as many of the flags and numbers do. Occasionally, since ideas have no volume, they may even expand to occupy the *same* space, like the overlaid numbers in *0 through 9* (1960) or else they float weightless on the painting's surface like the targets, or the word "the" in *The* (1957), or the floating flag in the Bellagio Collection's *Flag on Orange Field II* (1958) and its immediate predecessor *Flag on Orange Field* (1957), which now resides in the Ludwig Collection in Cologne.

These two floating flags on orange grounds, considered as a pair, also demonstrate the ability of a visual idea (like a flag) to adapt its proportion as well as its size to the domain allotted to it. The rectangular flag in *Flag on Orange Field* (1957) has a ratio of height to width that is approximately 5 to 8; the flag occupies approximately 25% of the surface area of an inversely proportioned 8 to 5 canvas. The flag in *Flag on Orange Field II* (1958) is analogously proportioned 3 to 4; it occupies approximately 25% of a canvas that is inversely proportioned 4 to 3. Thus the size and proportion of the idea in these paintings derives from the size and proportion of the field, as it does in several of Johns's flag paintings in which the flag fills the canvas, only in a more nuanced and arbitrary way. The orange color of the ground in these two paintings might be considered arbitrary, as well, if the blue field in the flag didn't complement the orange field of the painting and set off the red of the flags' stripes so handsomely.

In any case, the argument that Johns seems to be making in his work, at this point in his career, would seem to concern the rough, complex physicality of art and objects and the absolute malleability of ideas as they enter this physical realm. As a consequence, when we look at these paintings, the ideas—the flags, targets, words, and numbers— function as little more than signals; they provide a common bond, a conceptual footbridge that connects us personally to the physical object. Thus a painting by Jasper Johns from this period, in its optimum state, is just a painting, alone in a room with a beholder. For Johns, this is the relationship that matters: two bodies in the world—a painting and a person—in an equitable relationship.

A few years after Johns began exhibiting his flag paintings, Pop art would begin in earnest when Andy Warhol set out to politicize Johns's artistic focus on the relationship between the work and its beholder within his rhetoric of "fame." In Warhol's view, a famous painting created a *society* of people who maintained a personal relation with it, and this society could change the world. Thus a painting's fame became a measure of its political power. In this sense, Warhol's Campbell's Soup and Marilyn paintings may be seen as Andy's versions of Johns's American flags—because, finally, it doesn't matter to us who made the soup, or the painting, any more than it matters who made the flag—any more than it matters who Marilyn Monroe "really was." It matters that we love them—that we stand before them and salute.

—Dave Hickey

Jasper Johns

Highway

1959. Encaustic and collage on canvas,
75 1/2 x 61 inches.
© Jasper Johns/Licensed by VAGA, New York, NY.

On first impression, there is nothing about the imagery of Jasper Johns's *Highway* that evokes a highway landscape. The picture space is relatively flat and does not in any way suggest a view of the open road. Neither *Highway*'s color scheme nor its composition reveals an obvious connection to its title. While the word *highway* is printed in large stenciled letters in the center of the picture space, it is nearly invisible, blending in with the surrounding field of colorful brushstrokes. However, its ambiguous role in the painting does not prevent the intriguing title from becoming a conceptual focus for the work. Indeed, it is a perfect example of how Johns uses language to elicit a range of personal and cultural associations.

Highway is one of a small group of paintings that signaled the new directions Johns's art would take after his first solo exhibition at the Leo Castelli Gallery in 1958. The Castelli exhibition featured Johns's signature paintings of flags, targets, and numbers. These paintings of familiar objects or signs rendered in primary colors, or tonal monochromes, that revealed relatively little evidence of the artist's hand brought Johns instant recognition as an innovative artist. His new fame rested in part on the fact that his style constituted a radical departure from the emotive abstract gestures characteristic of Abstract Expressionism, the dominant mode of painting in New York at the time.

Highway, painted in 1959, differs substantially from the works in the 1958 exhibition. It is abstract, multicolored, and openly gestural. *Highway*, a somewhat idiosyncratic, minimalist composition, is actually a construction that features a large square piece of unstretched canvas covering most of the painting's upper section and two small rectangular panels inserted into the space below. The painting's entire surface is covered with animated brushstrokes, drips, and splatters of encaustic (wax medium) interspersed with newspaper collage. Johns's preferred palette of red, yellow, and blue predominates here, but he has extended the range of hues and tones by including areas of orange and green, along with passages of gray, black, and white.

In adopting gestural brushwork in *Highway* and other works from this period (the first of these was painted slightly earlier in 1959, ironically titled *False Start*), Johns appears to simulate the bravura paint

Portrait of Jasper Johns (1930–), Front Street, New York City, 1962.

Photograph: Edward Meneeley. © Dorothy Zeidman.

handling of the Abstract Expressionists. For Johns, however, paint is not used as a direct means of self-assertion or expression. It is presented, first and foremost, as a material with particular properties (hue, tonality, fluidity, density). This paint-as-material, together with the newspaper collage, canvas, and stretcher bars, makes up the physical reality of the painting. The red and yellow rectangles could be taken as samples from a color chart.

Johns's insistence on the literal reality of the painting keeps the viewer focused directly on the act of perception with all of its complexity and uncertainty. This fundamental idea has been a continuous theme running through Johns's art, even as he has constantly found new ways to call attention to the materials and processes used to make a painting and to examine how art conveys meaning.

Johns began the practice of constructing the surfaces of his paintings with multiple panels in 1954-55, with the first of his flag paintings. The panels interrupt the picture plane and thus serve as reminders of the painting's three-dimensional canvas-on-stretcher construction. Johns strongly makes this point in his painting *Canvas* (1956), where he has displayed the reverse side of a small canvas, revealing its stretcher bars.

The type of canvas panels in *Highway* were first used in *Gray Rectangles* (1957). In both works the canvas panels assert tangible depth, defining the painting as "object." While the rectangles infer space *behind* the picture plane, the canvas collage in *Highway* creates a layer *on top* of it, almost completely hiding the original surface from view.

In other works, such as *Reconstruction* (1959) and *Disappearance II* (1961), Johns complicated the layering by folding the piece of canvas collage into various geometric configurations. In *Painting with Two Balls* (1960), the artist used wooden spheres to pry apart two of the

Jasper Johns, *Painting with Two Balls,*
1960. Encaustic and collage on canvas
with objects, 65 x 54 inches (3 panels).

Collection of the artist. Photograph: Rudolph
Burckhardt. © Jasper Johns/Licensed by VAGA,
New York, NY.

painting's three panels, literally opening the surface to reveal the otherwise hidden space behind. As in *Highway,* the activated brushwork and advancing and receding effects of color create a spatial illusionism that provides a foil to the literal dimensions of the object that hangs on the wall. Decades later, in *Mirror's Edge* (1992), Johns remained engaged with the play of literal and fictive space that preoccupied him earlier in *Highway* and *Painting with Two Balls.* In the later work, however, Johns used an array of illusionist devices common to trompe-l'oeil still lifes. They are employed to present a fictive space made up of layer upon layer of pictures that "mirror" his own life and art.

Highway was one of the first paintings in which Johns consciously introduced autobiographical references into his work—but in a way that allows many possibilities of meaning to coexist. Johns has said that the painting was inspired by his first experience of driving an automobile at night. A drawing directly based on *Highway* (completed the following year) reinforces this autobiographical connection through its title, *Night Driver.* With this personal connection in mind, the red and yellow rectangles (found in both painting and drawing) may refer to automobile headlights or taillights shining in the dark, as well as samples from a primary color chart. Even without knowing the association with Johns's first learning to drive, the word *highway* elicits images of

Jasper Johns, *Gray Rectangles,* 1957. Encaustic on canvas, 60 x 60 inches.

Private Collection. Photograph: Rudolph Burckhardt. © Jasper Johns/Licensed by VAGA, New York, NY.

open roadways passing through countryside, towns, and cities.

In the late 1950s highways were expanded and modernized, inspiring a number of American artists to create a new kind of landscape. The experience of the contemporary interstate highway, with its uniform appearance, billboards, and roadside architecture inspired the Abstract Expressionist Willem de Kooning to begin what are called his "abstract parkway landscapes." In 1958, just the year before Johns produced *Highway,* de Kooning painted *Merritt Parkway* and *Montauk Highway,* using wide swaths of color applied with housepainter's brushes to capture sensations of the landscape observed from a moving car. De Kooning particularly wanted to recreate the emotion of the highway experience, in his words, "the feeling of going to the city or coming from it." Later, in the 1960s, highway iconography was featured in many works, most notably in Alan D'Arcangelo's anonymous highway landscapes painted in the hard-edge style of Pop art.

The space Johns evokes in *Highway* is neither the emotive space of

Jasper Johns, *Map,* 1963. Encaustic and collage on canvas, 60 x 93 inches.

Courtesy, Agnes Gund. Photograph: Rudolph Burckhardt. © Jasper Johns/Licensed by VAGA, New York, NY.

de Kooning's paintings nor the anonymous, commercialized landscapes of D'Arcangelo. It is complex space that is both literal and psychological.

Other of Johns's works besides *Highway* evoke landscapes through their titles, among them *Out the Window* (1959), *By the Sea* (1961), and *Lands End* (1963). The year after Johns did *Highway*, he began a series of paintings on the theme of maps that encapsulate the entire sweep of the American landscape in a single, diagrammatic image.

—Roberta Bernstein

Jasper Johns, *Mirror's Edge*, 1992. Oil on canvas, 66 x 44 inches.

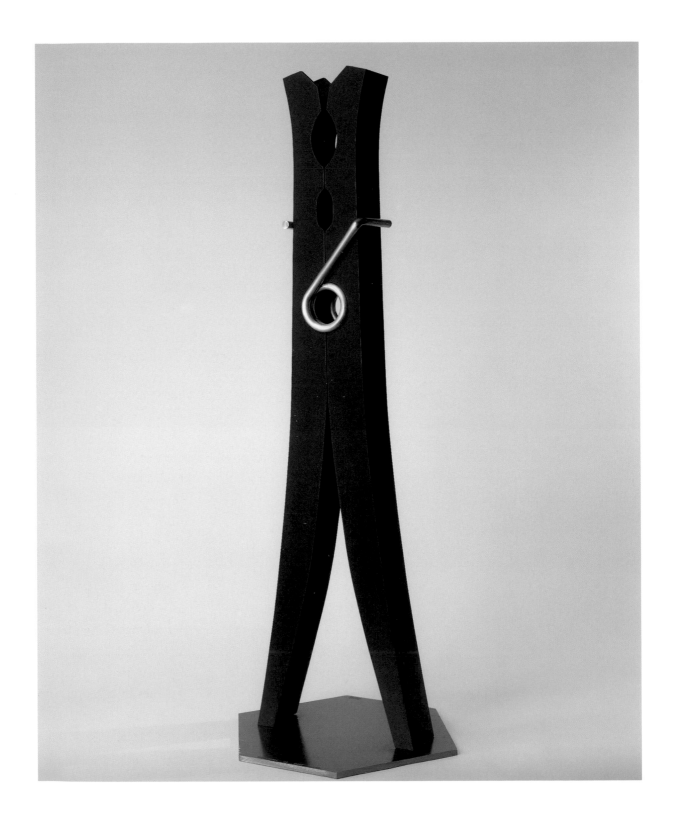

214

Claes Oldenburg

Clothespin—45-Foot Version (Model)

1976-79. Cor-Ten and stainless steel, 60 x 24 x 19 5/8 inches.

The Bellagio Gallery's *Clothespin—45-Foot Version (Model),* served as the original from which Claes Oldenburg's monumental sculpture *Clothespin* was modeled. The large-scale *Clothespin* is forty-five feet high and made of ten tons of Cor-Ten steel. It stands in Centre Square, at Fifteenth and Market streets, in downtown Philadelphia where it presents a dramatic contrast against its backdrop of International Style skyscrapers and historic government buildings. When the gargantuan, seemingly whimsical sculpture was first hoisted into position just over twenty years ago, many local citizens were shocked. Despite the fact that the sculpture has virtually become a logo for the city of Philadelphia and now is one of the most widely recognized and admired public sculptures in existence, the sight of it still rankles those who believe the representation of a common clothespin is out of place in a public square, particularly a public square in Philadelphia where the Western tradition of reserving prominent public venues for sculpture of noble themes has long been honored. *Clothespin's* critics, however, miss the point. Oldenburg has simply redefined what constitutes a noble theme.

Clothespin was selected by the developer Jack Wolgin as one of two large-scale sculptures to enhance his new building at Centre Square, in 1974, under the city of Philadelphia's requirement that one percent of his construction budget be allocated to art. (Jean Dubuffet's *Milord La Chamarre* was placed in the lobby.) It was erected in 1976, but the artist had conceived of a variation on the clothespin project nearly ten years earlier, in 1967. At that time Oldenburg was already well known, having been one of the five artists—with Andy Warhol, Roy Lichtenstein, James Rosenquist, and Tom Wesselmann—who in 1962 originated what soon came to be known as Pop art. In individual exhibitions these artists had introduced the use of images and themes drawn from popular culture into their works. Oldenburg's earliest Pop pieces focused on the theme of ordinary consumables: crude papier-mâché facsimiles of ordinary clothing and comestibles, such as pieces of cake and dishes of Jell-O, that he hand-painted Abstract Expressionist-style and sold out of a New York storefront, and, slightly later, oversized soft constructions of hamburgers, ice cream cones, telephones, typewriters, household appliances, and such, sewn of vinyl plastic and stuffed.

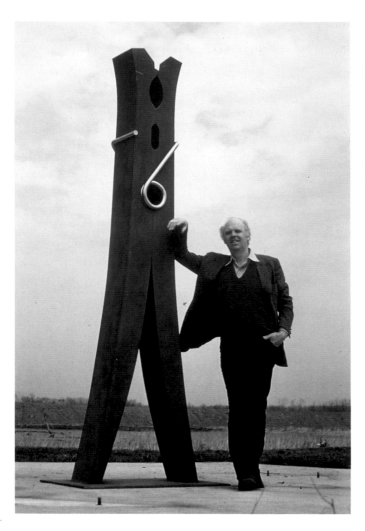

Claes Oldenburg (1926–) standing beside the maquette for his sculpture *Clothespin*.

Courtesy of Claes Oldenburg/Coosje van Bruggen.

In October 1967 Oldenburg was flying from his home in New York to Chicago, to prepare for an exhibition of his work. As the plane neared the airport, he took out a clothespin he had brought along. (Oldenburg kept clothespins around his studio to join parts of his soft sculptures in preparation for sewing.) He held the clothespin up to the window and compared it to the skyscrapers on the ground below. The following month he made a drawing of a skyscraper in the form of a clothespin, in response to a commission for a cover for *Artforum* magazine. As the artist tells it, he perceived in the clothespin "a certain Gothic character" and thus visualized it as a substitute for the Chicago Tribune Tower on Michigan Avenue.[1] He titled his drawing *Late Submission to the Chicago Tribune Architectural Competition of 1922: Clothespin—Version Two* and treated it as if it were a recently discovered entry in that famous 1922 competition held to select the design for the Chicago Tribune building, which had elicited a number of proposals featuring skyscrapers that verged on fanciful sculptures themselves. In Oldenburg's ersatz proposal the insides of the clothespin's "legs" are sheathed in blue glass, the ends of the "springs" on either side of the structure are glassed-in restaurants, and passages through the building produce a variety of sounds as wind passes through them.

For the 1974 Philadelphia commission, the artist began by selecting one of the several types of clothespins he had in his studio as a starting point. He then developed profiles of the face and side through many drawings, finally constructing a prototype. Two smaller editions of the prototype followed, one in bronze and the other, the Bellagio Gallery's sculpture, in Cor-Ten steel, a material with a sandpaper-like orange-brown patina that rusts to a deeper brown. It was decided that the large-scale sculpture would also be made of Cor-Ten, so in March 1976,

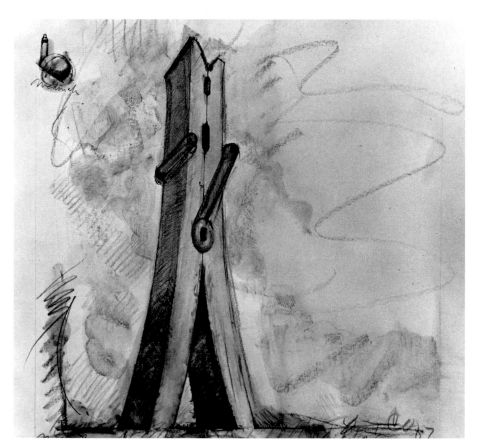

Claes Oldenburg, *Late Submission to the Chicago Tribune Architectural Competition of 1922: Clothespin—Version Two,* 1967. Pencil, crayon, and watercolor on paper, 22 x 27 inches.

the Bellagio *Clothespin* was taken to the Lippincott factory in North Haven, Connecticut, to serve as the model. Neither the smaller nor the larger version originally had a base. The large-scale *Clothespin* acquired a raised platform by default when the city of Philadelphia installed a subway entrance in the spot where Oldenburg had intended the sculpture to rest on the plaza floor. The artist later added a base to the model, inscribed it with his name, the name of the piece, and of the factory, and released it as a work of art in its own right in 1979.

When the Philadelphia *Clothespin* was erected in 1976, Oldenburg told a reporter in New York that it had become to him a Bicentennial tribute to Philadelphia: "Its steel spring forms the figure 76. And it is identical to the Liberty Bell in several ways. Not only does it have a crack in the middle but it resonates like a bell. If you bang it, it makes a lovely sound."[2] Even before the piece had been commissioned, it had come to be identified with Philadelphia in a roundabout way: for the exhibition *Object into Monument* that traveled from Pasadena to Philadelphia in 1972-73, the Friends of the Philadelphia Museum of Art published a poster illustrating an Oldenburg clothespin together with a photograph of Constantin Brancusi's stone sculpture *The Kiss,* of 1916.

Thus, Oldenburg's clothespin, its joined parts bound by the two springs wrapped around them, were seen to recall the embracing couple in Brancusi's small stone sculpture, one of the Philadelphia Museum's most treasured possessions. But, it would seem, *Clothespin* won the hearts of the citizens of the City of Brotherly Love—and ultimately

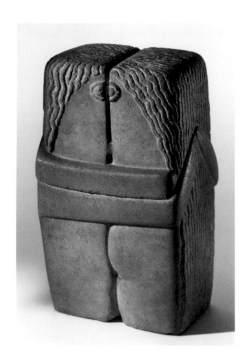

Constantin Brancusi, *The Kiss*, 1916.
Limestone, 23 x 13 3/4 x 10 1/4 inches.

Philadelphia Museum of Art: The Louise and
Walter Arensberg Collection, 1950-134-4.
Photograph © Graydon Wood, 1994, Philadelphia
Museum of Art. © 1998 Artists Rights Society
(ARS), New York/ADAGP, Paris.

silenced its philistines' cries—not by virtue of its symbolic connections, but by virtue of its sheer aesthetic beauty. Oldenburg's *Clothespin,* of course, is no more a replica of an actual clothespin than Warhol's or Lichtenstein's paintings are unmediated copies of popular imagery. The process of refinement can be seen in the many preparatory drawings—a thinner profile here, a more elegant line there. As the artist himself said at the time, "It's much more than a clothespin. It's my own design."[3]

Clothespin's proud, anthropomorphic stance, graceful planes and curves, and rich patina brighten and enliven its otherwise relatively glum urban setting. The towering *Clothespin,* however, is more than just a pleasing abstraction. In a city of monuments to America's noble history, it stands as a monument to quotidian American life—to the aspirations for domestic tranquility and prosperity that the founders sought to preserve, and to the dignity of simple work. Oldenburg's seemingly whimsical homage to democratic values, in fact, transformed forever notions of what constitutes a noble art.

The Bellagio Gallery's sculpted model for *Clothespin* is the second Oldenburg in Las Vegas, providing a worthy companion piece to the artist's *Flashlight* of 1981, whose monumental relationship to the Uni-

The urban scale of *Clothespin* did not become fully apparent until it was raised for the first time on April 28, 1976.

Courtesy of Claes Oldenburg/Coosje van Bruggen.

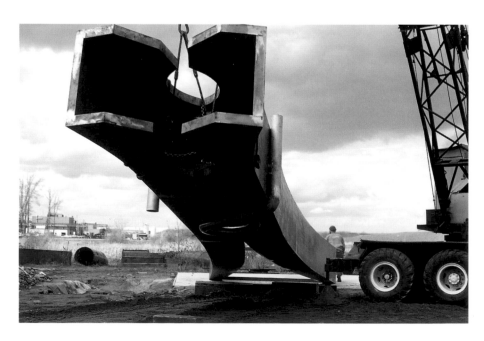

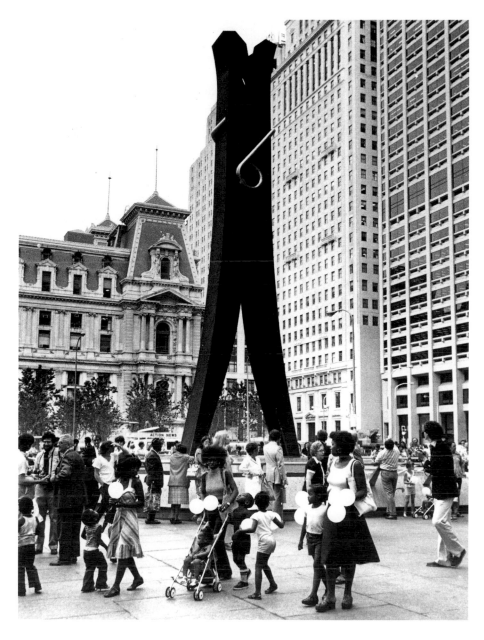

versity of Nevada Las Vegas campus is analogous to the large-scale *Clothespin*'s relationship to downtown Philadelphia. It stands as both a lovely work of art in its own right and a memento of one of the icons of our time. And, finally, it stands as something of a personal memento for its new owner, Stephen Wynn, who earned his degree in English literature at the University of Pennsylvania and has his own special affection for the City of Brotherly Love.

—Libby Lumpkin

Claes Oldenburg, *Clothespin*, 1976. Cor-Ten and stainless steel, 45 feet x 12 feet, 3 1/4 inches x 4 feet, 6 inches.

Centre Square Plaza, Fifteenth and Market streets, Philadelphia. Installed June 25, 1976; inaugurated July 1, 1976. Photograph: Ad Petersen, Amsterdam.

1. For Oldenburg's account of the development of *Clothespin*, see *Claes Oldenburg, Coosje van Bruggen: Large-Scale Projects* (New York: Monacelli Press, 1995), pp. 232-243.

2. Quoted in "Oldenberg Tops off Philadelphia's Bicentennial with a '76 Clothespin," *People Weekly* (New York) 5, no. 20 (May 24, 1976), p. 91.

3. Quoted in Linda Herskowitz, "It Is What It Looks Like," *The Philadelphia Enquirer* (June 26, 1976), p. 1-A.

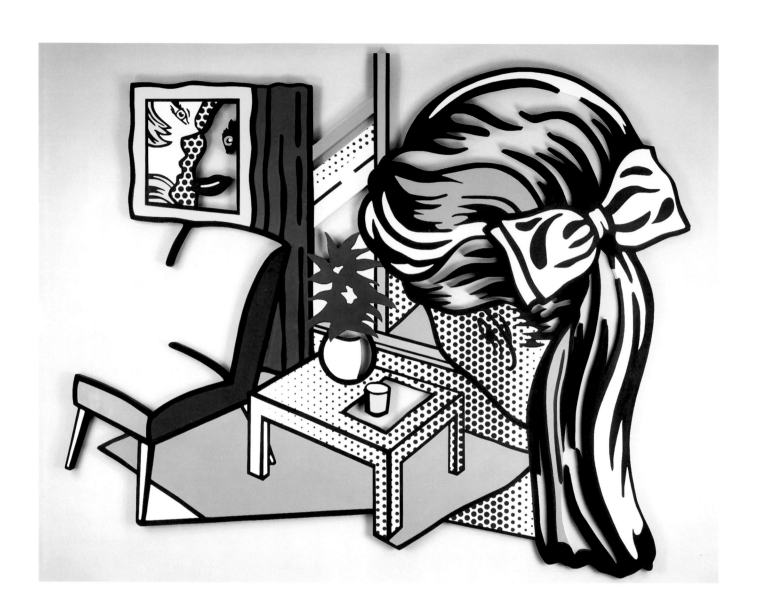

Roy Lichtenstein

Woman Contemplating a Yellow Cup

1995. Paint and wax on machined aluminum, 71 3/4 x 84 1/2 inches.
© Estate of Roy Lichtenstein.

Despite the fact the he was approaching his fortieth birthday in 1962-63, when he forged the cartoonlike style that produced instant fame, Roy Lichtenstein's first Pop works have the brash daring and insolence of youth. And though the work of his last decades maintains this early Pop vocabulary of mass-produced, freshly minted images, it also reveals a glowingly meditative quality, in which quotations from earlier decades keep popping up like memories of art and time gone by. This nostalgic mood, familiar to many old masters, is perhaps best represented in our century by Pablo Picasso's late work, which so often has a Proustian recall not only of his own youthful achievements but of the work of other artists. But it is a mood also shared by Lichtenstein's own generation. Both Jasper Johns and Andy Warhol, for example, constantly reincarnated in their later work some of their own most famous motifs—the American flag, Marilyn Monroe, among others—together with borrowings from other artists ranging from Grünewald to Picasso. And in Lichtenstein's late work this "remembrance of things past" is no less strong. Already in the 1960s, he had translated other artists' signature styles and paintings (Picasso, Piet Mondrian, Willem de Kooning, among others) into his personal version of art history; but from the 1980s on, the famous artist he was most likely to resurrect was himself.

Woman Contemplating a Yellow Cup (1995), a characteristic Lichtenstein mixture of painting and sculpture that would defy the rules of both media, was made two years before the artist's death in 1997. It is, in fact, a multiple (an edition of six), which might further underline the impersonal, machine-made look that marks all of Lichtenstein's work since the 1960s; but this shipshape surface, which seems untouched by a human hand or emotion, in fact belies the many layers of the artist's personal memory that haunt this immaculate fusion of machine-cut aluminum, paint, and wax.

The perfect American girl, whom Lichtenstein had transported in the 1960s from her comic-strip dramas to his own theater of irony, is still playing a central role here; but rather than acting out the simpleminded passions of *True Romance,* she mysteriously focuses her invisible gaze on the coffee table and, in particular, on the yellow cup isolated like a precious object on a rectangular mat or tray. And though

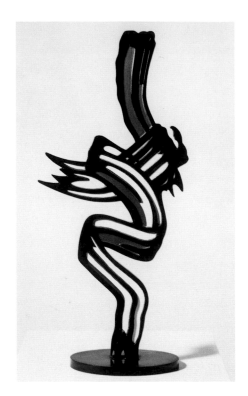

Roy Lichtenstein, *Brushstroke,* 1981.
Painted and patinated bronze, 31 3/8 x
13 3/4 x 6 1/2 inches.

Private Collection. Photograph: Glenn Steigelman,
Inc. Courtesy, Leo Castelli Gallery, New York.
© Estate of Roy Lichtenstein.

her hair, back in the 1960s, was almost always the blondest of printer's-
ink yellows, here it has changed color. Its waves of black, white, and
blue, kept in place by a perfect bow, unexpectedly evoke the graying
tonalities of advancing age.

The room she peers into is, in fact, another variation on an earlier
theme, in this case Lichtenstein's spic-and-span renderings of dustless,
wrinkle-proof modern interiors that had often appeared before and had
been given full-scale attention in a series of 1991-93.[1] The glimpse of
this showroom for machine-age living includes a coffee table with a
bowl of flowers and the equally purist yellow cup of the title; a blue
rug that coordinates with the two other blues of the chair; and most
evocatively, the framing elements in yellow, one of which encloses a
mock-Picassoid version of an ideal Lichtenstein blonde from the 1960s
and the other of which suggests the boundaries of both a plate-glass
window and a mirrored wall.

Since the 1960s Lichtenstein had been fascinated by mirrors, reflec-
tions, and framed images, translating these optical fictions into his own
artificial language of Ben Day dots and schematic geometries. Nor did
he ever stop exploring the paradoxes of two versus three dimensions,
creating, for example, such stupefying contradictions as a sculpture that
represents a trio of thick brushstrokes. Here, too, what appears to be a
flat, cartoonlike image of a woman in a domestic interior becomes a
palpable, metallic shape, not only in terms of its incisively cutout con-
tours, but even of its see-through voids that puncture what we expect
to be the seamless illusion afforded by a framed rectangle of paint.
These jugglings of tactile fact and visual fiction, a familiar theme in his
art, reach new heights of subtlety here (as in the rendering of the
cropped aluminum armature of the upholstered chair). Similarly, his
vocabulary of Ben Day dots becomes ever more nuanced (as in the
diminution of dot size that creates a reflection of the coffee table and
that, rather than conforming to the diagonal enclosure of the furniture,
floats magically above it, ever so slightly askew). Perhaps most mesmer-
izing here is the framed pseudo-Surrealist head that, like Picasso's *Girl
before a Mirror,* seems to reflect the internal mysteries of the real-life

Jasper Johns, *Untitled,* 1986. Charcoal and pastel on paper, 29 3/4 x 42 inches.

The Museum of Modern Art, New York. Fractional gift of Agnes Gund. Photograph © Dorothy Zeidman, 1987. © Jasper Johns/Licensed by VAGA, New York, NY.

Pablo Picasso, *Girl before a Mirror,* March 1932. Oil on canvas, 64 x 51 1/4 inches.

The Museum of Modern Art, New York. Gift of Mrs. Simon Guggenheim. Photograph © The Museum of Modern Art, New York. © Estate of Pablo Picasso/Artists Rights Society (ARS), New York.

woman whose image it echoes. Picasso, in fact, was always very much on Lichtenstein's mind; and he was constantly drawn to the master's distortions of the female face, in which profile and frontal views were joined and eyes and mouths could be scrambled into grotesque physiognomies. For Lichtenstein, these startling inventions were usually re-created as smiling parodies of the long-ago pretensions of artists who would follow Freud into the jungle of the unconscious. But seen again here, especially in tandem with the aging comic-strip head in the foreground, a strange psychological aura of introspection emerges. And to add another layer to this mood of reverie, the monstrous inventory of a pinup girl's assets (lipsticked mouth, blue eyes, perky profile, blonde hair) may also cast a sidelong gaze at the later work of Jasper Johns.

Like Lichtenstein, Johns often quoted Picasso; and in the 1980s, he began to concentrate on a painting of 1936 that provided a particularly bizarre deformation of a woman's head.[2] Johns used this grief-wracked physiognomy, with its glazed eyes desperately strewn to opposite sides of the face, for many drawings and paintings that Lichtenstein, another long-standing member of Leo Castelli's gallery, surely knew. And we may wonder, too, whether these references to Johns may not also in-

223

Roy Lichtenstein, *Girl in the Mirror,* 1964. Enamel on steel, 42 x 42 inches.

Photograph: Rudolph Burckhardt. Courtesy, Leo Castelli Gallery, New York. © Estate of Roy Lichtenstein.

clude the surprising use of wax in this painted metal relief (a material as common in Johns's work as it is uncommon in Lichtenstein's) as well as the oblique rear view of a woman's head, which recalls the double-image cartoon (wife and mother-in-law) that Johns at times juxtaposed with his glosses on Picasso.[3]

Lichtenstein has always been a master of deception, making simple things look complicated and complicated things look simple. *Woman Contemplating a Yellow Cup* may at first look as shallow, impersonal, and mindless as a mail-order catalogue illustration or a generic comic strip. But the efforts of contemplation suggested by the joking title can also disclose how this perpetually smiling artist, in his seventy-third year, could fuse in one work not only an astonishing inventory of visual paradoxes but a poignantly nostalgic scrapbook culled from the history of his own art and that of his century.

—Robert Rosenblum

Roy Lichtenstein, *Interior with Bonsai Tree,* 1991. Oil and magna on canvas, 118 x 140 inches.

Private Collection. © Dorothy Zeidman. Courtesy, Leo Castelli Gallery, New York.© Estate of Roy Lichtenstein.

Portrait of Roy Lichtenstein (1923-1997) by Sebastiano Piras, 1992. Gelatin silver print.

© Sebastiano Piras, New York. Courtesy, Joseph Helman Gallery, New York.

1. On this group of domestic interiors, see Diane Waldman, *Roy Lichtenstein* (New York: Guggenheim Museum, 1993), Chapter 13.

2. The painting, in the Musée Picasso, Paris, is at times titled *Straw Hat with Blue Leaf* as well as *Woman with Straw Hat.*

3. On these, see Nan Rosenthal and Ruth E. Fine, *The Drawings of Jasper Johns* (Washington: National Gallery of Art, 1990), no. 98.

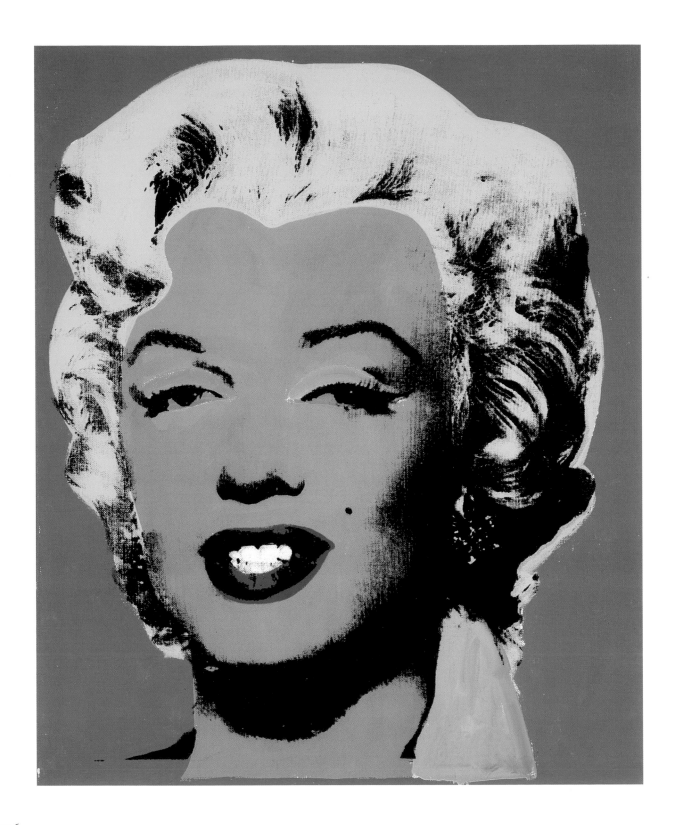

Andy Warhol

Orange Marilyn

1962. Silkscreen ink and
synthetic polymer paint on
canvas, 20 x 16 inches.

© Andy Warhol Foundation for the Visual
Arts/Artists Rights Society (ARS), New York.

It would be hard to imagine a less promising prospect for international
fame and fortune than little Andrew Warhola in his youth, or a less
likely candidate for spectacular, world-changing, artistic achievement.
Born on August 6, 1928, on the precipice of the Great Depression, An-
drew Warhola grew up in a working-class ghetto of Pittsburgh, Penn-
sylvania, in an impoverished, Slovak-speaking immigrant household.
His father, Andrej Warhola, worked in the steel mills when he could.
His mother, Julia, made paper flowers, arranged them in tin cans
wrapped in crêpe paper, and peddled them door-to-door. Andrew was
her third child, a painfully shy, sickly boy with bad eyes, bad skin, a big
nose, and hair from hell. He didn't fit in. When he was eight, he
suffered a nervous breakdown and was confined to his bed, where he
spent a month coloring in coloring books, playing with paper dolls,
and sending off for autographed photographs of movie stars. (Shirley
Temple was his dream-girl then.)

 In other words, if you had come across him then, you would have
sworn that little Andrew didn't have a bleepin' chance. And he didn't,
but he took it anyway. By the time he was twenty-one, Andrew
Warhola was ensconced in his first Manhattan apartment. He had just
received his degree in commercial design from the Carnegie Institute of
Technology in Pittsburgh, which he attended on a scholarship supple-
mented by money his family earned selling homegrown vegetables in
the suburbs. By the time he was thirty-one, Andrew had purchased a
large town house on Lexington Avenue near 89th Street and moved
into it with his mother. He was the best-known, best-paid, most highly
acclaimed commercial illustrator in New York City, with a sideline rep-
utation as a precious (if not a "fine") artist of gay *objets* (exquisite draw-
ings of beautiful boys and lovely books on handmade paper). He
exhibited and sold these works in galleries that catered to the uptown,
homosexual carriage trade.

 By the time he was forty-one, he wasn't Andrew Warhola anymore.
He was Andy Warhol, internationally acclaimed artist and media super-
star, the father of Pop, the pope of the Factory, and the dark priest of
dystopian fame. By the time he was fifty-one, he was nothing less than
an artfully designed conglomerate beneath whose umbrella he func-

Andy Warhol (1928-1987) amid his Brillo box sculptures at the Stable Gallery, New York, opening day, April 21, 1964.

Photograph © Fred W. McDarrah.

tioned variously as avant-garde artist, society-portrait painter, author, filmmaker, television host, nightclub owner, record producer, band manager, theatrical producer, magazine publisher, film actor, and fashion model. "My style was always to spread out rather than to move up," he would explain, and, as such, Andy's enterprise constituted a prophetic model for the transformation of American commercial culture that took place in the late 1980s and early 1990s.

When he died in 1987, at the age of fifty-nine, Andy Warhol was acknowledged to stand along with Pablo Picasso and Jackson Pollock as one of the three major artists of the twentieth century, and recognized, as well, along with Walt Disney and Norman Rockwell, as one of the true visionaries of American popular culture. Little Andrew Warhola, in other words, had come a long way up from a long way down, and, in truth, if he had only made it from the steel-smoke to the town house on Lexington Avenue, his life would have been a triumph. In 1962, however, Warhol emerged from obscurity and entered the public's consciousness with his first two solo exhibitions in avant-garde galleries—and entered the history of Western art, as well, with a flurry of works that, if he had done nothing more, would guarantee his position in the pantheon of Western painters.

During this year, Warhol made his first Campbell's Soup can paintings, his first Marilyns and Elvises, his Do-It-Yourself paintings and Coke bottle paintings, his grid paintings of dollar bills, air mail stamps and S&H green stamps, his grid portraits of Troy Donahue, Warren Beatty, Babe Ruth, and Natalie Wood. When asked about his choice of subject matter, Warhol always replied with a shrug: "Pop art is a way of liking things," by which he meant that he painted things he "liked," and hoped we liked them too. But he also meant that Pop art is a way of showing how things are alike—a way of showing how, in the cos-

mology of sublimated appetite, things that "taste good" and things in "good taste" are really not all that different. Warhol argued this point in his first two solo exhibitions with two series of modest 20 x 16 inch paintings on the theme of appetite and taste.

In July 1962, at the Ferus Gallery in Los Angeles, Warhol exhibited a series of thirty-two, virtually identical, silkscreened Campbell's Soup cans, each labeled with a different flavor of soup—Clam Chowder, Chicken Noodle, Cream of Vegetable, and so on. In November of that year, at Stable Gallery in New York, he exhibited his Marilyn Monroe "Lifesaver" paintings, a series that came in "flavors" too—as indicated by their colors: mint, lemon, orange, and the rest. The Bellagio Gallery's *Orange Marilyn* (1962) is one of this series. It was acquired from Warhol in 1962 by Irving Blum, then director of the Ferus Gallery; it hung in his home until the early 1990s, when it was acquired by the private collector from whom Stephen Wynn acquired it for the Bellagio Gallery of Fine Art.

Warhol's Campbell's Soup cans in flavors, however, are no more about soup than his Lifesaver Marilyns are about Marilyn Monroe or candy. In these paintings, for the first time in history, a modern artist is making art, not about its own creation, but about its own consumption—paintings about us liking things, about how we look at things, and the way we care about them. Blatantly, these paintings draw a crisp (and, at that time, blasphemous) analogy between our appetite for "fine art" and our appetite for food, sex, and glamour (for soup, candy, and movie stars)—and our "taste" in both. When we are hungry for soup, these paintings ask, don't we go to the supermarket, seek out the culturally sanctioned brand name (Campbell's), and then select the flavor we prefer? When we want a sweet, don't we reach for the trademark Lifesavers, then select the flavor we prefer by its color? And when a guy wants a girl (or in Warhol's case, perhaps, wants girlish glamour) doesn't he seek the one who looks like Marilyn Monroe, the brand name of American sexual promise, while secretly hoping for that particular version of Marilyn who is most congenial to his own emotional taste and decor?

If so, how is our appetite for, and taste in, art any different? We

might take art much more "seriously," but is the process really that much more refined? When we want a picture of a horse, don't we go to the best equestrian gallery on Madison Avenue and select the horse picture we prefer? When we are hungry for American-style painting, don't we visit the gallery that features the latest, critically sanctioned, brand name artist (Mark Rothko, for instance), then examine works he has created in his trademark format (eerily evocative of a Campbell's Soup can) and select the one whose colors are most congenial with our taste and decor? In this way, Warhol's first two solo exhibitions argue the case that selling soup and selling art are not that different, except that works of art are advertisements for themselves. So, with art, the package is the prize and the so-called content of that package is, almost inevitably, some object of desire that remains un-possessable. Otherwise, an ad is an ad.

Apropos of this, I once asked Andy to explain to me the difference between a painting by Mark Rothko and a Campbell's Soup label, and he replied immediately: "Oh, Mister Campbell signs his on the *front*," clearly intending this distinction to be just that, and not a criticism of either. So we should be clear about this: Andy Warhol was an artist. He never hated anything he thought was beautiful. He did, however, hate what beautiful objects were often taken to mean. In the advertising parlance of that time, it was a truism that one didn't sell the steak, one "sold the sizzle." It would be fair to say that, in the American art world of the late 1950s and early 1960s, Andy Warhol loved the steak, but hated the sizzle, because the art world at that moment was quite literally *marketing* contempt for commerce, selling paintings by selling the idea that buying advanced art marked one as "better" than those in the workaday world of mercantile concerns.

Warhol's contempt for this hypocrisy was political. He was a Jacksonian democrat, a kid from the ghetto who believed that in "a democracy of objects" we may all aspire to anything we can find the cash to buy. So, Warhol took commerce seriously. He was beguiled by the mystery of it, which, to him, was the mystery of democracy, but he never took art lightly. Jackson Pollock and Willem de Kooning and Mark Rothko were heroes to him, and his Campbell's Soup cans and Life-

Above, left: Mark Rothko, *Orange and Tan*, 1954. Oil on canvas, 81 1/4 x 63 1/4 inches.

Above, right: Andy Warhol, *Campbell's Soup Can (Black Bean)*, 1962. Synthetic polymer paint on canvas, 20 x 16 inches.

saver Marilyns may be taken as an affectionate homage to their "American-style" painting. They mimic its "look" using different methods to suggest different meanings, while poking fun at its pretensions. By implicitly comparing Rothko's oft-repeated design format to soup can labels and mimicking de Kooning's proliferating paintings of "women" with the series of Marilyns executed with reusable silkscreens, Warhol implies that his elders' penchant for repeating similar subject formats in different colors is, in fact, a marketing ploy, a form of "trade-marking." But he does not condemn it. Rather, he *exploits* it with a series of fixed-format paintings that do the same thing and don't pretend to be doing otherwise.

The only criticism of Abstract Expressionist paintings one may infer from these paintings is that they do not distinguish between their trademark signifiers and the specific flavor with which they appeal to

Willem de Kooning, *Marilyn Monroe*, 1954. Oil on canvas, 50 x 30 inches.

the specific beholder. In Warhol's paintings of this period there is always a visible distinction between the image of the object we desire (and can never possess) and the physical presence of the painting we prefer (and can always acquire). Thus, in the *Orange Marilyn*, and in all of the other flavors, the photographic picture of Marilyn Monroe on the silkscreen is clearly distinguishable from the colorful painting of Marilyn that Warhol himself has made—as if little Andrew, sitting in bed with his coloring book, discovered that the images he was making were, somehow, more his own if he colored outside the lines.

Marilyn achieves this "double-ness" by mimicking Jackson Pollock's method of laying down one field of paint over another. The painting was begun by laying down the "flavor" color on a primed canvas, then applying a preliminary, black photo-silkscreen of Marilyn Monroe, upon which Warhol painted the irregular fields of color that indicate the actress's face, hair, eyes, lips, teeth, and blouse. Then another, edited version of the silkscreen was laid down over these colors. Then Warhol painted some final grace notes—the "art part" as he called it. In this way Warhol's actual painting seems to move over and under the photographic image of Marilyn. The picture and the painting coexist, but they remain separate.

In Willem de Kooning's *Marilyn Monroe* (1954), on the other hand, the picture of the actress and the expressive painting are one and the same. Similarly, the transcendental landscape in a Mark Rothko is coextensive with the exquisite fields of color that constitute the painting.

In this sense, de Kooning's and Rothko's paintings aspire to possess their subjects, leaving the inference that we, by acquiring the painting we prefer, are somehow acquiring the object we desire. This, of course, is a recipe for the spiritual elitism that Warhol detested. It implies that

we fulfill our desires in some transcendent way by exercising our taste. Andy is never so foolish. He never pretends to possess Marilyn. He only borrows her image for a painting, as an icon of that which we can *never* possess. In Warhol's democratic vision we are all alike in our unquenchable longing. Appetite and desire hold us together as a society, while taste and preference distinguish us; they make us special. Neither, however, exists without the other. So even though we may never possess that which we desire, we may possess the physical trace of that desire we most prefer—to remind us of the dreams that stuff is made of.

—Dave Hickey

234

Andy Warhol

Campbell's Elvis

1962-64. Silkscreen ink and synthetic
polymer paint on canvas, 20 x 16 inches.
© Andy Warhol Foundation for the Visual
Arts/Artists Rights Society (ARS), New York.

Andy Warhol chose silkscreening as his technique, he once told me, be-
cause it was "quick and chancy." And although he was attracted to the
idea of sameness in the repeated silkscreen images, he was just as drawn
to the small variations in the images that each pass of the screen made,
and those slight changes were, of course, the changes of chance. Then,
on top of these changes of chance, there were the chances for change—
for even larger changes—that came whenever mistakes of, say, position-
ing or coloration occurred or whenever two things came together
through no human planning.

"Mistakes" were a fertile source of inspiration for things Andy did in
any creative area. If your job was to transcribe his tapes, for example—
as mine was when I began working at the Factory, typing up conversa-
tions between Andy and various friends and celebrities—there was
nothing you could ever do that he would consider wrong, since he
loved every misheard word and misspelled name and instructed you to
"just leave it like that." His 1968 book—confusingly titled *a, a novel*—
was published with the typists' typographical errors meticulously repro-
duced on every page, and certainly one of the reasons he accumulated
so much *stuff* in his lifetime was his hope that at a moment when he
most needed them, two or three things would tumble providentially to-
gether off a dusty shelf or out of an old box and supply him in the
process with a brilliant idea for his next project.

The methods used by John Cage and Merce Cunningham in creat-
ing their works—the ingenious incorporation of any accidental "in-
truding" sounds or gestures into their musical and dance pieces—had a
strong influence on Andy's painting, as critics over the years have
pointed out. But their collective effect on Andy amounted to less of an
influence than a reinforcement, for even in his previous career, as an il-
lustrator, Andy would draw in ink and then repeatedly press the still-
wet outlines onto other paper, with the image getting fainter and
fainter—and changing—at each press, and with Andy becoming in-
creasingly pleased with those automatic mutations.

Once he became a painter, however, he found that the silkscreening
process was an even more chance-driven operation. Each time a screen
was placed, re-placed, or re-re-re-placed on the canvas, the resulting

image varied at least slightly, and sometimes profoundly. In silkscreening photographic images, which Andy gravitated to after an early period when he made silkscreens from drawings, he worked this way: he chose a photograph, had it blown up into a large transparency, had that image transferred in glue onto silk, and then rolled ink across the silk "screen" so that the image went through the silk but not through the glue. If an image got increasingly fainter with repetition—as it inevitably did—that meant that excess ink was clogging up the holes in the silkscreen and that it was getting closer and closer to time to clean the screen. At this point, to remove the excess ink, either Andy or his silkscreening assistant, the poet Gerard Malanga, might grab a piece of leftover scrap painting that was lying around on the floor or curled in a corner—an outtake, maybe, from a *Marilyn* or *Jackie* or *Campbell's Soup Can* or *Elvis*—and run the currently clogged-up screen over that other "painting" to clean (unclog) it. On a couple of those occasions Andy apparently was impressed enough with the chance result to raise the status of this hybrid piece of seriate serendipity to that of a legitimate full-fledged painting—a work of his art.

When I met Andy in 1968, he had just moved down to the loft at 33 Union Square, from the much larger Silver Factory on East 47th Street. In these new quarters there was very little space in which to paint—the front room was filled with desks, and the back room had a couple of couches and a television/stereo console and was used for screenings of the unfolding "Factory Films"—and there was virtually no room on the newly polished wood floors for a messy space-consuming silkscreening operation. By now Andy had decided he would no longer work with the screens himself—he would merely paint in the backgrounds and work with an outside screener. The latter would pick up the transparencies from Andy, then go back to his own workspace and put the image, according to Andy's specifications, onto Andy's painted canvas. So the Factory mess was gone—but then, gone, too, was the potential in the mess for the kind of lucky accidents that may have led to stunning curiosities like *Colored Mona Lisa* with its various-sized images of the unreadable model. Or like the even more mysterious *Campbell's Elvis* in the Bellagio Gallery's collection, where six brooding Presley

Portrait of Andy Warhol, Café de Flore,
Paris, 1986.

© Martha Knowlton Peeples.

faces intermix with the large turned-on-its-side label for "Campbell's Condensed…," and it's hard to even tell which screen was laid down first, the "Campbell's" or the "Elvis," on the red, silver, and yellow canvas.

When Andy finished this unusual painting, Elvis himself was long since back from serving in the Army in Germany—in fact he had been

out in Hollywood for quite some time already, making movies like *Fun in Acapulco*. Andy, meanwhile, when he wasn't turning out silkscreened canvases, was in New York rushing to Times Square with his friends to see all those Elvis movies. He was apparently not influenced as an artist by those *Viva Las Vegas*-type vehicles that, as a movie-*goer*, he so loved to watch. He had just become a movie-*maker*, of sorts, and his cinematic efforts were notoriously nonmusical, no-action affairs with self-explanatory titles—and themes—like *Eat, Sleep, Couch*, and *Taylor Mead's Ass*. And whereas Elvis gave us *Girls Girls Girls*, Andy offered *13 Most Beautiful Boys*. The photograph of Elvis that Andy used to make this silkscreen was not a then-current one. Elvis's experiences in the Army, the death of his beloved mother, and many other circumstances had toughened him up, and his face, though still startlingly handsome, was sharper and more cynical than it had been in the early days. Andy had to reach all the way back into the 1950s for a publicity shot of the pre-Army, top-of-the-charts Elvis: a young, brooding, unjaded phenomenon with high, voluptuous hair and thick, sullen lips. The power of that famous face in the original photograph is such that it manages to penetrate through every obfuscating, obliterating element in the makeup of *Campbell's Elvis*. In the 1970s when Andy came back from photographing Muhammad Ali at his training camp, he told me, "Muhammad reminds me of Elvis, they sort of look alike and he has that same kind of ego."

For Andy, this early period of Elvis's was the ultimate one, just as, when he was commissioned in the 1980s by Mattel to paint the Barbie Doll, he was crushed when the company insisted that he portray the current Barbie—it was the original 1950s version that he loved because she "was much more beautiful and French-looking with a very femme mouth that pouts." "Why," he wailed to me, "would they ever make Barbie smile when she used to be so sexy? Dolls don't *have* to change!"

While *Campbell's Elvis* may be a more subtle juxtapositioning of images than, for example, Meret Oppenheim's famous Surrealist work *Fur-Covered Cup, Saucer, and Spoon*, it's hardly less of an absurd association. Then it's easy to see how the cohesive incongruity of the images in this one particular painting of Andy's appealed so strongly to Sal-

vador Dalí that he determined to own the *Campbell's Elvis* and kept it hanging in his own personal collection for many years. (Somehow it's hard to apply standards for incongruity anywhere near Elvis, when the official *Presley Family Cookbook* [1980] contains his favorite recipe for "Pepsi Cola Salad.") Dalí knew Andy personally and was quite familiar with his work, so he must have been surprised when he first encountered the *Campbell's Elvis* since there is very little else of Andy's that contains elements even approaching surreal. Aside from one silkscreen on paper showing Troy Donahue's face over—or is it under—a bottle of Smirnoff's and some lettering, I don't think I've ever seen any other celebrity image like this in combination with a product in all of Andy's work.

—Pat Hackett

Steve Wynn (Red)

1983. Acrylic and silkscreen enamel on
canvas, 40 x 40 inches.

© Andy Warhol Foundation for the Visual Arts/
Artists Rights Society (ARS), New York.

Steve Wynn (White)

1983. Acrylic and silkscreen enamel on
canvas, 40 x 40 inches.

© Andy Warhol Foundation for the Visual Arts/
Artists Rights Society (ARS), New York.

Andy Warhol

Steve Wynn (Gold)

1983. Acrylic, silkscreen enamel and diamond dust on canvas, 40 x 40 inches.

© Andy Warhol Foundation for the Visual Arts/Artists Rights Society (ARS), New York.

I remember very well the day Andy Warhol and I met the first time. It was in 1983 and I went to Andy's Union Square studio in New York City, where he had invited me to lunch. The meeting had been arranged by Roger Thomas, who, almost from the beginning, has been the director of design operations for my resorts. Roger was supposed to have joined us, but he had come down with flu that morning and had to cancel. Andy called his studio "the Factory." When I arrived, he greeted me warmly and showed me around the place. Like everybody else in America, I knew that Andy was a very successful artist and that he used the mechanical process of photo-silkscreens to produce his paintings. But his "Factory" didn't look like any kind of factory I had ever seen—more like a group of offices. He had recently moved out of a larger studio, and was sending a lot of the silkscreen work out to be produced by other people under his direction.

We went to his office for lunch. I remember it was a very nice meal; Andy had inquired as to what I liked to eat. When we sat down, he put a tape recorder on the table. "Steve," Andy said, "I have this little magazine called *Interview*. Do you mind if I interview you?" I didn't mind.

Mostly he asked questions about the Golden Nugget, the resort I had just opened up in Atlantic City. His style of interviewing was more casual than that of the journalists I was accustomed to talking to. When I read the interview later, I was surprised that it had not been edited. At first it seemed to me to lack the polish that one expects to see in print. Then it occurred to me that it was Andy's great insight that culture is the product of the activities of individual people, and that the public is interested not only in what certain people do but how certain people *are*—how they actually talk and behave in ordinary conversation.

After we finished the lunch and the interview, Andy took me to a corner of the studio and pointed to a wooden straight-back chair: "Straddle that chair backwards, look at me on your left, and don't

smile." I obliged, and he took my photograph with a Polaroid camera. "Look this way again, and don't smile." Another photograph, then one more. Afterward, he called me over and held the three photographs in his hand. "Which one do you like?" I pointed to one. "Me, too," he said. Then he dropped the two unwanted photographs on the floor, stepping on them as we left the room.

My meeting with Andy had been arranged in conjunction with an event that we were planning for the Nugget. We were arranging for Hubert de Givenchy to do his fall season fashion show in Atlantic City instead of in New York. Diana Ross, who was performing in the main showroom at the time, was going to model some of the clothes. Andy had recently done Diana's portrait for an album cover and he was brought in on the project to do portraits that would be used for publicity. A lot of interesting people were involved—Cordelia Guest, Ludovic Autet, Christopher Makos—it was shaping up into one of those fun, trendy, "air kisses" kind of affairs. Andy loved that sort of thing. I would see him in the casino with friends he had brought with him. "Hi, Steve, thanks for having us. We're having a great time," he would call out from across the room in that unique voice that David Bowie captured so well in Julian Schnabel's movie *Basquiat*. But plans for the event fell apart when Diana insisted on featuring her favorite designer, Bob Mackie. The tone changed; the people changed; Andy dropped out. We had the event, but it had a Mackie flair altogether different from Givenchy.

I was not expecting the three portraits of myself that arrived one day in Las Vegas. Andy had sent them as a "thank-you" for the interview. I was delighted, of course, and have hung them ever since in various of my homes and offices. He used the same silkscreen process to apply photographic images to the canvases that he had first developed in the 1960s, when he did portraits of icons like Marilyn, Liz, Jackie, and Elvis. He later told Roger that he had been inspired to do the portrait of me with the red background and the one with the white, each of which has bright blue highlights in the tie, because he thought of me as an all-American boy—red, white and blue. The sparkling paint used on the portrait with the gold background is diamond dust—he also said he pictured me as a "golden boy."

I didn't see Andy again after the few encounters I had with him in 1983 and 1984. I am sorry he died unexpectedly in 1987. When I was on my way to Andy's studio the day of the interview, I first stopped off for a visit to the Frick, one of my favorite museums. As I was walking toward the door, a stranger stopped me on the street: "Hey, Steve," he said, "where's Frank and Deano?" (Frank Sinatra, Dean Martin, and I had been doing a lot of publicity for the Nugget.) "Me and the boys," I said, "at the Frick, every Thursday. Nobody looks for us here." Andy laughed out loud at the story. I am sorry he can't be here to see the collection I have put together for the Bellagio Gallery of Fine Art that includes two of Andy's earliest important works, *Marilyn* (1962) and *Campbell's Elvis* (1964). I like to think he would be pleased.

—Stephen Wynn

Contributors

Friedrich Teja Bach is Senior Professor and Director of the Institute for Art History at the University of Vienna, Austria. He was among the organizers of the Brancusi retrospective shown in Paris and Philadelphia in 1995. His publications include *Constantin Brancusi, Metamorphosen plastischer Form* (1987), *Brancusi, PhotoReflexion* (1991), *Constantin Brancusi 1876-1957* (1995), and *Struktur und Erscheinung, Untersuchungen zu Dürers graphischer Kunst* (1996).

Roberta Bernstein is Professor of Art History and Chair of the Art Department at the State University of New York at Albany. She is author of *Jasper Johns's Paintings and Sculptures 1954-1974: "The Changing Focus of the Eye"* (1985) and contributed an essay to the Museum of Modern Art's catalogue for the 1996 retrospective of the work of Jasper Johns. She has written extensively on contemporary artists and is preparing a book on Johns's works since 1975.

Susan Davidson is a curator at the Menil Collection in Houston, Texas. She was co-curator of *Robert Rauschenberg: A Retrospective* at the Solomon R. Guggenheim Museum, New York (1997), and assistant curator of *Robert Rauschenberg: The Early 1950s* at the same institution (1991). She was the coordinating curator of *Franz Kline: Black and White 1950-1961* at the Menil Collection (1994).

Jacques Dupin is the author of *Miró* (1993). He is also the author of a monograph on Alberto Giacometti and of a collection of essays on contemporary artists, *L'Espace autrement dit* (1982). In 1988 he was awarded the Grand Prix National de Poésie by the French government.

Jack Flam is Distinguished Professor of Art History at Brooklyn College and the Graduate School of the City University of New York. He is the author of numerous books and catalogues on modern art, including *Matisse: The Man and His Art, 1869-1918* (1986) and *Matisse On Art* (1973; rev. ed. 1995).

Andrew Forge is a painter and the William Leffingwell Professor of Art, Emeritus, at the Yale School of Art. He is the author of *Monet* (1983) and *Degas* (1988) and has published essays on the work of Paul Klee, Chaim Soutine, Édouard Manet, and other artists of the nineteenth and twentieth centuries.

Françoise Gilot is a painter and writer who divides her time between Paris and New York. Her paintings are on permanent display in museums in France and the United States, and exhibitions of her works have traveled to museums and galleries in Europe, Canada, Australia, and the United States. She is author of six books including *Life with Picasso* (1964) and *Matisse and Picasso: A Friendship in Art* (1990).

Robert Gordon is a specialist in nineteenth- and twentieth-century French painting and photography with expertise on the work of Claude Monet and Edgar Degas. He is co-author of *Monet* (1983), *The Last Flowers of Manet* (1986), and *Degas* (1988).

Pat Hackett was a close friend of Andy Warhol's, collaborating with him on *Popism: The Warhol '60s* (1980) and *Andy Warhol's Party Book* (1988). After he died she was editor of *Andy Warhol Diaries* (1989).

Dave Hickey is Professor of Art Criticism and Theory at the University of Nevada Las Vegas. He is a contributing editor for *Art issues,* Los Angeles, and the author of numerous books, monographs, and critical essays on contemporary art and artists, including *The Invisible Dragon: Four Essays on Beauty* (1993) and *Air Guitar: Essays on Art and Democracy* (1997).

Richard Kendall is an independent art historian and exhibition curator who specializes in the work of the Impressionists. His publications include *Van Gogh to Picasso: The Berggruen Collection at the National Gallery,* London (1991) and *Degas: Beyond Impressionism* (1996). He has recently written the exhibition catalogues *Degas and the Little Dancer,* Joslyn Art Museum, Omaha (1998) and *Van Gogh's Van Goghs: Masterpieces from the Van Gogh Museum, Amsterdam,* The National Gallery of Art, Washington (1998).

Anette Kruszynski is Exhibitions Curator at the Kunstsammlung Nordrhein-Westfalen in Düsseldorf, Germany, where she organized "Max Beckman" in 1997. She is the author of *Amedeo Modigliani, Portraits and Nudes* (1996).

James Lord is an American writer who has spent most of his life in France. He is the author of numerous books, including *A Giacometti Portrait* (1980), *Giacometti: A Biography* (1985), *Picasso and Dora: A Personal Memoir* (1983), *Six Exceptional Women, Further Memoirs* (1994), *Some Remarkable Men, Further Memoirs* (1996), and *A Gift for Admiration, Further Memoirs* (1998). He has been made an officer of the Légion d'Honneur by the French government in recognition of his contributions to the culture of France.

Libby Lumpkin the curator of the Bellagio Gallery of Fine Art and the editor of this volume.

Charles Moffett is Co-Chairman of Impressionist, Modern, and Contemporary Art (Worldwide) at Sotheby's, New York. He is the author of *Van Gogh as Critic and Self-Critic* (1973) and *Impressionist and Post-Impressionist Paintings in The Metropolitan Museum of Art* (1985). He has published numerous articles and essays on Impressionist and Post-Impressionist art and organized or co-organized a number of exhibitions, including "Manet: 1832-1883," The Metropolitan Museum of Art (1983), "The New Painting: Impressionism 1874-1886," The National Gallery of Art, Washington, and The Fine Arts Museums of San Francisco (1986), "Impressionists on the Seine" and "Impressionists in Winter: Effets de Neige," The Phillips Collection, Washington (1996 and 1998 respectively).

Joachim Pissarro is the Seymour H. Knox Curator of European and Contemporary Art, Yale University Art Gallery. His books include *The Impressionist City: Pissarro's Series Paintings* (1992), *Pissarro* (1993), and *Monet and the Mediterranean* (1997). His curatorial projects include "Impressionism and Post-Impressionism from Private Collections in Switzerland," Royal Academy, London (1995), "Pissarro," Israel Museum, Tel Aviv (1995), "French Impressionism," Bunkamura Museum, Tokyo (1996), and "Cézanne and Pissarro: An Impressionist Collaboration," Los Angeles County Museum of Art and the Musée d'Orsay, Paris (1995). He is currently preparing the catalogue raisonné of Camille Pissarro's paintings.

Robert Rosenblum is Professor of Fine Arts at New York University and the Stephen and Nan Swid Curator of Twentieth-Century Art at the Solomon R. Guggenheim Museum of Art. He has published widely on nineteenth- and twentieth-century art. His books include *Modern Painting and the Northern Romantic Tradition: Friedrich to Rothko* (1975), *Paintings in the Musée d'Orsay* (1989), *The Jeff Koons Handbook* (1992), and *Andy Warhol Portraits* (1993).

Richard Shiff is the Effie Marie Cain Regents Chair in Art at the University of Texas at Austin, where he directs the Center for the Study of Modernism. He is author of *Cézanne and the End of Impressionism* (1984) and has published numerous interpretive essays on the work of Paul Cézanne, Henri Matisse, Willem de Kooning, and other major modernists.

Peter Schjeldahl is the art critic for *The Village Voice*, New York.

Gary Tinterow is Englehard Curator at the Metropolitan Museum of Art. He has been responsible for nineteenth-century European painting at the museum since 1983 and has organized a number of exhibitions devoted to individual artists, including Pierre-Paul Prud'hon, Théodore Gericault, Camille Corot, Edgar Degas, and Georges Seurat, as well as exhibitions of wider scope, including "From Poussin to Matisse," "The Russian Taste for French Painting," "Splendid Legacy: The Havemeyer Collection," and "The Private Collection of Edgar Degas."

Colophon

The Bellagio Gallery of Fine Art: Impressionist and Modern Masters
was printed and bound by Arti Grafiche Amilcare Pizzi S.p.A.
in Milan, Italy, and was designed by Abraham Brewster. The
typeface used is Adobe Garamond, a modern digital interpretation
of Paragonne Roman, a type created by the great sixteenth-century
French designer Claude Garamond.